No: 4.

WILLIAMSTON COMMUNITY SCHOOLS
WILLIAMSTON, MICHIGAN 48895

TVRE HISTORIQVE

Joh. Ulrich Kraus sc: Aug: Vind:

PANORAMA OF WORLD ART

BAROQUE AND ROCOCO ART

BAROQUE

AND ROCOCO ART

759.04
A

Text by LISELOTTE ANDERSEN

HARRY N. ABRAMS, INC. Publishers NEW YORK

Front end papers:
JOHANN BERNHARD FISCHER VON ERLACH (1656–1723). Illustration on title page of *Entwurff einer Historischen Architectur* . . . , Vienna, 1721, Book I

Back end papers:
JOHANN BAPTIST MODLER (1700–74), attributed. New Episcopal Palace, Passau. Detail of the stuccoed ceiling of the former third antechamber.
c. 1768

Translated from the German by Barbara Berg

Standard Book Number: 8109–8027–4
Library of Congress Catalog Card Number: 69–75041

Copyright 1969 in Germany by
HOLLE VERLAG GMBH, BADEN-BADEN
All rights reserved. No part of this book may
be reproduced without the written permission of the publishers
HARRY N. ABRAMS, INCORPORATED, NEW YORK
Printed in West Germany. Bound in the Netherlands

Contents

Introduction (page 6)

Summary of the Text:

Chronological Tables (page 254)

Bibliography (page 258)

Index (page 260)

Photo Credits (page 264)

Introduction

European art between 1600 and 1800—the period covered in this book—encompasses a great number of different trends, varying from country to country, that can be characterized only broadly as "Baroque" or "Rococo." Works of art produced in Europe during the International Gothic period—that is, around 1400—appear relatively homogeneous, whatever their country of origin; however, it was during the seventeenth and eighteenth centuries that particular national characteristics, the specific tendencies of the various European peoples, emerged in art.

It is therefore impossible, in an introductory work such as this, to trace one uniform line of artistic development in a continuous chronological sequence. Rather, one must attempt to understand the period by studying the individual, isolated centers of artistic activity, explaining how each area developed out of its own political and social conditions and describing the kind and extent of the influence that it exerted. Thus Rome, the first center of the new style, and the artistic community of the *grand siècle* in France, with its focal point at Versailles, are each treated as a separate unit, as are also the wealth of Flemish and Dutch painting and the cultural centers that developed at the German princely courts during the eighteenth century. On the other hand, certain subjects can more usefully be studied in a broader context: when works dealing with a particular theme, drawn from all of Europe, are compared, the specific national differences are more evident than if a single country is studied in isolation without reference to developments elsewhere. Above all, one can recognize the many different ways that European artists have discovered to assimilate and reinterpret the influence of Italy, the source of most artistic trends since the Renaissance. Thus, Caravaggio's influence with its varied effects in different countries, the themes of landscape and of still life, even the motif of the staircase, can all reveal, in a number of characteristic examples, the very different ways in which national styles developed.

The influence of France upon the great palaces of Europe is similarly demonstrated. Toward the end of the book, in a discussion of ornamentation, international tendencies are once more grouped together without reference to national boundaries; although ornamentation is often regarded as an element of little significance, it is frequently in such work that artistic trends can be more easily recognized than in the major art forms. In this survey, the individual work of art does not merely stand for itself. Throughout, an attempt has been made to see the work in relation to its context—the social and political climate that made it possible for such a work to be conceived and to receive its final form as we see it here.

The term Baroque, like many other expressions used in art history—among them Gothic and Rococo—was first used in a pejorative sense. The word comes from the Portuguese and means "an irregular pearl." In the sixteenth century, the term was taken up in France, where it came to connote "peculiar." *Le goût baroque,* judged according to the standards of the classicism prevalent in France in the late eighteenth century, meant a tendency to transform Renaissance clarity and classical simplicity into bizarre and obscure forms. Even Goethe and the Romantics used the term deprecatingly to mean "strange" or "ridiculous." Baroque was first used in German art history as a purely stylistic description—as a means of referring to the art of a particular period without implying a value judgment—by Cornelius Gurlitt and, more especially, by Heinrich Wölfflin, who were among the first to make a proper study and objective evaluation of the style.

The Baroque originated in Italy, where various tendencies had developed during the course of the sixteenth century that today are often collectively known as "Late Renaissance" or "Mannerist." It was characteristic

of this period that classical proportions—whether in architecture, in the representation of the human body, or in the composition of paintings—were no longer as strictly observed as they had been during the High Renaissance. The organic balance between the supports of a building and those parts constituting the load or weight pressing down on them was now disturbed by the addition of top-heavy cornices or of columns enlarged to colossal dimensions. The human body was elongated or shown in twisted and contorted postures. Paintings lost the feeling of harmony produced by spatially balanced composition, becoming instead full of movement and direction. All these features already point to the Baroque. The germ of the whole tendency—which continued to develop through Mannerism and Baroque and on into the eighteenth century—can be found in the works of Michelangelo. In his ceiling frescoes for the Sistine Chapel in Rome, he broke the tradition of classical pictorial composition, giving sculptural force to his figures and using architectural illusionism. In many of Michelangelo's sculptures, particularly in his *Victory* in the Palazzo Vecchio, Florence, the classical proportions of the human body are disregarded, and the pose of the triumphant youth is made credible through the powerful turn of his body. In the interior of the stair hall of the Biblioteca Laurenziana in Florence, Michelangelo abandoned the traditional architectural use of columns as a visible means of supporting a load and, instead, sank them as lines of force into the wall mass itself. These are all fundamental tendencies that were to be further elaborated and consistently developed in Baroque art.

Heinrich Wölfflin, the great Swiss art scholar, reduced the elements of the Baroque to a few basic concepts that are still valid today, after the period has been much more precisely and searchingly investigated. These concepts form the basis for this book.

The first of Wölfflin's characteristics was movement, a quality to be found in all forms of Baroque art. The meaning of the term "movement" will immediately become clear if one compares an early painting by Raphael with one by Rubens: Raphael's self-contained, stable, carefully ordered composition reflects the serene presence of mother and child—for instance, in his early Madonnas. Rubens' use of the human body expresses movement, often carried to a high dramatic pitch—as when a battle of the Amazons is depicted as a vortex of living forms (see page 97). The body is shown at a fleeting moment in time, revealing the movement the figure has just made and that about to be made.

In architecture, which is intrinsically static, it is more difficult to define the concept of movement. One means of expression is through the use of lines or spatial areas set in opposition to each other: in the church of S. Maria della Pace in Rome (see page 14), Pietro da Cortona used a convex projecting portico to contrast with concave wings flanking the building. But movement in architecture can also mean that lines of force or support are revealed instead of being concealed beneath wall surfaces or ornamentation. The architect, as it were, lets the building take shape before the eyes of the viewer, not as a static arrangement of masses, but as an organic structure. The volutes flanking the façade of S. Susanna in Rome seem to push the pediment upward (see page 13). Simultaneously, the center of the building receives new emphasis. No longer conceived of as a harmoniously balanced composition, a building is shown to contain tensions that may, for instance, seem to push the central pavilion of a palace forward, or the central pediment of a façade upward. Movement can also mean that a building takes on different aspects, depending on the point from which it is seen: S. Maria della Pace thus seems to change as one slowly approaches or looks at it from various angles. In sculpture, movement was sometimes so exaggerated that the composition could only be completed by the addition of rising and falling water: only when a jet of water spouts from Triton's conch horn can Bernini's fountain be considered a balanced and "finished" design (see page 50).

Related to movement, particularly in architecture, is the concept of mass. A wall is no longer shown as a flat surface enclosing a space; engaged columns, recesses, and pilasters help to convey the feeling that a building is indeed made of massive, powerful materials. Double or even triple columns contribute to and intensify

this impression (on the façade of SS. Vincenzo ed Anastasio [see page 14] for instance), while simultaneously introducing into architecture the contrast of light and shadow. Through this device, a façade could be broken up into illuminated and darkened areas, which seem to move according to the time of day. A similar principle can be found in painting. Caravaggio exposed his figures to a harsh, glaring light, apparently from a single source somewhere off the canvas, making them stand out sharply from the dark background and increasing

THOMAS GOBERT (c. 1630–1708). Designs for the ground plans of churches spelling out LOVIS LE GRAND (the letters doubled in mirror fashion)

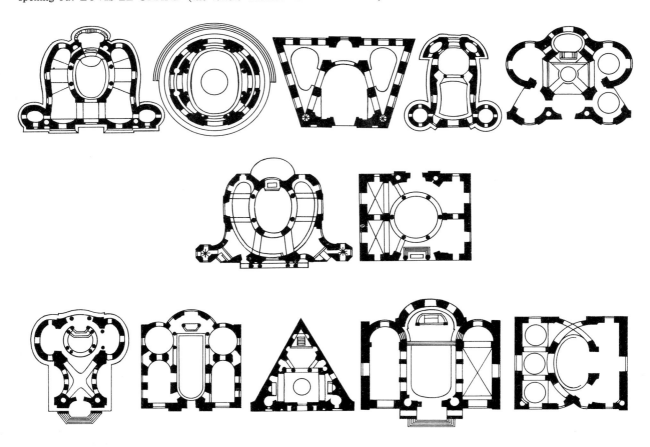

the dramatic impact of the entire painting. A similar kind of contrast is possible in sculpture, where deeply carved folds in drapery were used to open up the surface of figures, thus introducing a play of light. Such a treatment gives sculpture some of the features of painting and helps to blur the distinctions between artistic mediums—distinctions that were to become less and less clear in the eighteenth century. Architecture and painting were combined at a very early date, especially in ceiling frescoes. Using techniques of perspective formerly employed only in autonomous painting, artists could make the actual structure of a building seem to continue upward and open out into the sky.

Of course, all these characteristics can be fully applied only to the Italian Baroque. In Italy at the time of

the Counter Reformation, the Church and its dignitaries were the most important source of commissions for new art works. The Council of Trent (1545–63) had reinvigorated Catholicism and assigned new tasks to religious art: art was to be used as a means to propagate the faith and as a weapon against heresy. The faithful were to be drawn back to the established beliefs by representations of Biblical subjects or of scenes from the lives of the saints. Works of art intended to serve such a didactic purpose had to be easy to understand and had to have a strong, direct emotional appeal in order to arouse piety. At the same time, the power and authority of the Catholic hierarchy had to be conveyed as impressively as possible. Although it would be going too far to say that these newly defined religious goals were the point of departure for the Italian Baroque, they did coincide with, and contribute to, other tendencies that were appearing at the time.

In France, where quite different circumstances prevailed, Gothic features persisted in provincial art, particularly in the north, until well into the seventeenth century. However, the art of the court, concentrated in Paris and around the residences of the aristocracy, was derived from, and represented a further development of, Italian Renaissance architecture. The rules of the classical theoretician of architecture, Vitruvius, were repeatedly translated, retranslated, and commented upon until well into the eighteenth century; they remained the basic laws of French architecture during the *grand siècle* and for official buildings of the succeeding period, particularly in Paris. This art is often described as "classicist," yet such a description is not really appropriate. French court architecture was neither an imitation nor a direct copy of classical models; rather, rules that had originated in Antiquity were developed and changed within a continuing tradition; they were constantly discussed at the royal academies and were varied and developed in new and creative ways. This was no "dead" classicism, but a living art that, at its best, attained a classical level. The French spirit of *clarté* was incompatible with that of the Italian Baroque. Any deviations from the classical rules of architecture—the rules of simplicity and serenity—was alien to the French; the exuberance that burst forth in all areas of Italian art was incomprehensible and even offensive to the French sensibility. Attempts were made to establish a link with the Roman Baroque style; Bernini, the most famous seventeenth-century Italian architect, was invited to Paris to complete the royal palace, the Louvre. There he received a princely welcome; but eventually he returned to Rome without having achieved his purpose—his designs for the Louvre were rejected. The attempt to introduce Italian Baroque into France had failed.

Just as in Italy the Church was the center of artistic life, in France the court was the major source of commissions and of new inspiration. The construction of the Louvre (which lasted for centuries) was the focal point around which were gathered the outstanding artists of the time—not only architects, but others such as Poussin, who was brought from Rome to paint one large gallery of the palace.

In France, not only the sovereign but powerful ministers as well used art to display their power and enhance their reputation. Cardinal Richelieu, the mightiest French statesman of the first half of the seventeenth century, had a town, Richelieu, built at his birthplace—a rational, carefully organized and planned town that was to form a unit with his newly constructed palace. Nicolas Fouquet, the influential Finance Minister until the time that Louis XIV took power, challenged the young King by building a magnificent palace and park at Vaux-le-Vicomte. After 1661, when the Sun King decided to govern France himself, without the aid of a Chief Minister, the artistic center of France was Versailles. There, under the imperious gaze of the King, were concentrated the finest architects, painters, sculptors, stuccoworkers, landscape gardeners, goldsmiths, and even poets and composers that France could offer. France, where all power and resources were concentrated at the royal court, could stage a display of artistic magnificence that could not be paralleled by any other European country of that period. Thus, French court life at Versailles became the prototype for the princely courts of the West—a model that retained its influence throughout the eighteenth century.

In Germany, the Reformation had caused a sharp break between the Protestant north and the Catholic

south. The north continued for a time to follow Gothic traditions, while the south received new impetus from the Baroque art of Italy through contact with Italian artists who had been called in to work there. The Thirty Years War, with all its horrible destruction, cut short these developments. The countryside, laid waste during the war, required decades to recover. Thus it was not until toward the end of the seventeenth century that there was a reawakening in Austria and Bohemia which, aided by the numerous princely courts, large and small, led to the eighteenth-century flowering of German art.

English architecture of the seventeenth century is comparable in some respects to contemporary French architecture; in England, too, one finds scarcely any trace of Italian Baroque. The Gothic tradition survived for a disproportionately long time, through the entire sixteenth century and into the early seventeenth. Even the various court buildings and residences of the nobility kept largely to this style—until Inigo Jones's use of Italian architectural forms brought it to an end. Jones traveled to Italy but did not study contemporary Italian architecture; he found his inspiration primarily in the formal language of Palladio, the great classical architect of the late sixteenth century in Venice and Vicenza, who had clearly and coolly modified the strict Vitruvian rules. Thus the architectural theory of Antiquity was transmitted to England through the work of Palladio, and became the foundation for the so-called Palladianism that dominated the architecture of the Anglo-Saxon countries and of the countries they influenced (such as Holland) until well into the nineteenth century. Although Italy was, of course, the ultimate source of this style, it did not derive from contemporary Italian art; rather, as in France, it was inspired by that of the preceding century. Christopher Wren, the second great seventeenth-century English architect, did not even go to Italy but sought his inspiration from Paris and its classical buildings.

In the southern Netherlands (Flanders) the influence of Italian painting first appeared in the works of Peter Paul Rubens. Rubens had spent a great deal of time in Italy and had studied Venetian painting as well as the Roman artists of the late sixteenth century. When he returned to the Netherlands, he developed his impressions in a wholly personal way; in painting and in sculpture he made the lively Flemish Baroque the point of departure for trends that would continue to be influential, particularly in the Catholic areas of the continent. The painting and sculpture of all of southern Germany and Austria in the eighteenth century would have been inconceivable without this great Flemish artist.

In the northern (Protestant) areas of the Netherlands, painting reached new heights in the seventeenth century; the style that emerged was influenced by developments in Italy, particularly by Caravaggio's use of chiaroscuro, but eventually it evolved its own formal language, related to the Italian Baroque only in certain basic features that are not immediately apparent. There is scarcely a period in European art that is as astonishing as this flowering of Dutch painting which burst forth with an incredible richness and a truly remarkable level of accomplishment in a country that had once before, during the fifteenth century—at the time of the brothers Van Eyck and their successors—brought painting to a peak of development. In the seventeenth century, however, a real passion for painting took hold: not only professional artists, but also landlords, sailors, town clerks, and real-estate brokers painted—and frequently displayed a surprising talent.

In Spain, which was closely bound to Naples and southern Italy through dynastic relationships, and which shared with all of Italy its strict Catholicism, the influence of Italian Baroque architecture was also strong Even in Spain, however, forms were modified to make them more expressive of national character. Because of the additional factors of Islamic influence resulting from the Moorish era and a continued lively feeling for ornamental effect, highly unusual architectural forms appear in Spanish art. These forms, with their forcefulness and bizarre vivacity, add a special note to the concert of European art, while in the Spanish colonies in the Americas, they were enriched and intensified through contact with native traditions. The greatest or "classic" Spanish art is, of course, in the realm of painting. When one looks at the canvases of the great

masters—Velázquez, Murillo, Zurbarán, and (toward the end of the epoch) Goya—it is obvious that the trends of the times can be seen in the work of such geniuses. But in the last analysis, the paintings of these men, in their most essential qualities, evade strict categorization as to style—an observation that is also true of Rembrandt and Vermeer.

With the death of Louis XIV in 1715, the period of the imposing, court-supported art of the *grand siècle* came to an end. The King himself had been the focus of this art and the one who set standards as to its worth; every artistic medium had been employed to surround the mighty, godlike ruler with as much luxury and magnificence as possible. But even in the last years of the King's life, the nobles had already begun to leave the court and to disregard the strict etiquette decreed by the King at Versailles. Young people in particular moved back to Paris, tired of the rigid splendor and longing for a more cheerful social life. The great, ponderous Baroque style was finished, dissolved in the lightness and grace of the Rococo. In the last decorative work done for the Sun King at Versailles, seemingly weightless forms made their first appearance. During the regency of the easy-going Duke of Orléans for Louis XV, who was still a minor, an art appeared in which the great gods Apollo, Jupiter, and Juno were no longer dominant; instead, there were lightly draped nymphs, satyrs, and bacchantes. The change was most noticeable in interiors—man's immediate surroundings. Light now entered the rooms through windows extending to the floor and was reflected by large mirrors. Not a shadow was allowed, even in the corners; the corners themselves were rounded off. Architecture, the structure of a building, was no longer something to be expressed in pilasters and heavy cornices; instead, the wall space between the mirrors was broken up into luminous, ornamented surfaces. The enormous ceiling paintings disappeared; ceilings became a bright, solid color, divided into panels by ornamental motifs. These motifs, originally derived from plant forms, were elaborated into abstract C-curves or double-S scrolls. Frequently a shell-like shape was formed: the *rocaille,* which gave its name to an entire style, had originated, and soon spread throughout Europe by means of engravings. One of the richest and most beautiful developments of the Rococo took place in southern Germany, where the new style was not limited to the decoration of secular interiors, as it was in France.

While in France all power, and therefore also all artistic activity, was concentrated in Paris as the capital and in Versailles as the seat of the court, Germany was divided into innumerable small principalities over which the Emperor exercised only a loose sovereignty. This lack of a central authority, particularly after the terrible Thirty Years War, caused political stagnation, but artistically, the fragmentation of the German lands was a source of enrichment. There was not only Vienna as capital of the empire and residence of the Emperor; each prince collected a circle of artists about him in an attempt to create a small-scale imitation of Versailles. Magnificent residential palaces were built in Würzburg, Stuttgart, and Karlsruhe. At the end of the seventeenth century, Augustus the Strong became Elector in Saxony; he was a ruler who was extremely conscious of his power and had a taste for splendor, but he also had an understanding of art and highly selective taste. Dresden, and Warsaw after Augustus became King of Poland, developed into cultural centers of great importance because of this man. In Berlin, a magnificent palace complex designed by Andreas Schlüter was built at the beginning of the eighteenth century, expressing the new dignity of the Elector of Brandenburg as the first King of Prussia; later, under Frederick the Great, there was a rich cultural life at Potsdam. In Bavaria, one of the strongholds of Catholicism in Germany, eighteenth-century courtly pomp was united with a deep piety. Both the people and their rulers attempted to express their reverence for the traditions of the Church through bequests and costly gifts. The *rocaille* entered the realm of religious art. In a rapturous exuberance that attained almost mystical proportions, the static laws of architecture seemed to be suspended; church interiors were flooded with unearthly light. Ritual vessels became ornamental scrolls, dissociated from their original purpose. On the exteriors of buildings, in window cartouches and pediments above entrances, static forms were broken

up with ornamentation. Even in the over-all floor plan of a monastery, such as the huge project at Weingarten, ornamental tendencies appeared; the great complex gives the effect of a cartouche surrounded by a swirling frame.

In France, the first signs of a return to classicism appeared toward mid-century, just as south German Rococo was reaching its peak. In the official architecture of the court and of the Parisian magistracy, supported by the Royal Academy, the connection with the classical style of the *grand siècle* had never been completely lost; now, however, classical rules acquired new life. Architectural writings and critical essays rejected as tasteless the bizarre richness of the *rocaille* style. True, a more carefree spirit continued to prevail in courtly and social circles and therefore also in painting, in which this life was reflected. Through the influence of Jean-Jacques Rousseau and his philosophy of nature, the strict courtly etiquette was undermined and transformed into something more casual. It was through Rousseau that those emotions were aroused which set man free from the external pressures of society, but which then, in the Revolution, put him at the mercy of a moral code modeled upon the sober virtue of Republican Rome.

Even before the overthrow of the French monarchy, a tendency toward cold, severe forms was noticeable. This was particularly true of architecture, which was classicist rather than classic as it had been in the seventeenth century. The Petit Trianon at Versailles, built by Louis XV for his mistresses, anticipates the basic features of the architecture of the Revolution. In architecture as in other art forms, developments were to occur during the nineteenth century that would result in an entirely new approach to art. Thus, in external events, the French Revolution and the subsequent upheavals in political and social life brought an end to the period discussed in this volume. In art, however—which registers the changes that take place in man and his attitude toward the world with seismographic sensitivity—one can already find in the old era the seeds of the new which would bear fruit in the following century.

CARLO MADERNO (1556–1629). Façade of S. Susanna, Rome. 1596–1603

The façade of S. Susanna in Rome, completed by Carlo Maderno at the very beginning of the seventeenth century, already displays in their pure form all the tendencies characteristic of the Baroque: the ponderous masses; the development toward the center from the pilasters through the engaged columns to the double engaged columns; the play of light and shadow in the niches. What is understood by the term "movement" in architecture is also apparent here: the upper story, crowned by the pediment with its heavy balustrade, seems to be pushed upward by the curving volutes. Maderno adopted the general plan of the façade from the Gesù—the model of so many Jesuit churches—but, characteristically, he transformed it by making changes in the proportions, by giving a stronger articulation to the columns, and by slight alterations such as in the bend of the volutes.

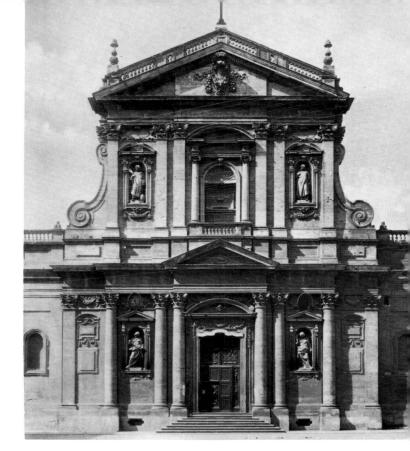

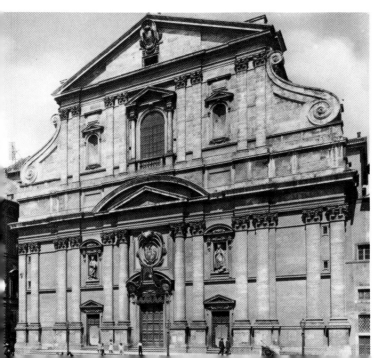

The façade of the Gesù, completed in 1573 by Giacomo della Porta as a modification of the original design of Giacomo Barozzi da Vignola, achieves a broad and stately effect, although here, too, emphasis is placed on the center through the use of such devices as the double pediment. Compared with this model, however, Maderno's façade is far more dynamic; it pulsates with the energy of the new Baroque spirit.

GIACOMO DELLA PORTA (c. 1537–1602). Façade of the Gesù, Rome. 1573. Construction of the church was begun in 1568 under the direction of Giacomo Barozzi da Vignola (1507–73)

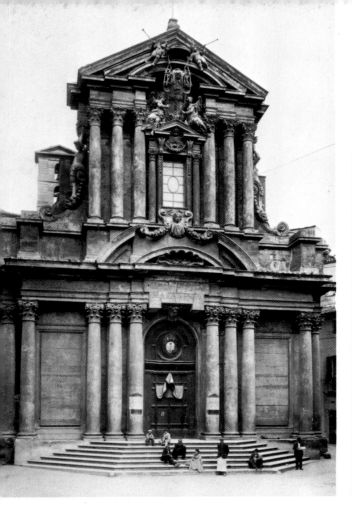

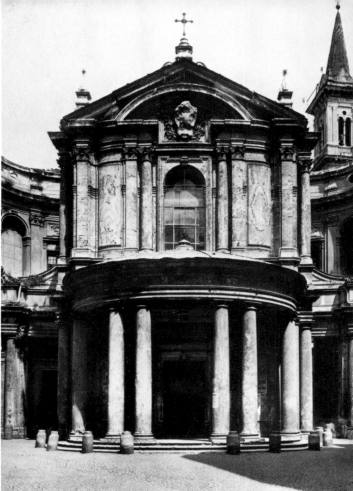

Martino Longhi the Younger (1602–60). Façade of SS. Vincenzo ed Anastasio, Rome. 1646–50

Pietro da Cortona (1596–1669). Façade of S. Maria della Pace, Rome. 1656–57

On the façade of SS. Vincenzo ed Anastasio by Martino Longhi the Younger, the play of light and shadow is created by the prominent groups of triple columns and the sharp forward projection of the cornices. Shadows cast by the brightly lit columns onto the surface behind them move with the time of day, contributing constantly shifting nuances to the building structure itself.

Light and shadow also play a decisive role on the façade of S. Maria della Pace by Pietro da Cortona: the semicircular colonnaded portico plunges the lower story into semidarkness. Another principle of the advanced Baroque is even more evident here: the conquest of volume, which made possible the sense of movement in architecture. The façade is constructed in one unbroken vertical plane; the forward swing of the portico is countered on the upper level by the concave layout of the wings.

ALESSANDRO ALGARDI (1595
–1654). Bust of Donna Olimpia Pamphili-Maidalchini, sister-in-law of Pope Innocent X. c. 1650. Marble, one and one-half times lifesize. Palazzo Doria Pamphili, Rome

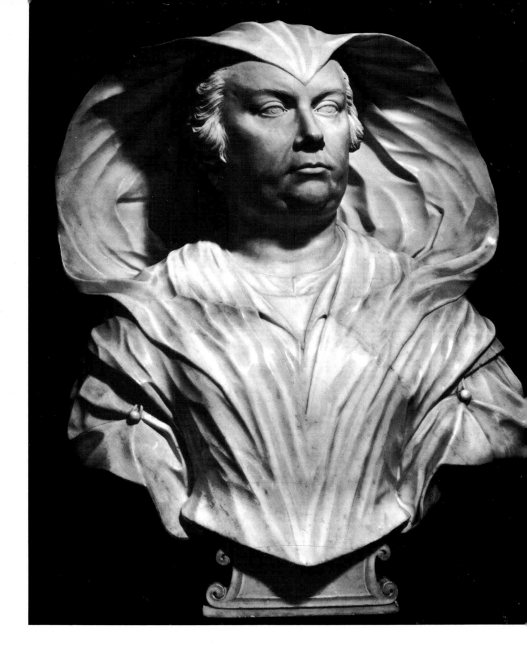

The same motif that appears in the architecture of S. Maria della Pace is also evident in contemporary sculpture: the powerful head of Donna Olimpia is surrounded by a puffed-out shawl, much as the center of a building is framed by its wings. Alessandro Algardi uses this device to add energy and forcefulness to his portrait bust of the woman who was the most powerful personality under Innocent X. Donna Olimpia, sister-in-law of the feeble Pope, was the real ruler of Rome. She was sarcastically referred to as "Papessa" by the people.

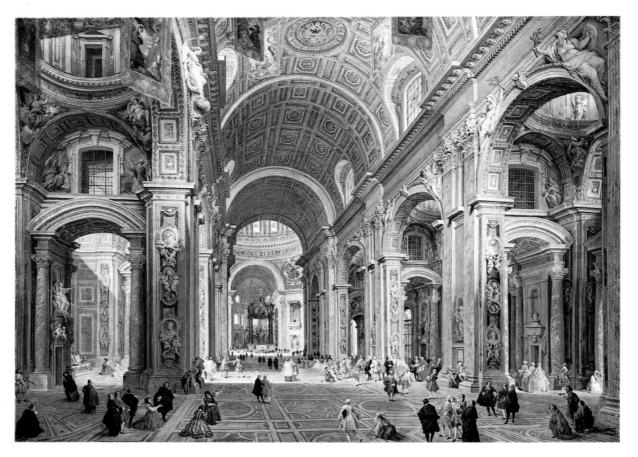

GIAN PAOLO PANNINI (1691/2–1765). *Interior of St. Peter's in Rome.* 1755. Oil on canvas, 38⅝ × 52⅜″. Niedersächsische Landesgalerie, Hanover

MADERNO. Interior of S. Andrea della Valle, Rome. 1608–28 ▶

A new feeling for movement is also evident in the interior of Baroque churches. The inside of the church is no longer a static structure composed of separate parts with each part given equal emphasis, as was the case in the centrally planned buildings favored in the Renaissance. St. Peter's in Rome was first designed as such a static structure; it was to be in the form of a Greek cross, with four equal arms extending outward from the dome over the crossing. In 1607, however, it was decided to extend the nave, and Carlo Maderno was commissioned to do so. At the entrance to the church, the nave receives the visitor and directs his attention to the altar. Here the high altar, the focus of attention, is not located in the apse as it was in most churches of the time. The presumed tomb of the Prince of the Apostles, with Bernini's baldachin above it, lies in the center of the cathedral beneath the dome. In this painting by Gian Paolo Pannini, the interior is given a much more pictorial aspect than it actually possesses. Through the distribution of light and the use of exaggerated perspective, the view down the barrel-vaulted nave to the brightly lit crossing is sharply emphasized.

Carlo Maderno worked simultaneously on the nave of St. Peter's and on the church of S. Andrea della Valle. Here, even more than in the principal church of Christendom, one can sense the influence of the Gesù.

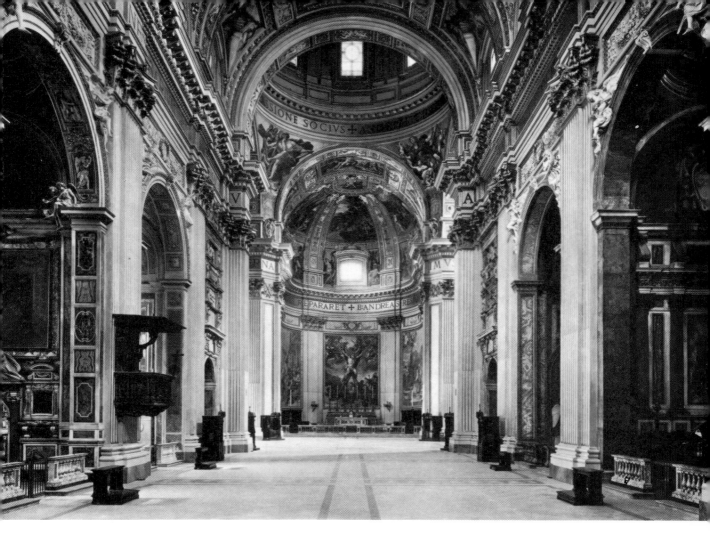

Broad pilasters separate the side chapels from the nave, so that the chapels appear as dark annexes and do not interrupt the forward movement down the main axis toward the altar. The heavy cornice, projecting only slightly over the pilasters, extends down the entire length of the nave, forming a clear base line for the barrel vaulting. Maderno came from Lombardy and was the first to introduce a powerful, dynamic feature into the architecture of Rome—a feature that is also apparent in the façade of S. Susanna (see page 13).

Overleaf: ANDREA POZZO (1642–1709). *Allegory of the Missionary Work of the Jesuits.* Ceiling fresco of S. Ignazio, Rome. 1691–94

Ceiling paintings were very often used to open up the Baroque interior and to create a feeling of great spaciousness. Thus, another feature of the period comes into play: the fusion of different mediums of art. In the painting by Andrea Pozzo on the ceiling of the nave of S. Ignazio in Rome, shown on the following pages, architectural perspective has been adopted. Through the use of *trompe l'oeil*, the actual architecture of the nave seems to be continued upward into the painting, opening into an entire cosmos of saints and angels, and finally merging with an imaginary heaven.

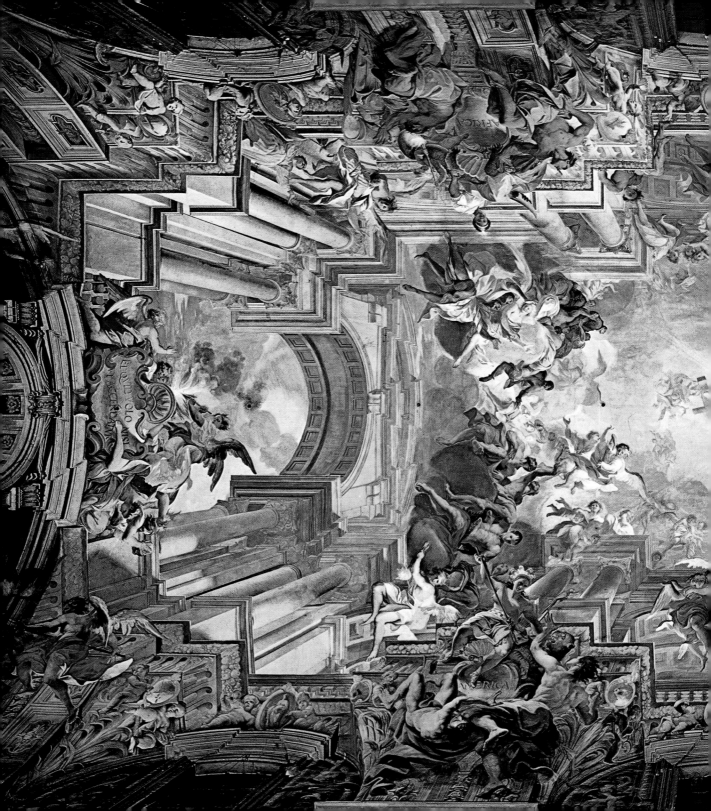

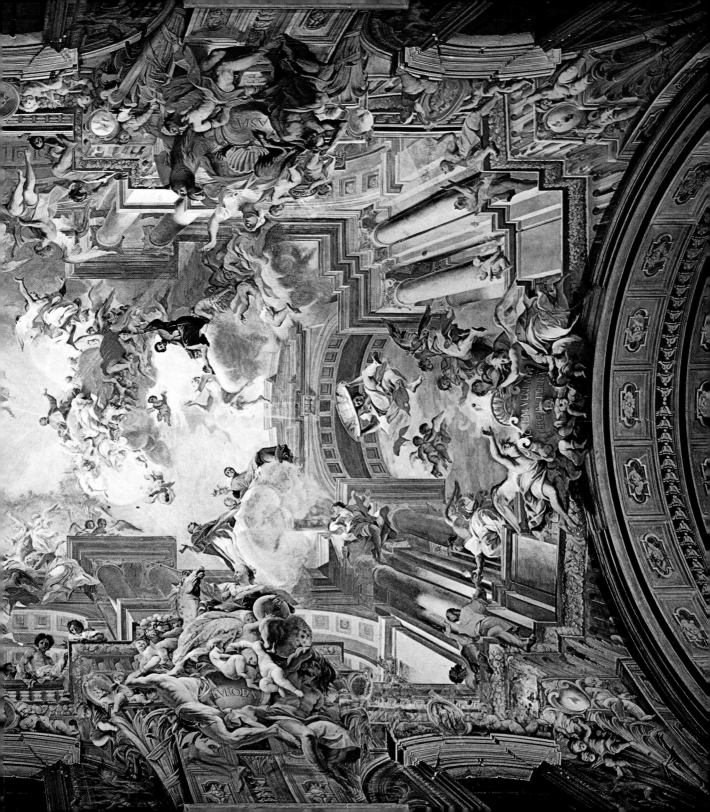

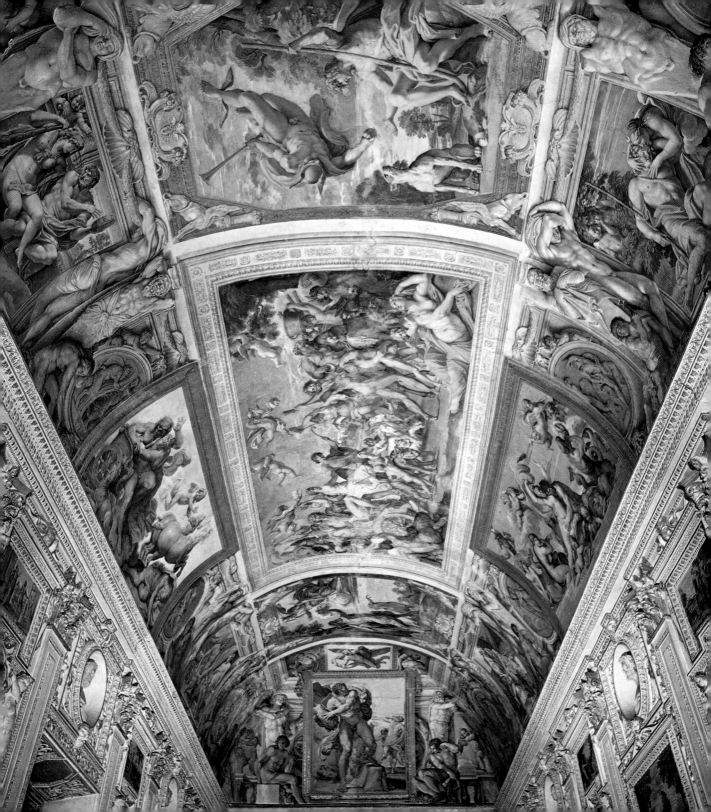

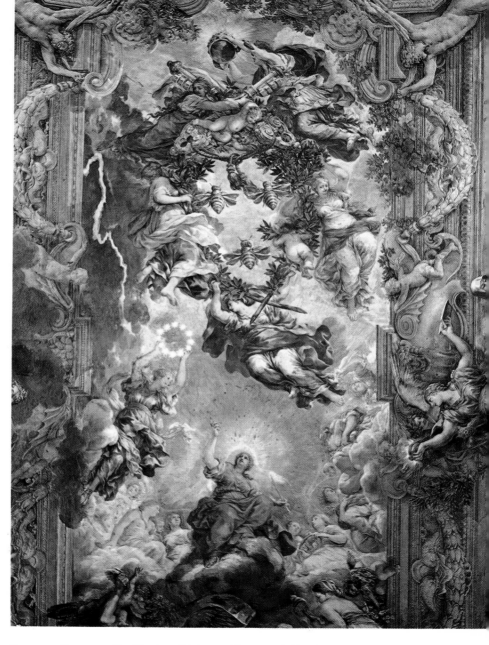

ANNIBALE CARRACCI (1560–1609) and other Bolognese masters. Gallery in the Palazzo Farnese, Rome. The frescoes illustrate themes from Ovid's *Metamorphoses*. c. 1600

Michelangelo's frescoes in the Sistine Chapel obviously served as models for the ceiling paintings with which Annibale Carracci and other painters of the Bolognese school decorated the gallery of the Palazzo Farnese around 1600. But a new spirit has loosened the strict arrangement of the Renaissance masters: framed paintings have been inserted into a many-layered, staggered architecture; the corners have been turned into free space, with patches of sky showing behind the sculptural figures. It is scarcely possible to distinguish the different degrees of realism in the various figures represented: which are painted pictures, which sculptures, and which illusionistically represented living forms?

PIETRO DA CORTONA. *Glorification of Urban VIII's Reign.* Ceiling fresco in the Gran Salone of the Palazzo Barberini, Rome. 1633–39

Here, in the fourth decade of the seventeenth century, Pietro da Cortona breaks open the architectural construction of the ceiling, allowing the allegorical vision to soar tumultuously over the hall as a testament to the glory of the papacy and of the Barberini house.

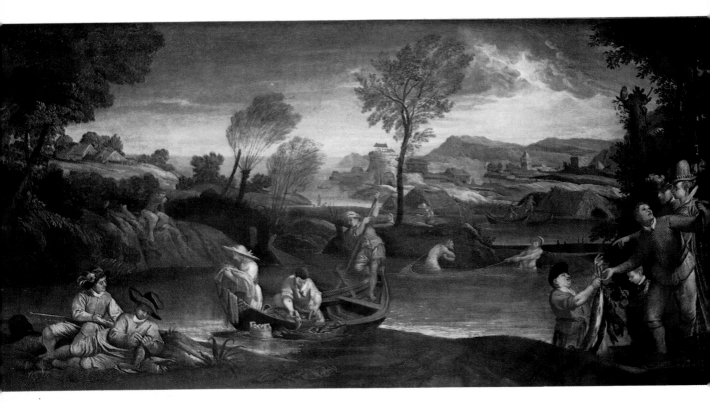

ANNIBALE CARRACCI. *Fishing Scene.* c. 1585. Oil on canvas, 53$^1/_2$ × 99$^5/_8$". The Louvre, Paris

Landscape painting played only a subordinate role in Italy, in contrast to the North, until the beginning of the seventeenth century. The Venetian painter Giorgione had been the first to place men in natural settings, but the human form continued to dominate Italian painting. The Bolognese school of painting, and particularly Annibale Carracci, was the first to introduce a new note. In his early *Fishing Scene*, the groups of human figures still determine the content of the picture, but in terms of its composition, they are subordinate to the landscape. A feeling of depth in the background is simulated by means of a series of small landscape areas, set one behind the other almost like theatrical backdrops—just as the figures appear to be standing on various stage levels. Here, space is still built up of separate parts, rather than disclosed through movement as it was to be later, in the High Baroque, by such devices as a river or a road leading into the distance. In this painting, one can distinctly sense the persistence of the tectonic approach of the Renaissance.

Adam Elsheimer was a German who first came in contact with the Netherlandish landscape painters, then went to Rome, and died there while still quite young. Through the Northern tradition, he had a completely different feeling for space in landscape. In this work, the gaze of the onlooker is led smoothly over the meadows and into the distance. The human figures are not related to the landscape merely as an object is to its environment; like Adonis, who has just come forth from the tree into which his mother Myrrha had been transformed, they seem born of nature, living and breathing in unity with her.

ADAM ELSHEIMER (1578–1610). *Myrrha (The Birth of Adonis)*. c. 1600. Oil on copper, $7^1/_2 \times 10^5/_8$″. Städelsches Kunstinstitut, Frankfurt am Main

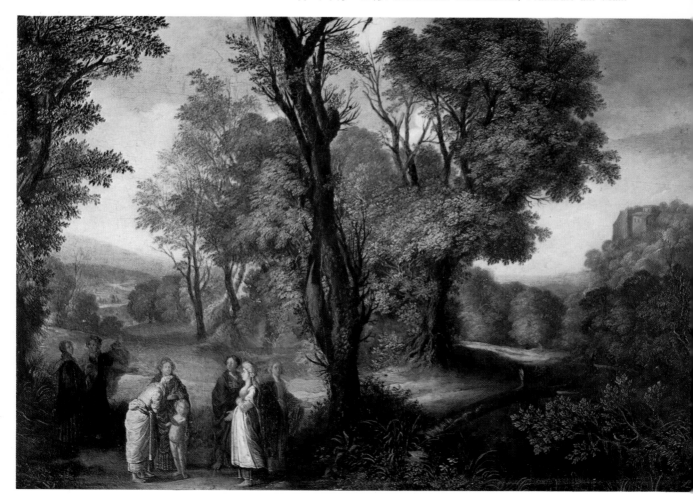

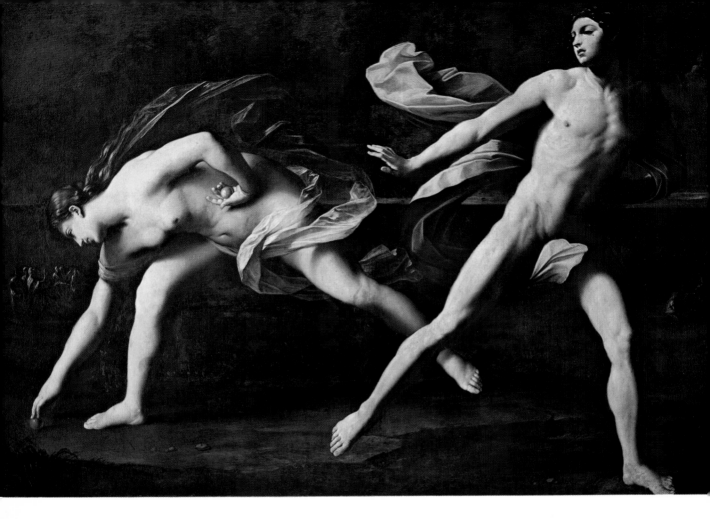

Guido Reni, a pupil of Lodovico Carracci, adopted and continued to develop the classical manner of the Bolognese school, becoming the most celebrated master of Baroque painting in Bologna. Both figures in his portrayal of the race between Atalanta and Hippomenes are conceived according to the Antique ideal of beauty, although their sinewy, slender bodies are related to the figures of the Late Renaissance rather than to the ideals of the High Renaissance. The composition of the scene, however, with the sharply contrasting movements of the two figures, is far removed from the harmony and balance of classical composition; it is dominated by the vehemence of the Baroque. The painting tells the story of the Boeotian princess Atalanta, who was beaten in the race by Hippomenes because she bent down to pick up the three golden apples dropped by him as he ran.

During his long stay in Italy, Simon Vouet, a native of Paris, was first influenced by the painting of the chief opponent of the school of Bologna—Caravaggio. Later, in Rome, he adopted the more idealistic style of the Carracci—a style he established, after his return to Paris in 1627, as the basis for the strictness of French Baroque painting. Vouet's Venus, who is also intended to express allegorically the ephemeral quality of all earthly beauty, is an almost perfect embodiment of the classical concept of the human form. Here, Vouet recalls Poussin, the greatest of the French painters in Rome.

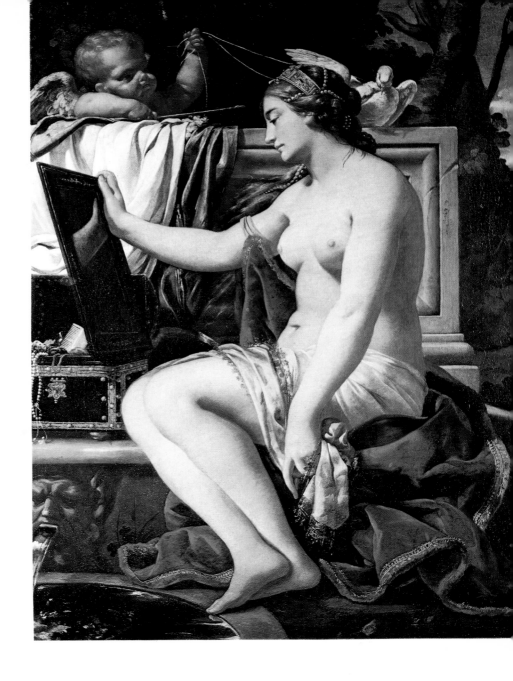

◀ GUIDO RENI (1575–1642). *Atalanta and Hippomenes*. c. 1624–26. Oil on canvas, 6′ 3¼″ × 8′ 7⅞″. Pinacoteca Nazionale di Capodimonte, Naples

SIMON VOUET (1590–1649). *Venus as Vanitas*. First quarter of seventeenth century. Oil on canvas, 53⅛ × 38⅝″. State Museums, Berlin (West)

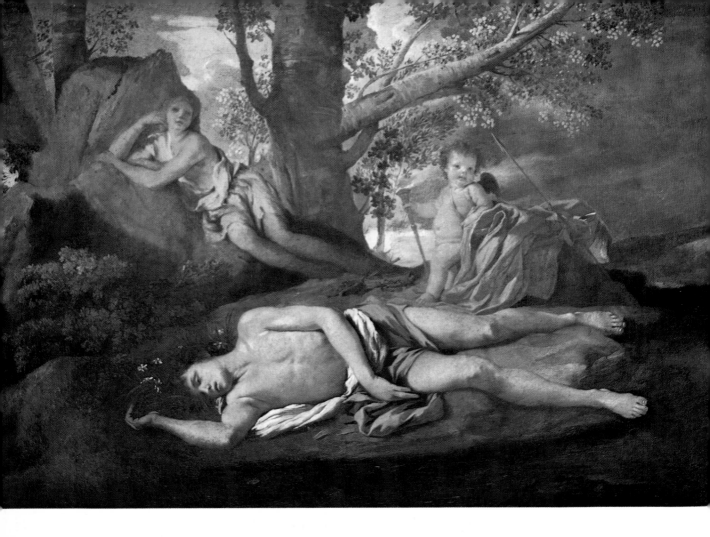

Nicolas Poussin was born in a village of Normandy, the son of a farmer, but spent most of his life in Rome, where he died. He returned to Paris only once, for two years, in order to decorate a gallery in the Louvre for Louis XIII, but he returned to Rome before the task was completed.

Poussin assimilated the idealizing tendencies current in painting in Rome differently from his contemporary, Vouet. Particularly in his depictions of stories from Ovid's *Metamorphoses*, done during his early period in Rome, he reveals an almost Greek feeling for the unity of man and nature. The nymph Echo, who faded away because of unrequited love, and the dead or dying Narcissus, about whose head are already growing the flowers into which he is to be transformed—both are creations that have emerged from nature and are returning to her.

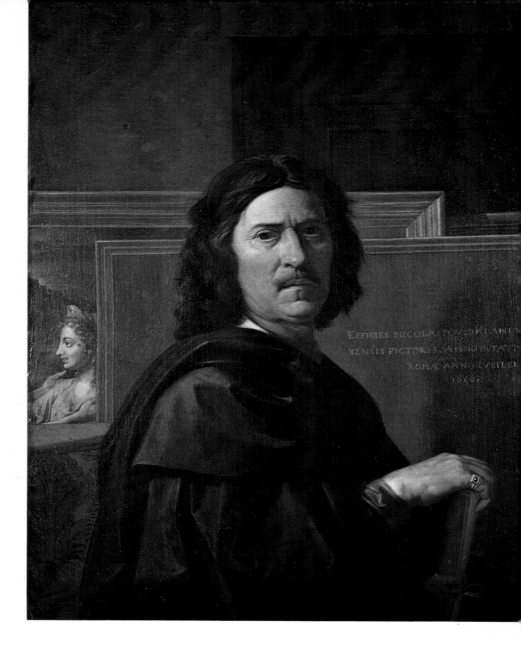

NICOLAS POUSSIN (1594–1665).
Echo and Narcissus. c. 1623–26.
Oil on canvas, 29^1/$_8$ × 39^3/$_8$".
The Louvre, Paris

POUSSIN. *Self-Portrait.* 1650.
Oil on canvas, 38^5/$_8$ × 25^5/$_8$".
The Louvre, Paris

A completely opposite quality of mind also makes itself felt in the art of Poussin. Deeply involved in philosophical speculation, he imposed upon his passionate temperament a stoicism that finds expression in this extremely stern *Self-Portrait*, painted for a friend. Here, one can sense the cool, rational spirit that distinguished this Frenchman from the Italian Baroque artists among whom he lived, just as French architecture of the *grand siècle* is distinguished from Italian Baroque architecture.

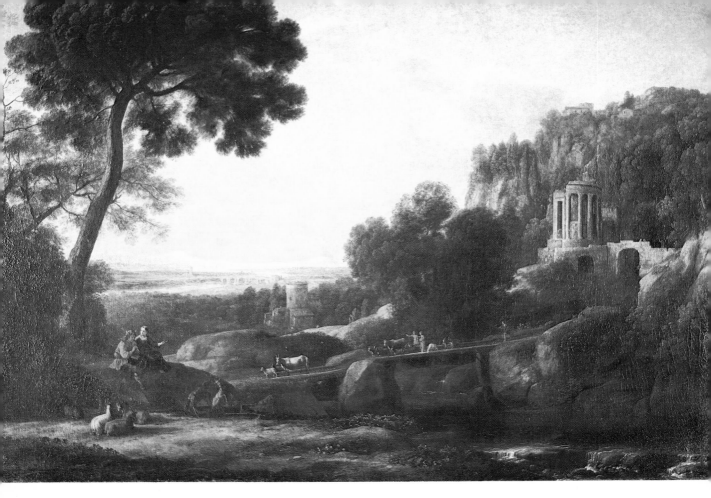

CLAUDE LORRAIN (1600–82). *Arcadian Landscape*. c. 1644. Oil on canvas, 38⅝ × 53⅞″. Musée des Beaux-Arts, Grenoble

In a conversation with Eckermann (April 10, 1829), Goethe said of Claude, the great landscape painter from Nancy in Lorraine: "His pictures possess the highest truth, but not a trace of actuality. Claude Lorrain knew the real world by heart, down to the smallest detail, and used it only as a means to express the world of his beautiful soul. That is precisely the ideality that knows how to use real means in such a way that the truth evolved produces an illusion of actuality." This ideality is even more astounding considering that Claude Gellée, as Claude Lorrain was actually named—he was later called "Lorrain" after his place of origin—came to Rome, not as a painter, but as a pastry cook, and was first introduced to the intellectual atmosphere of "Antique" ideality through friends of his who were painters. Claude bases his work, as Goethe correctly understood, primarily on the real world; he went about the neighborhood of Rome, immersed in drawing and sketching the landscape. Deeply moved by its beauty, he then did his paintings, which introduce portions of reality into a serene ideality. Claude became acquainted with pictures by Elsheimer in Rome and deeply admired them; the influence of Elsheimer can be seen in the way Claude makes groups of human figures melt

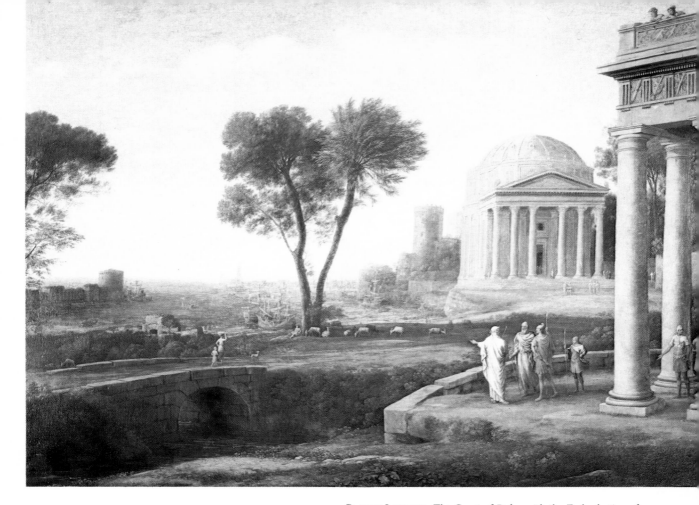

CLAUDE LORRAIN. *The Coast of Delos with the Embarkation of Aeneas*. Oil on canvas, $39^3/_4 \times 52^3/_4''$. National Gallery, London

into the landscape (see page 23). Generally it is shepherds, nymphs, satyrs, or bucolic characters inspired by Vergil, rather than the major gods of Antiquity, who populate his gentle meadowlands. The sea with its bays and inlets, which Claude came to know well during his stay in Naples, glows in the colors of the rising or setting sun—never storm-tossed, but smooth as a mirror. Architecture, when it appears in his pictures, is not the grand, representative architecture of Rome. In the lightness of its forms and the placement of columns so that they seem to open to the surrounding countryside, his architecture seems itself to be a part of nature, enveloped in the serene, almost fluid, light that fills his pictures.

Again and again, Claude Lorrain turned to Vergil's *Aeneid* for inspiration. Avoiding the great dramatic scenes such as the burning of Troy or Aeneas' meeting with Dido, he preferred to paint the departure of the heroes from Delos or idyllic scenes set in Italy before the founding of Rome. These scenes are appropriate to Claude's poetic concept of nature and of man's relationship to his environment.

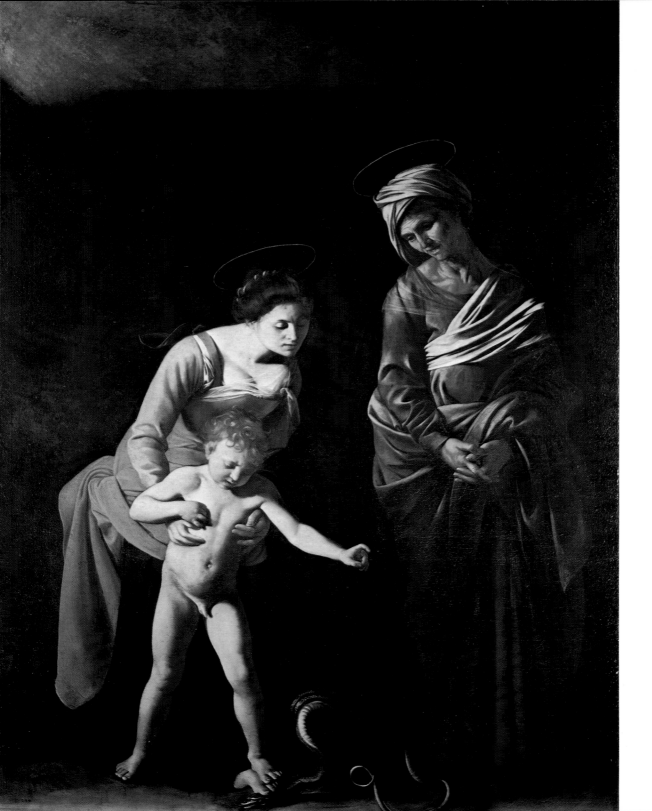

MICHELANGELO MERISI DA CARAVAGGIO (1573–1610). *The Virgin and Child with Saint Anne,* painted for the Brotherhood of the Palafrenieri. 1605. Oil on canvas, 9' 7" × 6' 11 1/8". Borghese Gallery, Rome

CARAVAGGIO. *Amor Victorious.* Shortly before 1600. Oil on canvas, 60 5/8 × 43 1/4". State Museums, Berlin (West)

The greatest opponent of the classical Bolognese school, which derived its ideals from those of Antiquity, was Michelangelo Merisi da Caravaggio. In contrast to the handling of the Carracci brothers, he avoided giving any outward signs of nobility to his figures: they were painted with a trenchant realism from among the common people, rather than being based on classical models. He did not shrink from ugliness in order to free his subjects from convention, give them immediacy, and increase their emotional impact upon the observer.

The mystical representation of Mary and the Christ child, who trample underfoot the head of the serpent, has been turned into a street scene; Amor has become an impudent urchin. The deliberately controlled, harsh light that tears the figures from the deep gloom of their surroundings only seems to be realistic. It intensifies and dramatizes facial expressions, and gives the figures a wholly new plasticity. "Tavern light" his contemporaries jeered. An altar painting in which Caravaggio portrayed St. Matthew as a dull-witted old man was considered coarse and shocking and was rejected by the church authorities. In his art, as in his life, Caravaggio stood in sharp opposition to the conventional world of his time. He was impetuous, boisterous, and violent. His temperament and his unstable wanderer's life were to blame for the fact that he had no pupils in the usual sense. Yet a whole series of artists grew up who imitated his irreverent realism and his strongly pronounced chiaroscuro, and who spread his new method of painting to other countries, especially France, Spain, and the Netherlands.

31

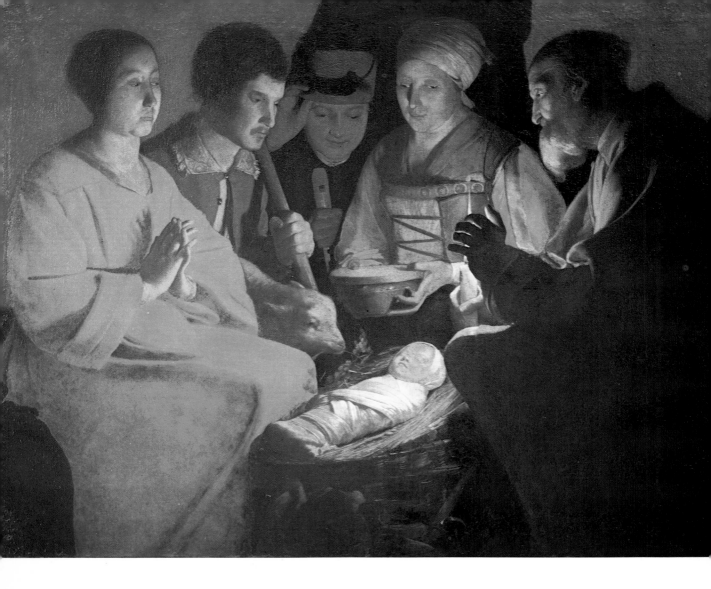

Caravaggio's influence produced very varied effects in the different countries in which it can be observed. Typical characteristics and traditions in the art of various nations were combined with his naturalism, as also with his sharp contrast of light and dark, each in their own way. Caravaggio had little influence in Paris itself; in the French provinces, however, his innovations received a much greater response. One finds a unique interpretation of Caravaggio's style in the work of Georges de La Tour. Like Claude, he came from Lorraine, but it is almost certain that he never visited Italy as Claude had. He came in contact with Caravaggio's art indirectly, through the Netherlands. La Tour adopts Caravaggio's realism to the extent that he uses farmers, shepherds, and artisans for his Biblical scenes, but he does not turn these into everyday creatures. In their quiet, introspective reverie, his subjects retain a nobility and serene stature in spite of the naturalism with which they are treated. A spirit of Franciscan piety pervades his pictures. Here, all the violent qualities of

◀ Georges de La Tour (1593 –1652). *Adoration of the Shepherds*. Second quarter of seventeenth century. Oil on canvas, 42 × 53³/₄″. The Louvre, Paris

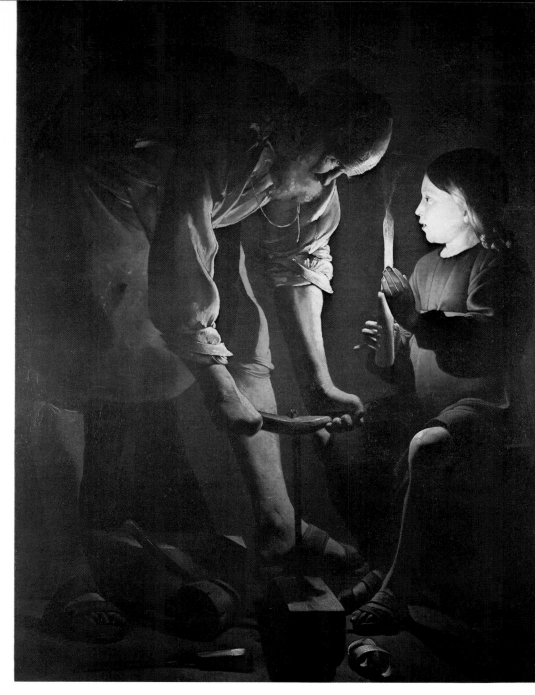

La Tour. *Saint Joseph the Carpenter*. c. 1640–50. Oil on canvas, 53⁷/₈ × 40¹/₈″. The Louvre, Paris

the art of Caravaggio have been eliminated and replaced with a clear, cool spirit that is typically French. In the serenity and inner dignity of his figures, Georges de La Tour approaches the style of Poussin, although in many respects their works are antithetical.

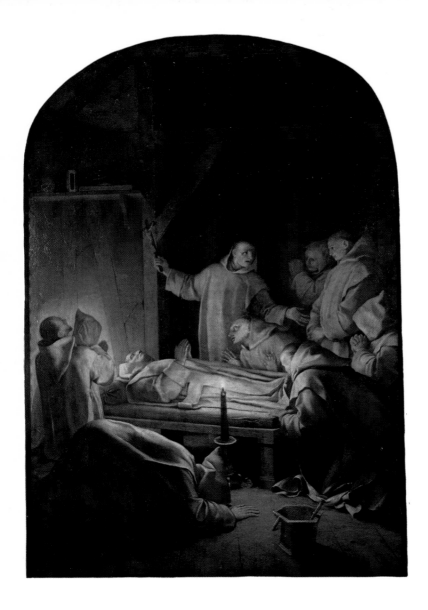

EUSTACHE LE SUEUR (1616–55). *The Death of Saint Bruno.* c. 1645–58. Oil on canvas, $76 \times 51^{1}/_{8}''$. The Louvre, Paris

Although Eustache Le Sueur was a product of the school of Simon Vouet, one can nonetheless see in his work—especially in his nocturnal scenes—the influence of Caravaggio. Here, it is true, his figures are not distinguished by their realism, but the lighting of Caravaggio determines the composition of the picture and imparts a profound emotion to the scene.

The three Le Nain brothers—Antoine (1588–1648), Louis (1593–1648), and Mathieu (1607–77)—adopted Caravaggio's realism and painted ordinary people—farmers, artisans, beggars. With a peculiarly quiet composure, their figures stand in pictorial space without any obvious relationship to one another; their commonplace surroundings seem invested with an atmosphere of poetry.

The etchings and engravings of Jacques Callot, on the other hand, are far removed from the mood of quiet dignity conveyed by the works of the Le Nain brothers, Eustache Le Sueur, or Georges de La Tour. Callot's *Caprices* and *Misères de la Guerre* are shocking portrayals of the terror and inhumanity of the world. In his condemnation of social injustice, Callot was the most notable forerunner of Goya.

LOUIS LE NAIN. (1593–1648). *The Forge*. c. 1641.
Oil on canvas, 27¹/₈ × 22¹/₂". The Louvre, Paris

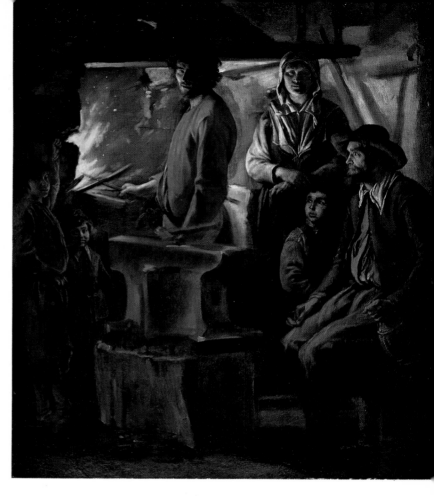

JACQUES CALLOT (1592–1635). *The Hanged
Men*, from *Les Grandes Misères de la Guerre*.
1633. Etching, 2⁷/₈ × 7¹/₄"
▼

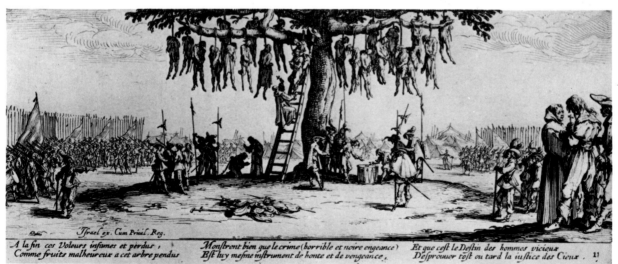

A la fin ces Voleurs infames et perdus,
Comme fruits malheureux a cet arbre pendus
Monstrent bien que le crime (horrible et noire engeance)
Est luy mesme instrument de honte et de vengeance,
Et que c'est le Destin des hommes vicieux
D'esprouuer tost ou tard la iustice des Cieux. 11

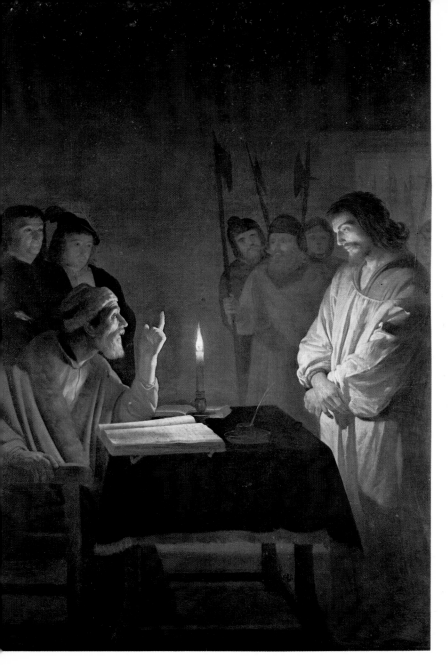

JUSEPE DE RIBERA (1591–1652). *The Martyrdom of Saint Bartholomew*. c. 1630. Oil on canvas, 92¹/₈ × 92¹/₈". The Prado, Madrid ▶

GERRIT VAN HONTHORST (1590–1656). *Christ before the High Priest*. c. 1617. Oil on canvas, 8' 11¹/₈" × 6'. National Gallery, London

Caravaggio's sharply rendered light, although it emphasized the modeling of his figures, was always in a sense abstract. Among his many imitators in the Netherlands, one of the early artists to transform this glaring light into realistically depicted candlelight was Gerrit van Honthorst. He placed the actual source of light within his picture, and used it to make his figures stand out against the darkness. While a student in Italy, he was called "Gherardo delle Notti" by the Italians, because of his many candlelight pictures. In this one, the lighting imparts an almost private atmosphere to the dialogue between the high priest and Christ. One can scarcely distinguish the executioners in the dark background. The urgency of what is happening is not expressed through any outward movement; on the contrary, the superficial appearance of peace only serves to heighten the tension and emphasize the gravity and inner drama of the situation.

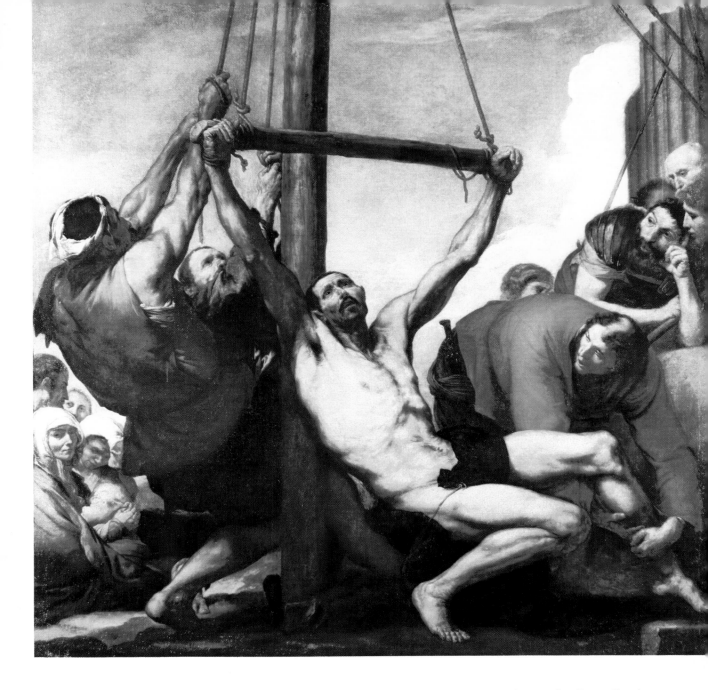

Jusepe de Ribera was born in Valencia but traveled extensively in Italy at a very early age, finally settling in Naples. Like so many others, he was influenced by Caravaggio, particularly in his early work. However, Ribera developed his own style, combining his sharp observation of reality with inner stature. The figures in his *Martyrdom of Saint Bartholomew* are portrayed with merciless realism, yet the horrible event does not degenerate into the banal.

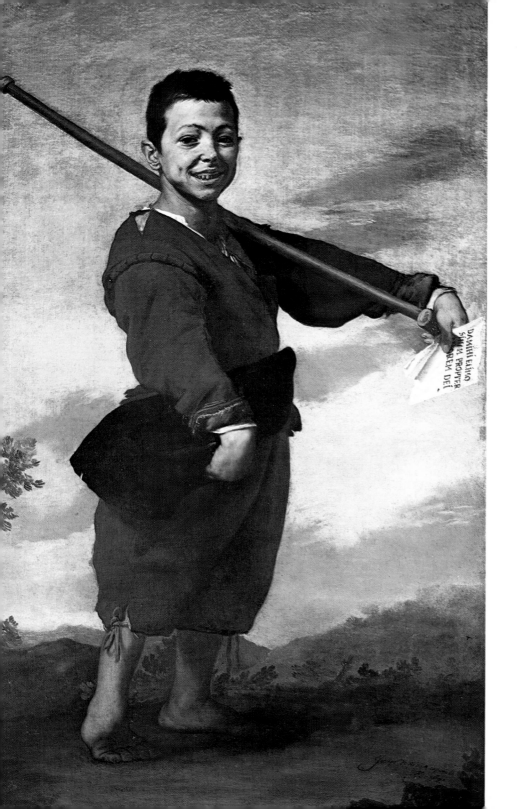

RIBERA. *The Boy with a Clubfoot*. 1642. Oil on canvas, 64⅝ × 36¼". The Louvre, Paris

Ribera became completely independent of Caravaggio in his use of color. Instead of the cold tones of the Italian, the canvases of the Spanish artist glow with warm, dusky hues that suggest that, during his travels, Ribera had experienced Venice, and the Venetian coloristic tradition, with open eyes. Here, in his painting of a clubfooted youth, the more sympathetic side of Spanish realism comes to the fore: the artist paints man, even in his deformity, as God's creation, unaffected and unadorned, yet full of a cheerful dignity—a feature that also distinguishes the street urchins of Murillo, for example.

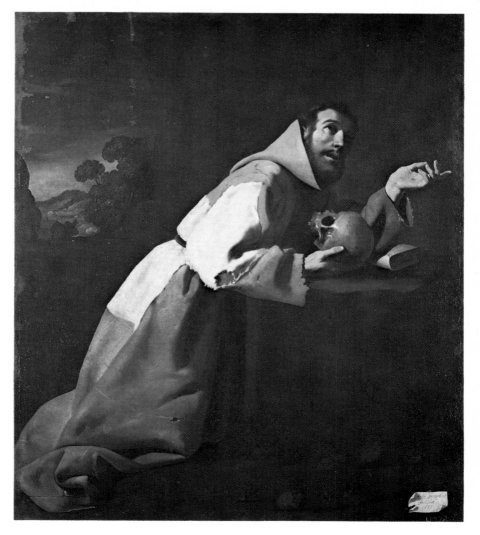

FRANCISCO DE ZURBARÁN (1598–1664). *Saint Francis in Meditation.* 1639. Oil on canvas, 63³/₄ × 54″. National Gallery, London

The School of Seville produced the two greatest Spanish painters of the Baroque era—Velázquez and Murillo—and it was from Seville that Francisco de Zurbarán also came. Like Velázquez, he became court painter in Madrid, yet there is nothing courtly about his art. On the contrary, it is characterized by a deep, often ecstatic piety. Two typically Spanish characteristics are juxtaposed in Zurbarán's work: sober realism and wild fanaticism. In his numerous pictures of St. Francis of Assisi, he again and again portrayed the theme of the man whose inner emotions are so intensified as to lead to a state of total self-renunciation. The spiritual condition of the saint and his passionate dialogue with God are the real subjects of the picture. The dominant hue in this painting is brown; there are no glowing colors to disturb the mystical atmosphere.

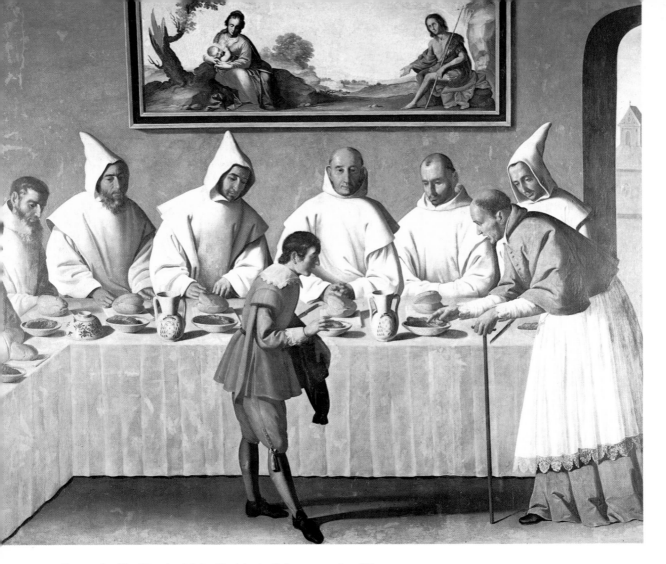

ZURBARÁN. *The Miracle of Saint Hugh in the Refectory*. c. 1633. Oil on canvas, 8′ 7¹/₈″ × 10′ ⁷/₈″. Museo Provincial de Bellas Artes, Seville

The miracle of St. Hugh takes place in a very different world: the colors are cool and clear as glass; the atmosphere is transparent, almost icy. The painting has an obvious tectonic structure; it is dominated by clear horizontal and vertical lines. The miracle is shown dispassionately—neither terror nor astonishment is reflected on the faces of the participants. All feeling seems to have been banished from this world. The picture represents the moment when St. Hugh enters the refectory of a Carthusian monastery and finds the monks seated at a table on which meat has been placed. The boy who has served the meat is still standing by the table. At the saint's touch, the forbidden food turns to ashes.

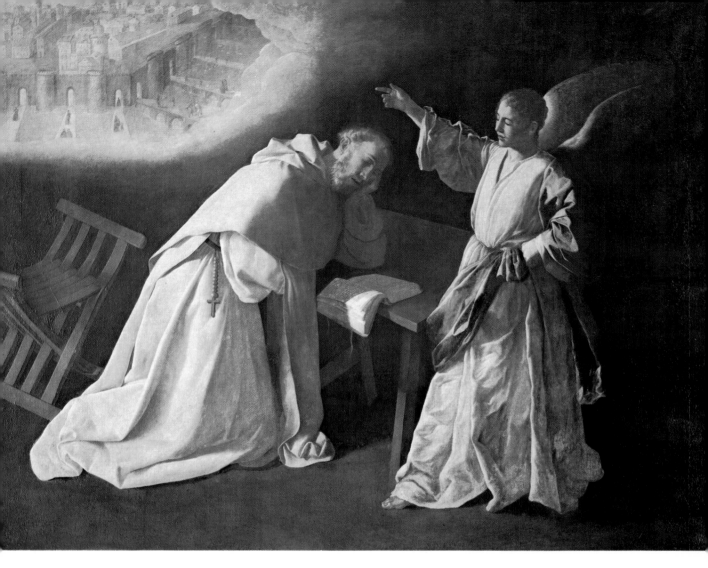

ZURBARÁN. *The Vision of Saint Peter Nolasco.* 1629.
Oil on canvas, 70$^1/_2$ × 87$^3/_4$″. The Prado, Madrid

About four years before his cool, sober representation of St. Hugh, Zurbarán, with assistants from his workshop, created a cycle of paintings for the Mercedarian monastery in Seville, illustrating the most important events in the life of St. Peter Nolasco, founder of the Mercedarian order. The saint, who had worked primarily for the liberation of Christian prisoners from the Saracens, is represented here with an angel who shows him the Heavenly Jerusalem in a dream. The contrast between Peter, kneeling and deeply asleep, and the angel, who enters vigorously and whose gesture seems to call forth the vision of the Heavenly City, gives the painting a unique kind of tension that serves to heighten its mystical atmosphere.

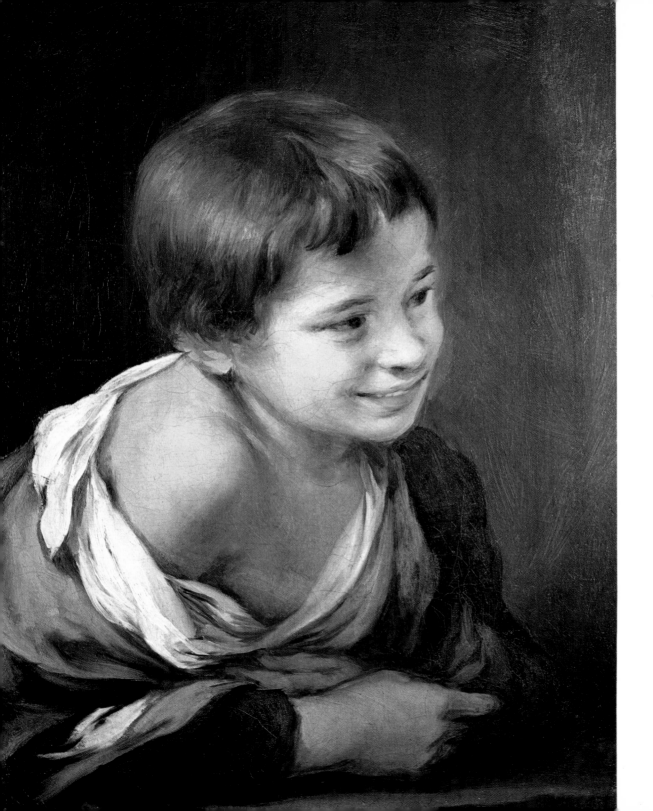

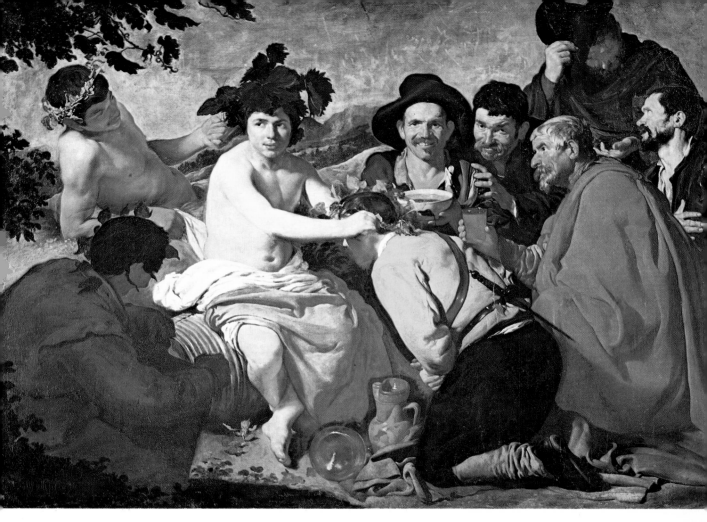

◀ BARTOLOMÉ ESTEBAN MURILLO (1618–82). *A Peas-ant Boy Leaning on a Sill*. c. 1650–70. Oil on can-vas, 20³/₄ × 15¹/₈″. National Gallery, London

DIEGO RODRÍGUEZ DE SILVA Y VELÁZQUEZ (1599–1660). *The Drunkards (The Triumph of Bacchus)*. Before 1629. Oil on canvas, 65 × 88⁵/₈″. The Prado, Madrid

Bartolomé Esteban Murillo also expressed a deep piety in his religious pictures, but in a spirit far removed from that of Zurbarán. Unlike the older artist, Murillo envelops his figures in a soft, "painterly" atmosphere. He frequently painted genre scenes in which the street urchins of his native Seville, with their lively, self-confident, and unbroken spirits, are lovingly portrayed.

Diego Rodríguez de Silva y Velázquez began by painting scenes of the common people, which he did in Seville while being taught by Francisco Pachico. These were carefully drawn from nature or from his models. In *The Drunkards*, the features of the ordinary people can be clearly recognized in the tramps and vagabonds who are carousing with the utterly ungodly god of wine. One can also recognize in this painting the strong in-fluence of Caravaggio's realism.

VELÁZQUEZ. *Portrait of the Cardinal-Infante Don Ferdinand.* c. 1634–36. Oil on canvas, 75¼ × 42⅛″. The Prado, Madrid

Velázquez was subject to quite different kinds of influences after he became court painter to Philip IV of Spain, and his style changed accordingly. During his two long trips to Italy, he had been deeply impressed with sixteenth-century Venetian painting, especially that of Titian and Tintoretto. In Madrid, Velázquez adopted more "painterly" colors; he used hues that were very low in intensity and with very little contrast between them, creating a soft gray atmosphere. He now began to specialize in portraits. In his portraits of the royal family, he used the skill he had acquired from the study of nature to combine successfully the demeanor and authority of royalty with human and personal qualities.

Velázquez' "*Las Meninas*" represents a deliberate modification of the royal portrait. At first glance, the content of the picture seems clear: the little princess is being attended by her servants in a high-ceilinged

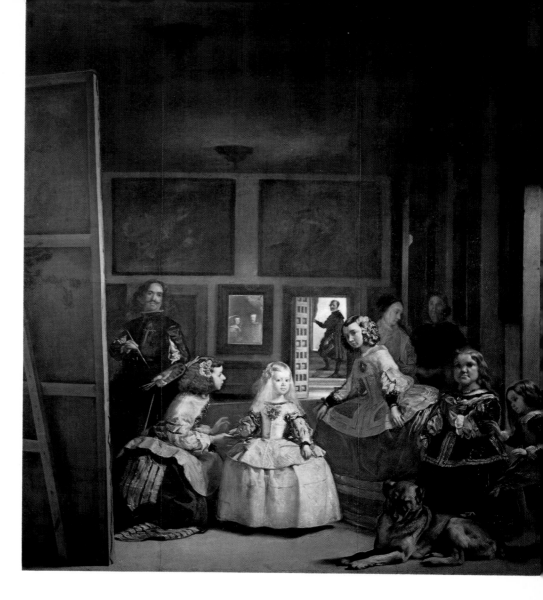

VELÁZQUEZ. *"Las Meninas"* *(The Family of Philip IV of Spain).* 1656. Oil on canvas, 10′ 5¼″ × 9′ ⁵/₈″. The Prado, Madrid

hall hung with pictures. A female dwarf is among the princess' retinue, as well as a male court dwarf. At one side, however, stands a painter before an easel—Velázquez himself. The picture is, therefore, also a self-portrait. The front of the easel cannot be seen. The artist has paused in order to allow the tiny princess in all her court finery a moment's rest from the exertion of sitting. The ladies of the court are handing her refreshments. However, it is obvious that the interruption has yet another cause: in the mirror on the back wall of the hall can be seen the King and Queen, who are just entering the room from the front—that is, from the point at which the observer stands. The entire scene is actually painted from the point of view of the royal couple—which is also the position of the person looking at the painting—and not from the viewpoint of the artist. This intentional confusing of the characters within the painting and "actuality" gives the scene a strong feeling of unreality, despite all the realism with which it is painted.

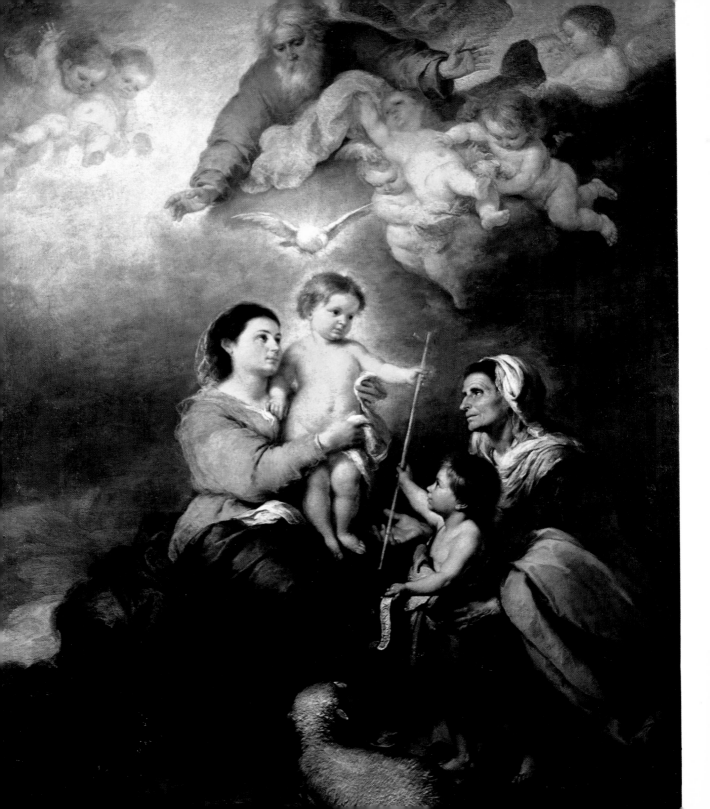

Murillo gives the figures in his religious pictures, especially his Madonnas, a lovable charm. Mary, Elizabeth, and the two boys, alluding here to the baptism of Jesus by John the Baptist (God the Father and the Dove hover above the Christ child) are transported into a world of purity and innocence through the *sfumato* of the colors and the handling of the figures—a world in which there is no hint of the tragedy to come. Such a scene is quite unlike Murillo's paintings of the common people (see page 42).

Pedro de Mena y Medrano was, like Murillo, from southern Spain. In his work, a deep, ascetic piety is united with sharply realistic tendencies in a manner similar to that of Zurbarán. This figure of Mary Magdalene sinking down at the sight of the crucified Christ is elevated to a noble pathos and is meant simultaneously to uplift the beholder and, through a realism that extends even to the texture of the fabric of her garment, to make him participate emotionally in the scene.

PEDRO DE MENA Y MEDRANO (1628–88). *Mary Magdalene Doing Penance*. 1664, dated and signed. Polychromed wood, height 65″. Museo Nacional de Escultura, Valladolid

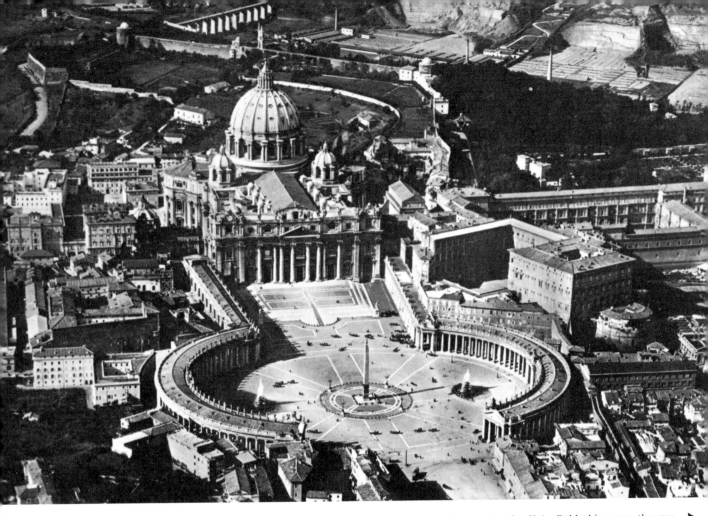

St. Peter's and St. Peter's Square, Rome. Colonnade, 1656–65, by Bernini. Aerial photo

GIANLORENZO BERNINI (1598–1680). Baldachin over the presumed grave of St. Peter, in St. Peter's, Rome. 1624–33. Height 23 ▶

The Roman High Baroque signifies above all Gianlorenzo Bernini, who is famous primarily as a sculptor. In 1629 he became architect to St. Peter's; but he also painted, and there are even poems extant by him. Once again, the Italian spirit was concentrated in a universal genius—a phenomenon that was particularly characteristic of the Italian High Renaissance. Bernini's earliest work in St. Peter's was the baldachin above the presumed tomb of the apostle. The twisted bronze columns, encircled with vine leaves, repeat on a far larger scale the shape of the Late Antique columns, supposed to have come from the temple of Solomon, which had been built into the original basilica of St. Peter. These "Solomonic" columns recurred again and again, in innumerable variations, until the end of the eighteenth century. In southern Germany, they became a principal motif in the design of altarpieces. In front of St. Peter's, Bernini created one of the most grandiose squares in Christendom. Four rows of columns frame a spacious ellipse with the obelisk in the center, and then lead toward the façade, giving an impression of added height to the dome. According to Bernini's plans, the square was to be closed on the east as well by colonnades. He thought of the square as an enormous reception hall for pilgrims, and as a forecourt for the most important church in the whole Christian world.

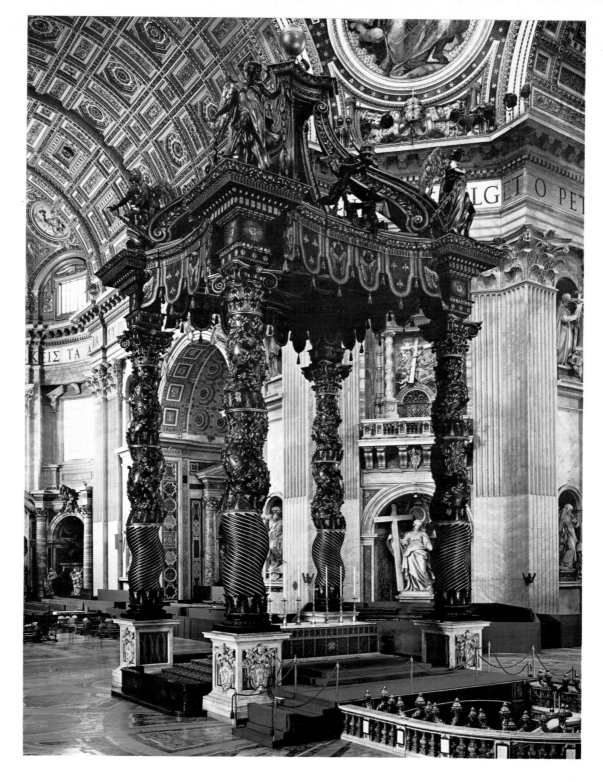

49

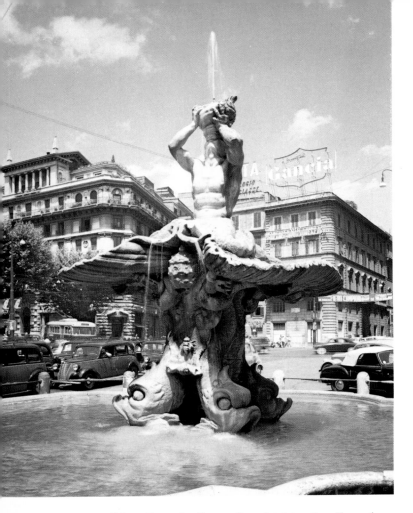

BERNINI. Triton Fountain, Rome. Completed c. 1637. Travertine

Water, with its intrinsic quality of motion, plays an important role in Baroque art, particularly in the construction of fountains. The jet of water itself is often an essential part of the design, complementing the sculptural forms. At the same time, its streams rising and plummeting down symbolize the power of the elements, enlivening the work of art not only for the eye but for the ear as well. All this is part of the Baroque idea of a unified work of art, designed to delight or to impress man through as many sensory perceptions as possible. Bernini's Triton rides on a shell supported by dolphins, their tails arching high in the air, and blows the water up out of a gigantic conch shell. This is a composition that seems to incorporate the very spirit of the Baroque. For one brief moment the dolphins form a support for the figure above them. Naturally, they could not carry such a burden long, for the shell would drop and all would fall together, but this dramatic moment is caught and held. The depiction of the dramatic high point of an action is one of the fundamental features of Baroque art—a feature that is prominent, for example, in many pictures by Rubens (see page 99).

Bernini constantly created new and varied designs for fountains. In the Four Rivers Fountain in Rome's Piazza Navona (see pages 54–55), a gigantic obelisk is placed on a base of broken stones, while the four streams, symbolizing the four parts of the world, spurt forth with Neptune's horses from the crevices. More than eighty years later, Nicola Salvi, using a sketch of Bernini's, combined palace front and fountain, letting Neptune himself, from the great central niche, govern the gushing streams of water. In the Trevi Fountain, Salvi thereby created an eighteenth-century monument to the High Baroque spirit of Bernini.

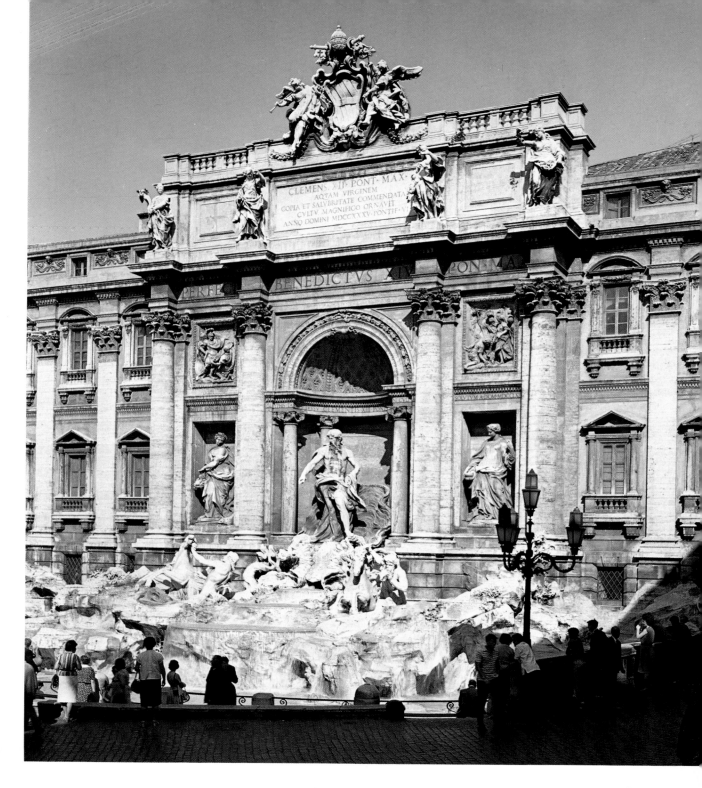

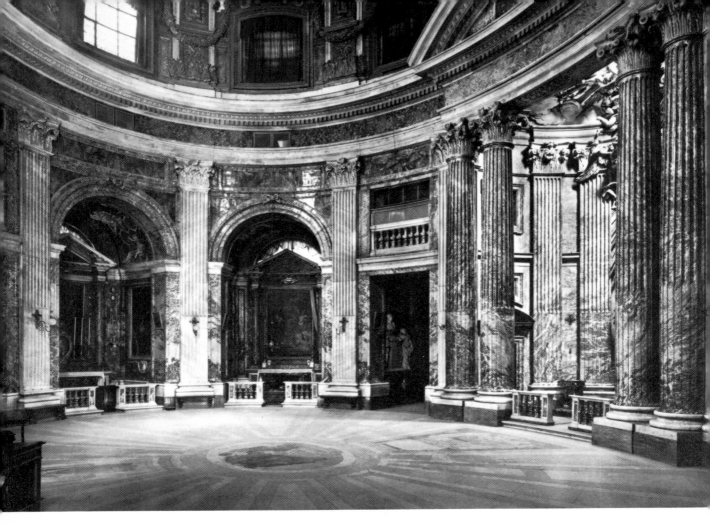

S. Andrea al Quirinale, Rome. Begun 1658 by Bernini

However daringly Bernini as architect designed his churches in accordance with the new tendencies of the High Baroque—by placing domed space above a round or elliptical floor plan, or by creating an interplay of concave and convex forms in the exterior—he remained faithful to the anthropomorphic Renaissance tradition that architecture must be related to the proportions of the human body. The individual parts of a building are organically divided from each other according to which parts represent the load or weight of the building, and which ones carry or support that load. In the interior of the church of S. Andrea al Quirinale, which Bernini began in 1658 for Cardinal Camillo Pamphili, the harmonious balance between the space for the congregation and the transverse oval dome is preserved. The cornice beneath the dome separates the two areas and thereby gives to each the significance appropriate to it.

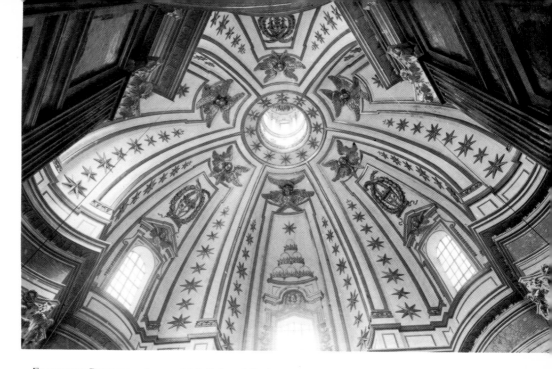

FRANCESCO BORROMINI (1599–1667). S. Ivo della Sapienza, Rome. 1642–60. View into the dome

A new spirit and a new approach to architecture characterize Bernini's great rival, Francesco Borromini. Bernini had worked with him on the baldachin in St. Peter's, but was disgusted by the architecture of his competitor, which he considered extravagant, fantastic, and contrary to the tradition of using human proportions. The blurring of distinctions between the component parts of a building was begun by Borromini. In the ground plan of the tiny church of S. Carlo alle Quattro Fontane in Rome, for example, a number of geometric primary forms are so fused with one another that the complex structure of the interior can no longer be easily defined. The entire façade of S. Carlo alle Quattro Fontane swings in and out as though it had been set into motion. In the interior of S. Ivo, the shape of the floor plan is continued into the vaulting. Base and dome are merged so that the "ribs" of the dome, continuing the line of the pilasters, seem to rise directly from the floor. Such innovations as this called forth astonishment and sometimes horror from Borromini's contemporaries. Nevertheless, they were to become fundamental for later Baroque, and particularly for Rococo, architecture.

BORROMINI. S. Carlo alle Quattro Fontane, Rome. 1634–67. Ground plan

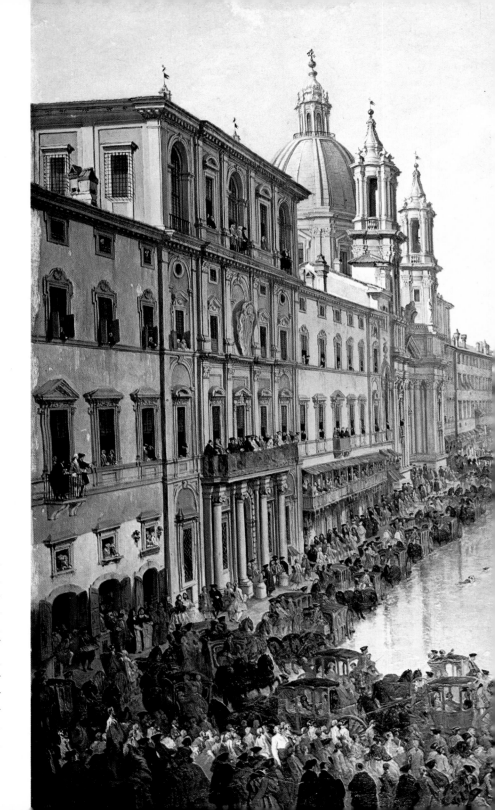

PANNINI. *The Piazza Navona Flooded*. At the center of the square is the Four Rivers Fountain by Gianlorenzo Bernini; at the left, S. Agnese by Francesco Borromini. 1756. Oil on canvas, $37^{5}/_{8} \times 53^{1}/_{2}''$. Niedersächsische Landesgalerie, Hanover

The two rival artists confront each other on the Piazza Navona in Rome with two of their major works: Bernini's Four Rivers Fountain stands directly in front of Borromini's church of S. Agnese. According to a contemporary anecdote, the personification of the Nile on Bernini's fountain was hiding his face because he could not bear to look at the "hideous" architecture of Borromini's façade. The piazza, which was once the site of an ancient circus, was often flooded on hot days in order to provide relief both for the common people and for the elegant ladies and gentlemen who drove around it in their carriages.

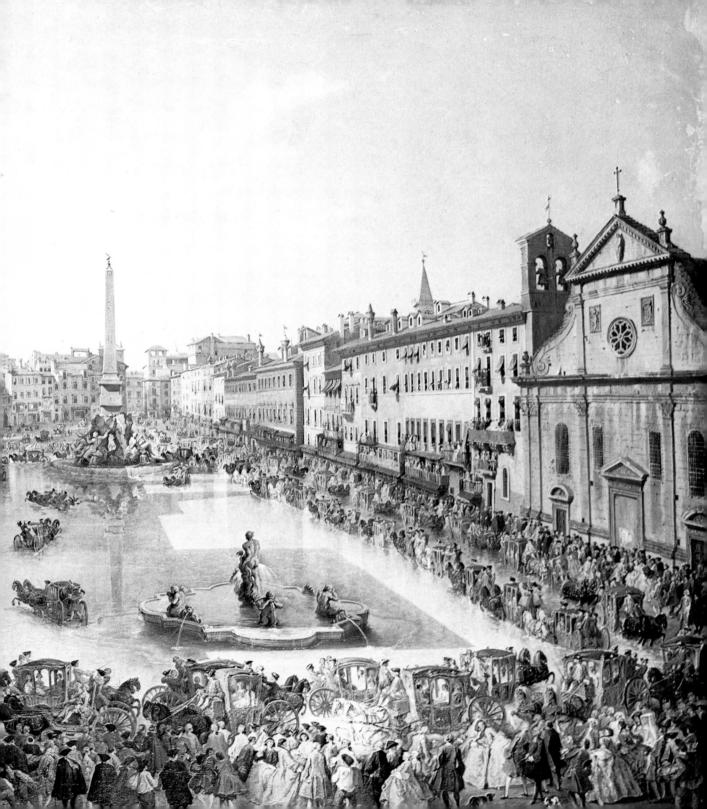

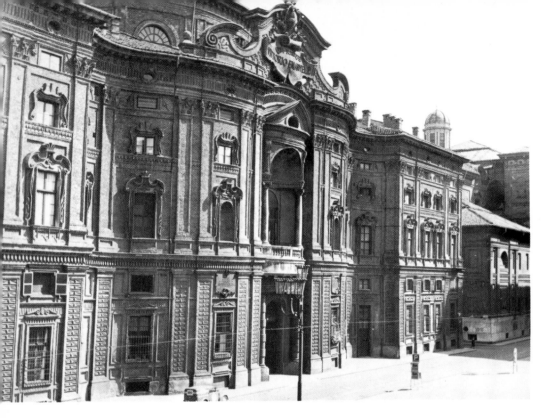

Borromini's art was further developed in the work of Guarino Guarini, a priest of the Theatine order from Modena. Borromini based his architecture on complicated geometrical combinations; Guarini also turned to architecture from a study of mathematics. In his architectural treatise, forms are developed step by step from basic geometrical and stereometrical principles. Inventive as his designs were, they remained rationally comprehensible; his work never became irrational and visionary, like the Late Baroque church architecture of southern Germany and Bohemia, which for the most part is based on Guarini's works. Guarini was well traveled; he built or designed churches in Messina, Lisbon, Paris, and Prague, but nothing remains of these

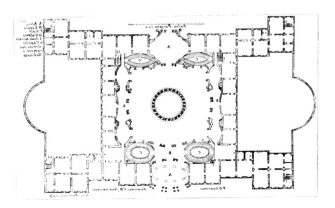

GUARINI. Ground plan of the so-called Palazzo
Francese. From Guarini, *Architettura civile . . .*,
Turin, 1737, plate 23

56

buildings. His chief works are in Turin, where he served as engineer to the court of Carlo Emanuele II of Savoy. Guarini's greatest secular work there was the Palazzo Carignano. Like that of Borromini's S. Carlo alle Quattro Fontane, the façade swings in and out in concave and convex curves. However, the individual forms seem more severe, less flexible, betraying a different, more sober spirit. In a design for a palace that was never built, the arcades surrounding the courtyard and the complicated stairways are arranged in ingeniously derived mathematical forms.

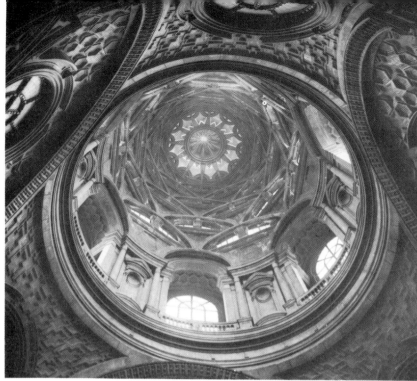

GUARINI. Cappella della SS. Sindone, Turin. View into the dome. 1667–90

In the construction of the dome of the Cappella della SS. Sindone (Chapel of the Holy Shroud) in Turin, Gothic and Moorish reminiscences are blended to form a structure which, in spite of the obvious cleverness of its construction, has an almost mystical atmosphere because of the way in which light is introduced. In his architectural treatise, *Architettura civile...*, Guarini analyzes Gothic architecture as well as Hispano-Moresque domes, which he greatly admired. Whether he ever actually set foot in the Iberian Peninsula, or merely sent his designs for churches to Lisbon, is still disputed. But the traces of Moorish architecture, especially the intersecting ribs that recur in the construction of his domes, make it seem very probable that he had personally studied Spanish architecture.

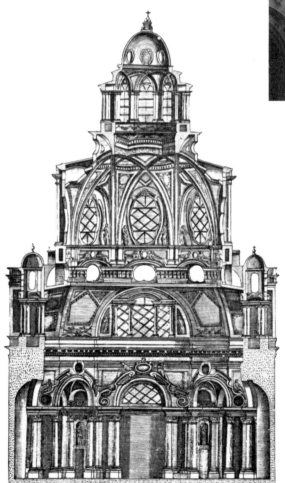

GUARINI. Cappella della SS. Sindone, Turin. Longitudinal section, from Guarini, *Architettura civile...*, Turin, 1737, plate 3

In 1665, Guarini was in Paris and began the Theatine church Sainte-Anne-la-Royale. Construction was soon halted; the church was not completed until 1720—with major alterations—and was demolished in 1823. Guarini left no trace on French architecture. His complicated intersections and use of different geometrical shapes were, when judged by the French spirit of *clarté*, abstruse and bizarre. But in 1665, another important meeting between the Italian and French spirits took place, this time within the official sphere of the court: Bernini came to the city on the Seine to complete the Louvre.

After the death of Cardinal Mazarin in 1661, Louis XIV declined to choose another First Minister, and himself took over the government. In order to induce the young King, whose love for his father's small hunting lodge at Versailles was well known, to stay in the capital, his powerful minister Colbert decided to enlarge the old royal palace, the Louvre. Originally a medieval fortress, it had slowly grown during the Renaissance and the seventeenth century around a quadrangular court. The interiors were largely uninhabitable, and the exterior was no longer splendid enough to be worthy of the French royalty. The most renowned French and Italian architects were asked to compete in submitting designs for the project. Colbert, however, then made special contact with Bernini in Rome and later invited him to Paris in order that he might get to know the site at first hand. The Italian was given a princely reception. Paul Fréart de Chantelou, head of the King's household, was assigned to accompany Bernini, and in his journal one can follow the events during Bernini's residence in Paris on an almost day-to-day basis. Although the courtly, friendly nature of the Italian was much admired, he committed the unforgivable error of criticizing French architecture, mortally offending his hosts. His first project for the façade of the palace, drawn up before he left Rome, was rejected almost unanimously. In his design, the oval central pavilion swings forward energetically and is topped with an attic story in the form of a crown, unlike anything that had been seen before. This pavilion is flanked by concave wings and the entire center of the façade, including both central pavilion and wings, is adorned with a colossal order of pilasters. This brilliant composition is a magnificent example of Roman High Baroque and would have been appropriate under Italian skies, but it was unsuited to the cool atmosphere of French classicism. A

BERNINI. First project for the Louvre, Paris. Sketch of the façade. $15^5/_8 \times 26^1/_4$″. Cabinet des Dessins, The Louvre, Paris. 1664

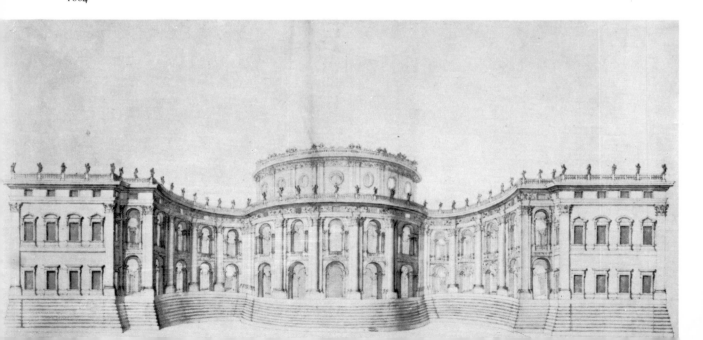

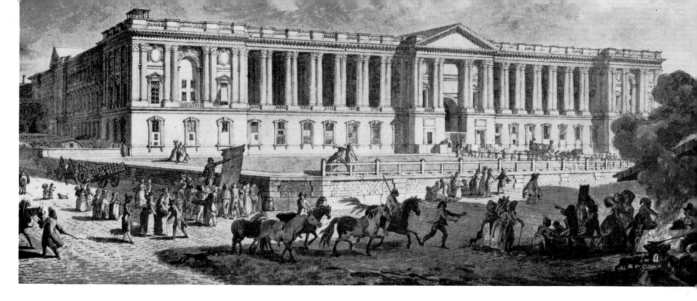

CLAUDE PERRAULT (1613–88), LOUIS LE VAU (c. 1612–70), and CHARLES LE BRUN (1619–90).
East façade of the Louvre (the Colonnade), Paris. 1667–74. Engraving by Meunier, 1788

further project, in which the forms suggesting motion had been eliminated, also failed to please. At that point Bernini departed, in October 1665. The entry of Italian High Baroque into France—at least as far as official, courtly art was concerned—had been repulsed. Colbert now named a commission: Louis Le Vau, Claude Perrault, and the court painter Charles Le Brun were to complete the project together. The so-called Colonnade, as it stands today, is the combined work of these three men. For a long time it was attributed to Claude Perrault alone, although he was not an architect, but rather a doctor and physical scientist who had turned to architecture only as a hobby. The cool, classical feature of the façade came from Perrault, who had carefully studied and translated the classical architectural work of Vitruvius. Le Vau contributed the motif of the coupled columns, as well as the idea of placing the wall far behind the colonnade, thus creating a dark zone behind the columns that gives the front, despite all its severity, a Baroque quality.

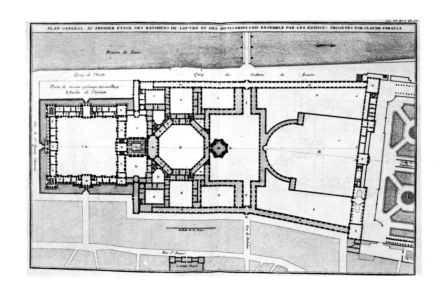

PERRAULT. Sketch for a plan of the Louvre. From Jacques-François Blondel, *Architecture françoise . . .*, Vol. IV, Book VI, No. 1, plate 1, Paris, 1756

In 1624, Cardinal Richelieu, the favorite of Queen Marie, moved from the Queen's service into the government. He remained the dominant figure in French politics—and also in art—until his death in 1642. Here, Philippe de Champaigne has portrayed him in the crimson robes of a cardinal; but Richelieu's stance and haughty expression emphasize far more the man of the world and the cunning politician than the priest, and thus masterfully characterize the position of the uncrowned ruler of France.

PHILIPPE DE CHAMPAIGNE (1602–74). *Cardinal Richelieu.* ▶ c. 1635. Oil on canvas, 87³/₈ × 61″. The Louvre, Paris

◀ JEAN BEEGRANDT. Chapel of the Jesuit College (Chapelle du Grand-Séminaire), Cambrai. Façade. 1680–92

Below: Cupboard, of French workmanship. c. 1650. Ebony, height 83¹/₂″. Rijksmuseum, Amsterdam

The official taste of the French court followed classical lines and was therefore unsympathetic to contemporary Italian art. In the provinces, especially in northern France, a strong attachment to Gothic proportions persisted until well into the seventeenth century; these forms were only superficially combined with Renaissance motifs and Mannerist ornamentation. The Jesuit Chapel in Cambrai was planned in 1613 and built in the late seventeenth century strictly according to the original plans. The steep proportions of the gabled façade express the Gothic striving upward; and in the coarse ornamentation one can see the delight in profuse decoration of sixteenth-century France—which is also expressed as late as 1650, for example, in the ornamentation of the ebony cupboard on the right.

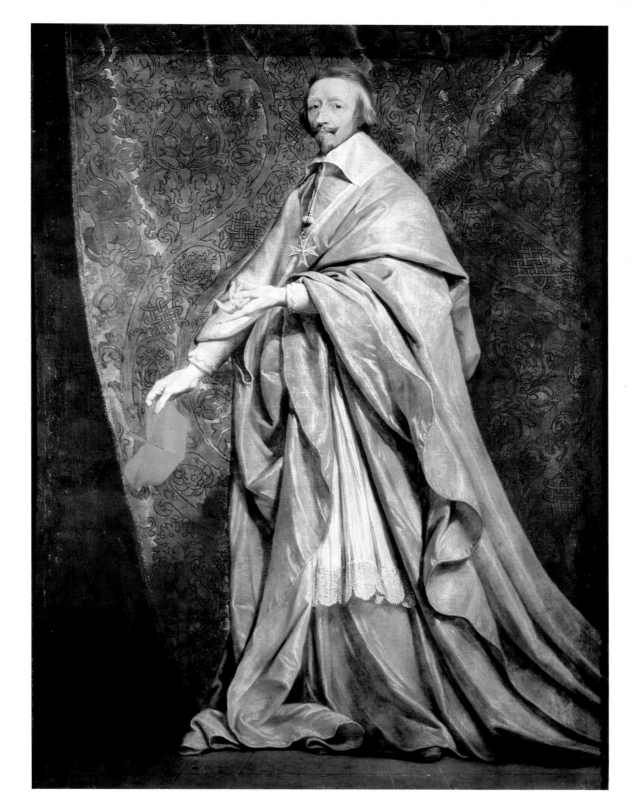

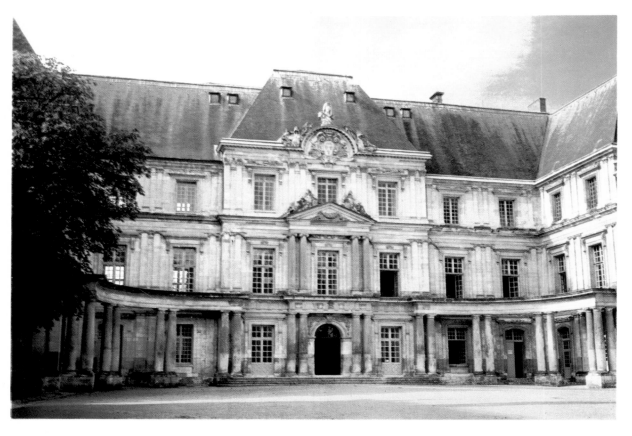

FRANÇOIS MANSART (1598–1666). Château of Blois, Orléans wing. 1635–38

François Mansart was of the same generation as the great architects of the Roman High Baroque, Pietro da Cortona, Bernini, and Borromini. A comparison of Mansart's buildings with the works of the Italian artists reveals the principal distinction between the two peoples, both in the concept of a building as an entity and in the feeling for its individual parts. Among the Italians, however much they might differ from one another, movement is especially important—concentrated energy that pulses through a building and denies it any feeling of serenity. With every turn one sees new aspects; each detail of the architecture changes in significance, depending on whether one observes the building from near or from far, obliquely or from a point directly in front of it. The Orléans wing of the château at Blois, the only one of Mansart's great projects to be completed, is, on the other hand, a clear, unequivocal architectonic structure. The visitor is attracted by the short wings at each side and led as a matter of course by the concave double row of columns to the central portion of the building and the entrance to the official rooms. The stories are clearly separated and, following the classical rules of Vitruvius, composed of Doric columns or pilasters on the ground floor, Ionic pilasters above them, and Corinthian pilasters on the uppermost story. A noble tranquillity pervades the building.

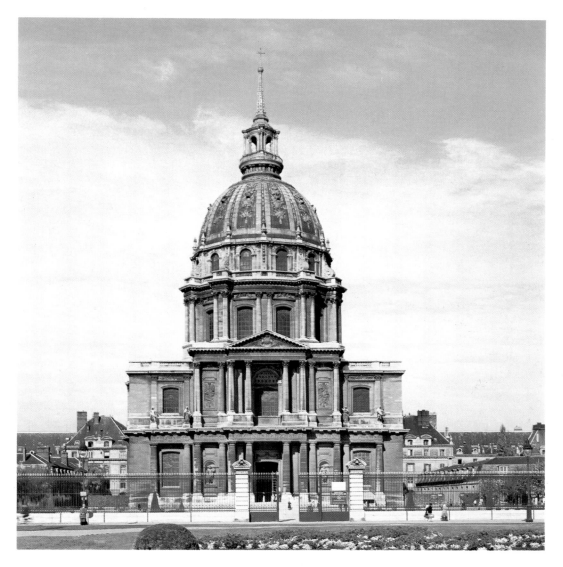

JULES HARDOUIN-MANSART (1646–1708). Church of the Invalides, Paris. 1680–91. Façade

The church of the Invalides in Paris was built in 1680–91 by François Mansart's nephew, Jules Hardouin-Mansart. With its towering drum and dome and the two orders of coupled columns on the façade, it has the same qualities of serenity and substance as Mansart's creations. *Clarté*—clarity—the dominant virtue in a world directed by human reason, is the great ideal of French classicism. It is the same spirit that governs the tragedies of Racine, the same unequivocal order from which anything arbitrary or ambiguous is eliminated because it is incompatible with that rationality on which human dignity is based.

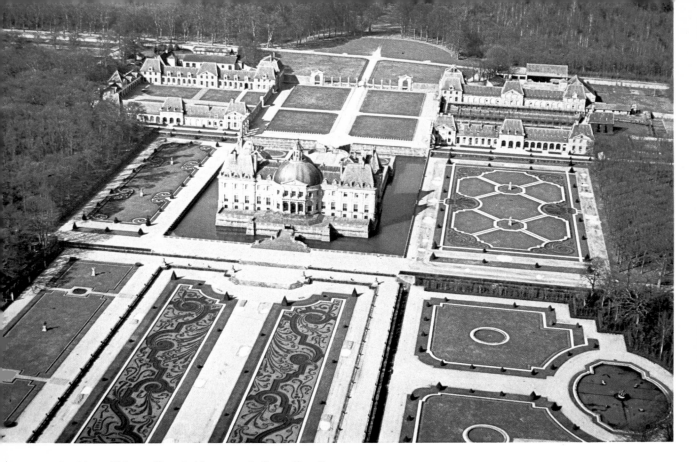

LE VAU. Château Vaux-le-Vicomte. 1656/57–1661. Gardens designed by André Le Nôtre (1613–1700). Aerial view

As we have seen (page 58), Louis XIV, who was scarcely twenty-three years old, himself took over the government of France after the death of Cardinal Mazarin in 1661. His powerful Finance Minister, Nicolas Fouquet, gave a splendid fete in the King's honor at his château, Vaux-le-Vicomte. The Queen, Mademoiselle de la Vallière (the King's mistress), and the entire royal household were there to see what the Minister had made out of his estate near Fontainebleau. A carefully selected team of brilliant artists had rapidly created a magnificent palace and a park—a unified work of art in which the patterns imposed upon nature in the park harmonized with the noble architectural forms, testifying equally to the wealth and fine taste of the owner. Louis Le Vau had begun the château in 1658, Charles Le Brun was the gifted interior decorator, and André Le Nôtre laid out the park in strict geometrical patterns that subordinated it to the château. He procured expensive varieties of foreign trees and enlivened the ordered landscape with statuary and great vases. The celebration on August 17, 1661, had more than just a splendid setting to offer: featured was a play by Molière, with music composed by Lully; and an enormous fireworks display blazed over the scene. Fouquet seemed to have attained his goal: the young King would know what splendor the Finance Minister could command, what riches and therefore what power he possessed. Three weeks later Fouquet was arrested; the King had accepted the challenge and returned it with unexpected vigor. The former Finance Minister was tried for embezzlement and died in prison; his property was confiscated. The entire team of artists that had created Vaux-le-Vicomte was taken over by

the King and was henceforth employed at Versailles. Thus, Vaux-le-Vicomte represents in some respects a full-dress rehearsal for the impressive spectacle that was now, under the direction of the King himself, to unfold at the site of the favorite hunting lodge of his father, Louis XIII.

The mythology of Antiquity plays a decisive role in the scene below. The King saw himself as the sun, the bringer of light, who bestowed life upon his entire country. Everywhere in the furnishings of Versailles, the King's emblem glitters—the royal countenance, surrounded by the rays of the sun. Apollo is the real inhabitant of Versailles, in his earthly incarnation as Louis XIV. But these references to the glory of the Sun King were not enough; his entire family was identified with ancient gods and goddesses. In this family portrait by Jean Nocret, the Queen appears as Juno; Anne of Austria, the Queen Mother, is shown as the Earth Mother Cybele, the King's niece as Flora, and so on. An entire royal Olympus is built up. There is something theatrical in this blending of mythology and life—and indeed theatrical-mythological performances were taken so seriously that the King himself appeared in a ballet as Apollo.

JEAN NOCRET (1615–72). *The Family of Louis XIV (L'Olympe royal)*. c. 1670. Oil on canvas, 9′ 9³/₈″ × 13′ 9″. Museum, Versailles

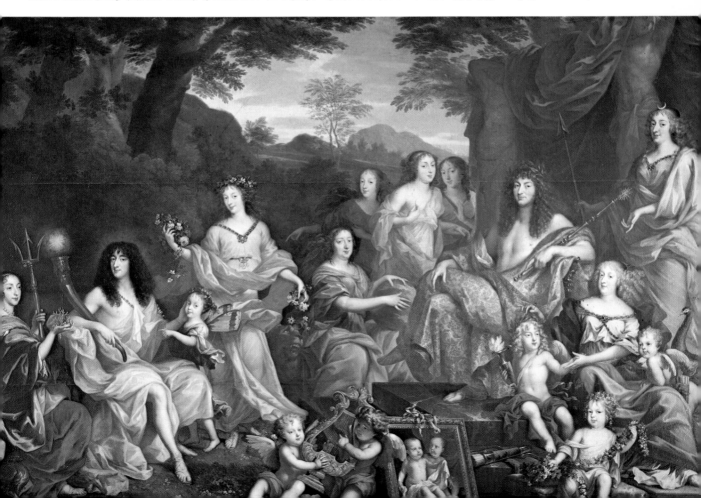

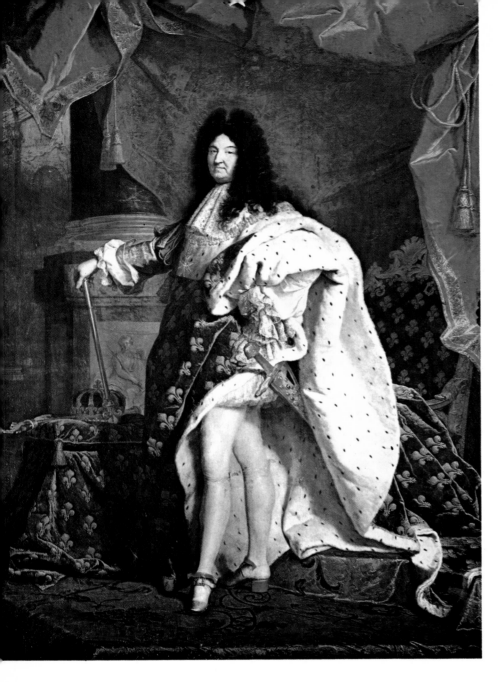

HYACINTHE RIGAUD (1659–1740).
Louis XIV. c. 1701/2. Oil on canvas,
9′ 1⅞″ × 6′ 2¾″. The Louvre, Paris

The King's deep conviction of his own worth, which had its roots in an almost medieval concept of the divine mission of kings, can be seen in all portraits of Louis XIV. Just as his entire life, from awakening to retiring, was enacted in public, like a drama—getting up and going to bed (*lever* and *coucher*) were important ceremonies at Versailles, executed according to an exacting protocol—so did his portraits always show Louis XIV in his role as king, never as a private person in the way that the Spanish kings and infantas were portrayed by Velázquez. Louis XIV is constantly surrounded, even here, by an atmosphere of the theater, of the grand entrance. Yet one cannot judge this whole ingeniously ordered world by twentieth-century standards. It was no pathetic performance upon an empty stage, for at the height of the Sun King's reign, France was the most powerful nation in Europe. Louis XIV had built up France through his own determination and his victories in the field. He was well aware of his power and wanted it to be fully visible to the world. Louis' ambitions were based on deep personal conviction, and were expressed with all the artistic means at his command.

Louis XIV had not originally intended Versailles to be the official seat of government. At first, the King allowed himself to be persuaded by his minister Colbert, who had been instrumental in the arrest of Fouquet, to remain in Paris. Yet the capital was associated in the young King's mind with the humiliating memory of the revolt of

the Fronde. When he was three years old, he had had to flee before the rebellious aristocracy, leaving the Louvre with his mother secretly and at night. Throughout his entire reign, Louis never forgot that degrading experience. Paris was spoiled for him and he hurried away—strangely enough, however, not to one of the many beautifully equipped châteaux in the vicinity, but to the small, unimposing hunting lodge of his father at Versailles. At first, only a small addition to the lodge was contemplated. In 1661, two wings were added for domestic offices. Although fairy-tale court fetes were held at the château, with Mademoiselle de la Vallière as the secret queen, Versailles remained the King's private refuge, not the official court residence. Meanwhile, Colbert had called Bernini to Paris to help make the Louvre a fitting residence for the King, with the hope that he would forget his private longing for Versailles (see pages 58–59). But Bernini had to leave without having accomplished his purpose; his plans had been rejected. The chief surviving token of his stay in France was his magnificent portrait bust of Louis XIV, which shows a lively insight into the nature of the King. The Louvre was completed by French architects, but in spite of all their efforts, the King could not be kept in Paris. In 1668, after the peace of Aix-la-Chapelle, which followed the King's first great military successes, it was decided to carry out new plans by Louis Le Vau: the château would be enlarged to permit the entire court to stay there, at least from time to time. Reverently, the King forbade the destruction of his father's little hunting lodge. It was to be the center of the new building and could only be remodeled externally. In 1678, Jules Hardouin-Mansart began the final enlargement, adding the vast north and south wings, so that in 1682 the whole court and the government of France could at last be transferred there. Thus, Versailles grew little by little into the imposing, unified work of art that became the incentive and the never-to-be-equaled model for most of the courts of Europe.

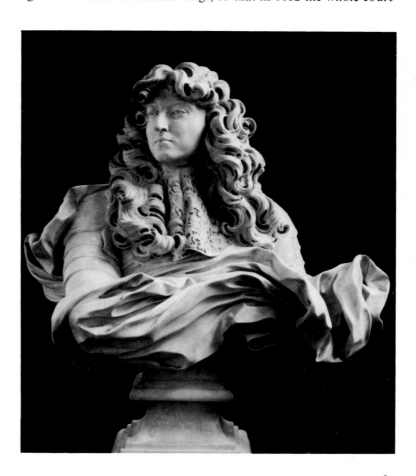

BERNINI. Bust of Louis XIV. 1665. Marble, height 31¹/₂″. Versailles

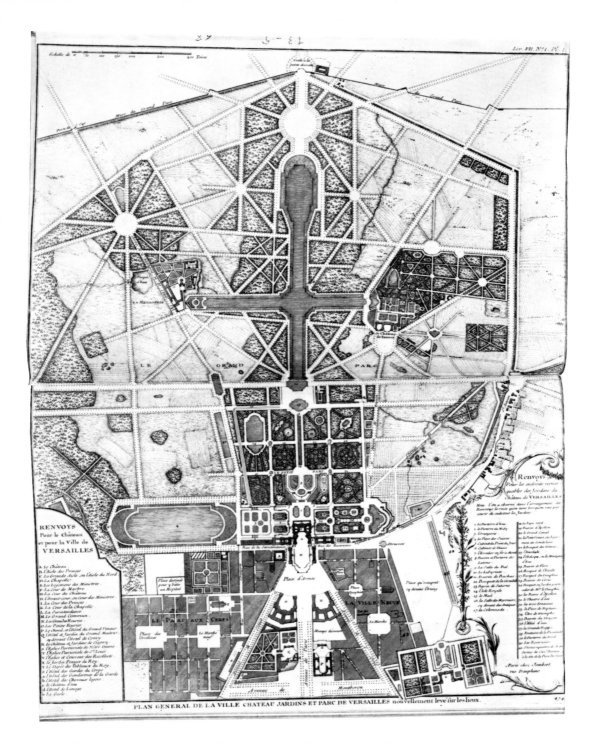

JACQUES-FRANÇOIS BLONDEL (1705–74). Plan of Versailles. Engraving from Blon-
del's *Architecture françoise* . . ., Vol. IV, Book VII, No. 1, plate 1, Paris, 1756

68

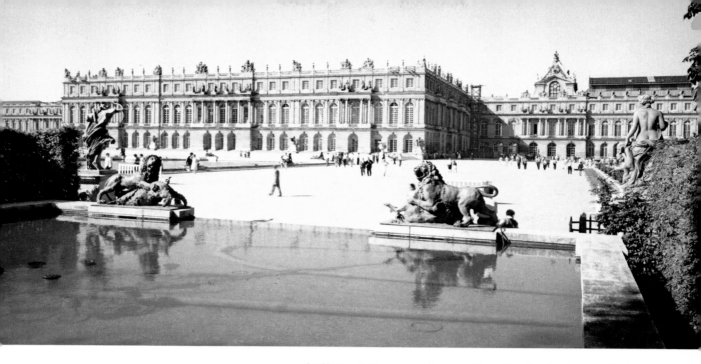

LE VAU and HARDOUIN-MANSART. Versailles, Garden Front. 1669–85

Versailles had to be wrested from nature. Situated in a swampy wasteland, the tiny hunting lodge of Louis XIII seemed completely unsuitable to be transformed into the site of a vast, imposing château and grounds. The Duc de Saint-Simon, who portrayed and mercilessly criticized the society of the court and the person of Louis XIV himself in his memoirs, ridiculed the King's incomprehensible decision: this of all places, "the saddest, most dreary of all locations, without a view, without a forest, without water, without earth—only sand and swamp" must be chosen as the site of a new residence? Why not one of the many beautiful, well-appointed châteaux in the vicinity of Paris? But precisely the seemingly impossible character of the site appealed to the vital, impetuous nature of the young King. Just as he unrelentingly vanquished his enemies and, uncompromisingly and with enormous energy, carried his wars through to victory—so he set out to subdue recalcitrant nature, regarding himself as the conqueror of all that was naturally unrestrained and chaotic.

Enormous quantities of earth had to be moved in order to drain and terrace the land for the park and palace. Water had to be brought from miles away by means of large pumping installations, so that it splashed from the fountains and filled the great channels. In order to satisfy the impatient King, who wanted to have the park, fully grown, before his eyes in the shortest possible time, mature trees were brought from Normandy, Dauphiné, and other distant provinces. The most unusual plants and the finest statues were taken to Versailles from the park at Vaux-le-Vicomte, and nature, already subdued, was thus embellished with the confiscated property of a defeated opponent. But not only nature was forced into an orderly arrangement; a whole new city was pounded out of the earth. In 1671, the King commanded that the insignificant village of Versailles be built up according to carefully regulated plans. Three great avenues radiated outward, so that the various quarters of the town were directed toward the château, and other avenues branched out on the park side of the palace. The royal residence was situated between the world of men, ruled by the King, and its natural setting—a setting the King had transformed into order out of chaos. The King's bedchamber was at the center, facing east. When the King rose, the sun rose: Apollo ascended and filled the world with light.

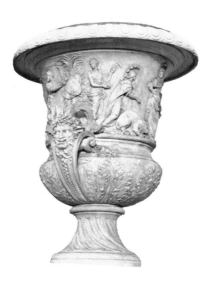

Hall of Mirrors (*Galerie des Glaces*), Versailles. 1678–84. Decoration by ▶
Charles Le Brun. The ceiling paintings represent victories and other deeds of
Louis XIV

Apollo—the sun—is lord of Versailles. The triumphal course of his
day is continually glorified, in the ceiling paintings as well as in the
sculptures in the park. At night, however, when Apollo plunges into
the sea, he is sheltered in a grotto and waited on by the nymphs of
Thetis. After his great victories and the treaties of Nijmegen, the
King appeared in his own form in the paintings in the Hall of
Mirrors, surrounded by the gods of Antiquity, in an allegorical
representation of his military triumphs. Apollo is no longer his
symbol; Louis XIV has himself become the sun, and the nations
recognize the divinely ordained superiority of himself and of his
country.

▲
ANTOINE COYSEVOX (1640–1720). Great
vase in the park of Versailles (*Vase de
la Guerre*). The relief represents "Spain
Swearing Allegiance to France." 1684
–85. Marble, height 98³/₈″

View of the original grotto of Thetis, Versailles. Sculptural group of *Apollo
Attended by the Nymphs of Thetis* by François Girardon (1628–1715), 1666.
Copper engraving by Johann Ulrich Kraus, from André Félibien des Avaux,
Description de la Grotte de Versailles, Augsburg, beginning of eighteenth
century, plate VII
▼

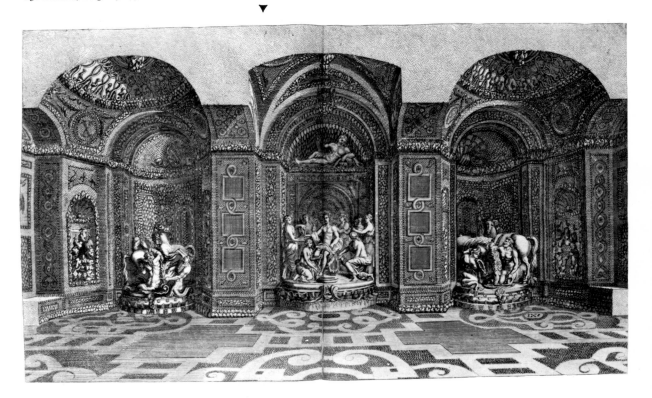

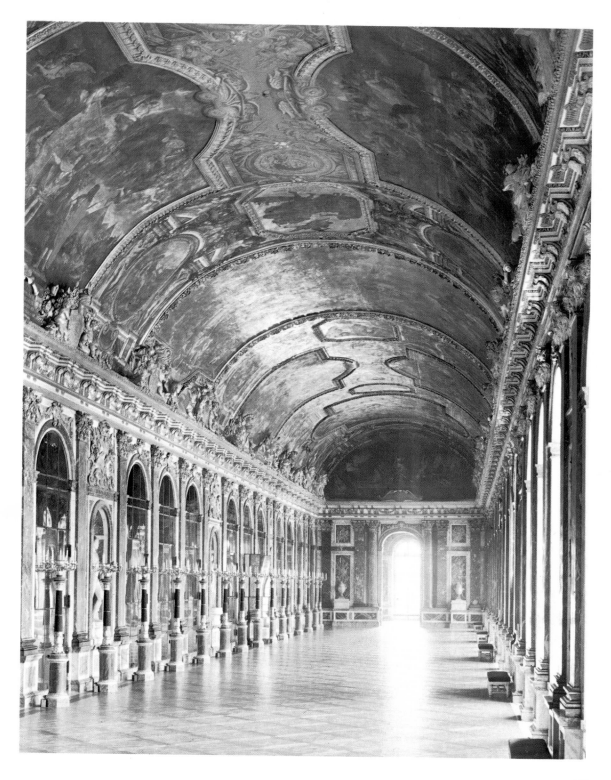

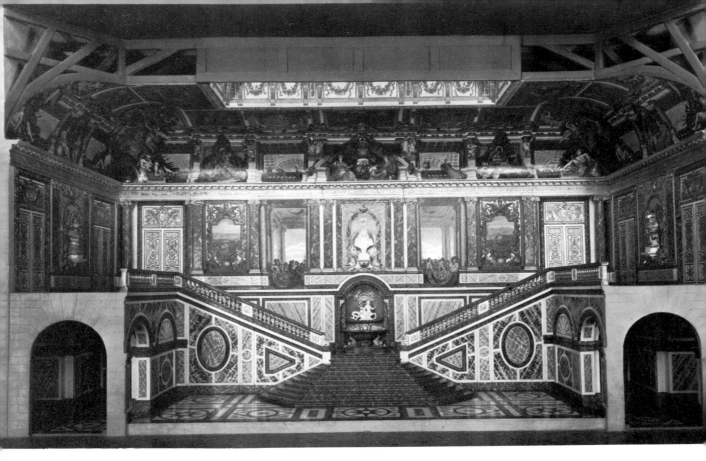

Ambassadors' Staircase (*Escalier des Ambassadeurs*), Versailles. Built after 1672 according to plans by Louis Le Vau, decorated by Charles Le Brun. Demolished in 1752. Modern reconstruction by M. Arquinet

WILLIAMSTON COMMUNITY SCHOOLS
WILLIAMSTON, MICHIGAN 48895

Versailles is now only an empty stage from which the actors have vanished. One beholds it with awe, and tries to imagine the lively scenes through which it received its *raison d'être*. Only in this way can we understand this grandiose show place in our own time, with its very different assumptions. Life, movement, the grand entrance: all this is most readily imaginable on the Baroque staircases. What fine gradations of ceremonial could take place here! Did the King wait above? Did he come down to meet his visitors? Or did he receive them below, and ascend the stairs with them? Each of these possibilities was evidence of a particular degree of royal favor. Ambassadors ascended the great staircase of Versailles, passing through ever more richly decorated rooms until they finally reached the Hall of Mirrors, where the King received his visitors seated on a silver throne. His bust was, of course, the focus of the ascent, with the blazing face of the sun hovering above it. On the wall, painted with deceptive realism, were depicted ambassadors from the four corners of the earth, gathered in an open loggia hung with tapestries. The finest marble, whose different hues were carefully harmonized with each other, golden ornaments, and the rich colors of the paintings lent the room a luster that was meant to give the ambassadors, as soon as they entered, a foretaste of the spectacle that awaited them before the throne. Although the staircase was sacrificed as early as the reign of Louis XV to allow a more comfortable arrangement of rooms, many imitations were built, the latest by Ludwig II of Bavaria in his Schloss Herrenchiemsee.

The Queen's Staircase in the opposite wing is still preserved in its original condition. Here, majesty of appearance was less important; beautifully proportioned rooms and the harmonious execution of the staircase are the distinctive features of this part of the château.

The Queen's Staircase (*Escalier de la Reine*), Versailles. Built after 1672 by Jules Hardouin-Mansart, following plans left by Louis Le Vau

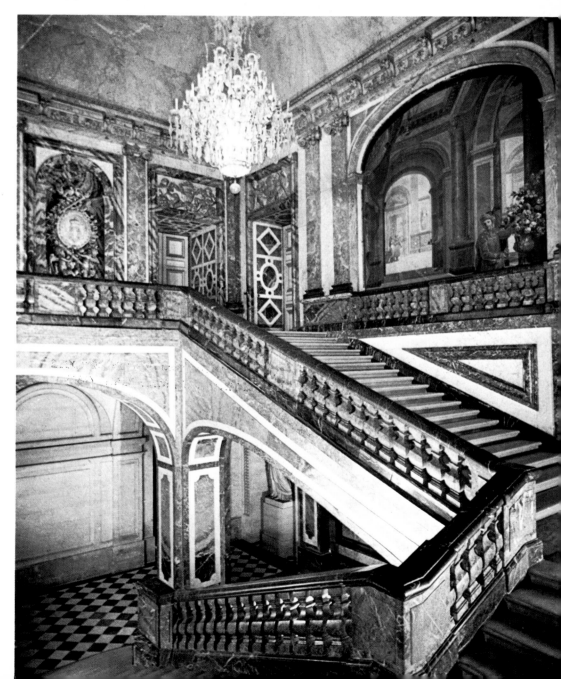

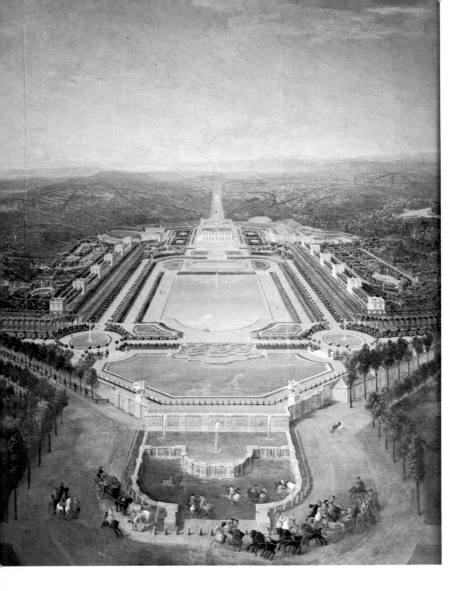

Karlsruhe. Begun 1715. Perspective view ▶ of the city and the palace. Engraving by Christian Thran, 1739

HARDOUIN-MANSART. Château, Marly-le-Roi. 1679–86, enlarged 1696–1703. Perspective view by Pierre-Denis Martin the Younger, 1724. Oil on canvas, 9′ 8¹/₂″ × 7′ 3³/₄″. Versailles

Versailles is not the only great château complex in which the spirit of Louis XIV—particularly his attitude toward the world, his subjects, and his court—takes visible form. At Marly-le-Roi, not far from Versailles, the King had Jules Hardouin-Mansart build a small château that formed the center of an unusual ensemble: grouped around a gigantic pool were twelve small pavilions, six on each side, dominated at one end of the water by the royal residence. Here, Louis XIV presented fantastic entertainments, done according to a strict protocol, for his special favorites from the court. Ladies and gentlemen lived on opposite sides of the water. Unlike Versailles, where it was decreed that court dress must be worn during the day, the specially chosen guests at Marly could dress less formally. They were allowed to feel that they had been accepted by the King into a familiar, gracious atmosphere. But in the very design of Marly, the ruler's claim to power is unmistakably expressed: the King reigns in his château in the middle while, at an appropriate distance from the main building, are the pavilions of his subjects, grouped in the unusual, sacred number of twelve. This arrangement bespeaks the hubris that appropriated not only Antique mythology, but even the Christian symbolism of numbers—a hubris that finds its echo in the sketches by Thomas Gobert for churches whose ground plans would form the name LOVIS LE GRAND (see page 8).

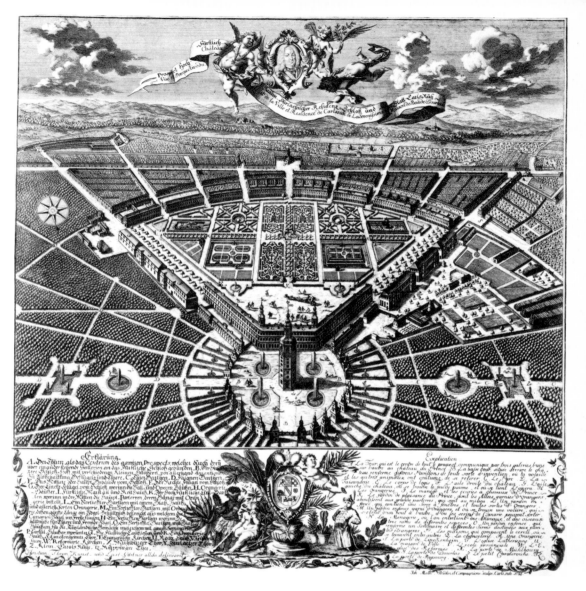

Versailles and the other buildings of Louis XIV became prototypes for many of the princely courts of Europe. In Karlsruhe, Margrave Karl Wilhelm of Baden-Durlach decided in 1715 to found a new capital on the Rhine. At the center of the layout was an octagonal tower; thirty-two avenues radiating from the tower were cut into the forest. The city was built in an area enclosed by nine of the avenues, facing the palace, which, with its obliquely projecting wings, seems to offer protection to the margrave's subjects. On one side of the palace stood the city, on the other the forest; on the forest side, grouped about the tower, the courtiers' houses were located. Not the palace, but the isolated tower formed the central focus. Here, as in Marly, an idea of the nature of the state is expressed visually. In Karlsruhe, however, the sovereign is not the center from which all else radiates; in his place is the abstract idea of the state, as expressed by the tower—an idea to which the prince, like his subjects, is related in a hierarchical order. Frederick the Great later expressed this idea when he described the prince as the first servant of the state.

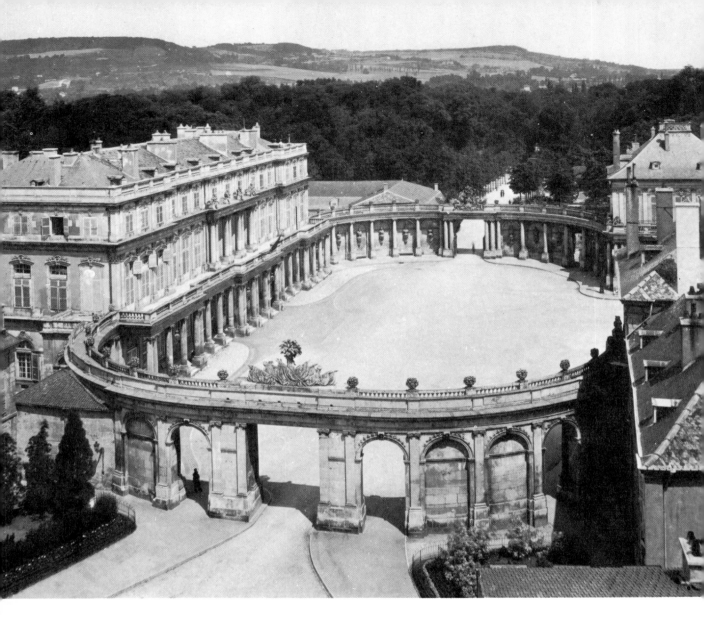

The piazza as an open space surrounded by buildings was one of the great architectural tasks of the Baroque that stimulated those who commissioned works—usually reigning monarchs—as well as gifted architects to achieve ever new solutions. A grandiose example is Bernini's St. Peter's Square in Rome (see page 48). It is said that the influence of Bernini's colonnades around the oval forecourt of St. Peter's can still be felt in the much later colonnade at Nancy. Stanislas Leszczinski, the dethroned King of Poland, had found refuge in Lorraine under the protection of his son-in-law Louis XV, and in the King's honor Leszczinski built a splendid square, the Place Royale, one side of which is closed by the colonnade and government palace.

The project that was designed, shortly after 1700, for the Schlossplatz in Berlin can best be understood as an expression by the newly created royalty in Prussia of their consciousness of power. The square was first opened

in 1733; it clearly shows the spirit of the great sculptor and architect Andreas Schlüter. His genius was well suited to express the new self-confidence of the Brandenburgs, both in the equestrian statue of the Great Elector, the victorious predecessor of King Frederick I, and in the construction of the Berlin Royal Palace.

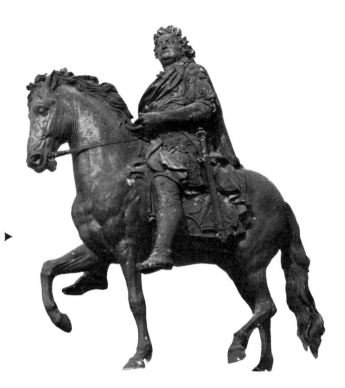

◄ EMMANUEL HÉRÉ (1705–63). Palais du Gouvernement and Place Royale, Nancy. Planned 1750–51, executed 1752–55. Palais du Gouvernement 1751–53 by Richard Mique after plans by Héré

ANDREAS SCHLÜTER (c. 1660–1714). Equestrian statue of the ► Great Elector. Begun in 1698, cast by Jacobi in 1700. Originally on the bridge in front of the Berlin Royal Palace, now at Schloss Charlottenburg, Berlin

Royal Palace, Berlin. Design attributed to Andreas Schlüter. "Place Royale de Berlin," from J. B. Broebes, *Prospect der Palläste und Lust-Schlösser Seiner Königlichen Mayestätt in Preussen*, Augsburg, 1733, plate I

▼

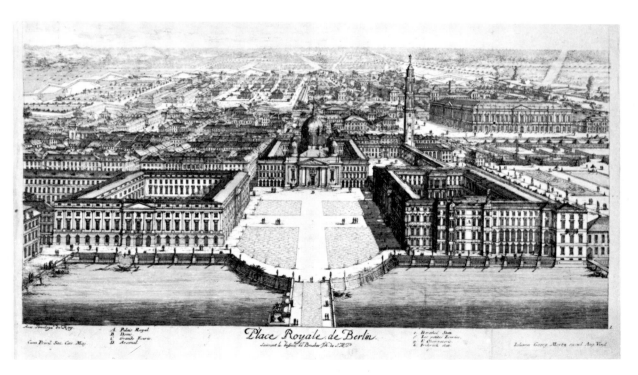

Place Royale de Berlin

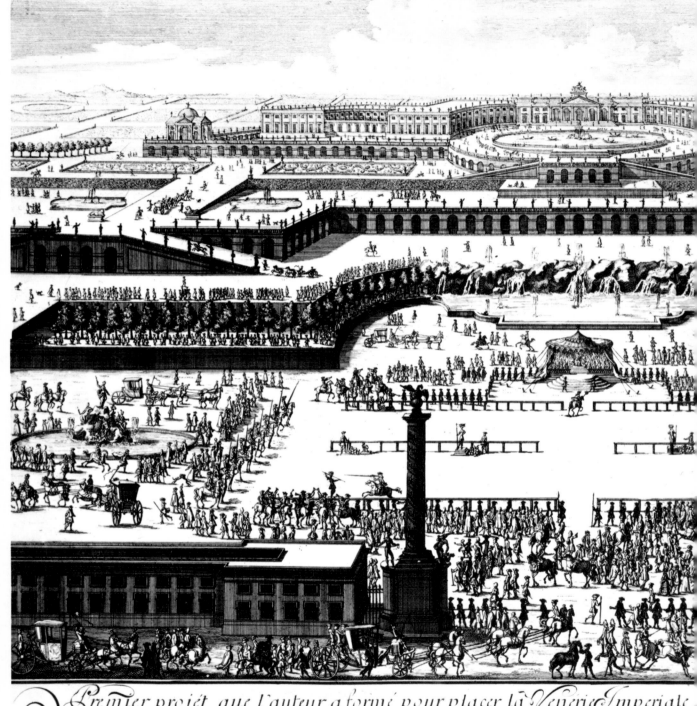

Premier projét que l'auteur a formé pour placer la Veneric Imperiale
d'un côté des terrasses & des cascades, aussi-bien que de ménager pour l'aven
fait ci-devant les délices de la Cour, découvrant à perte de vüe la Ville de

J. B. Fischer d. Erlac. d.

a hauteur de Schönbrun, afin de profiter
e l'autre côté vers Hezendorf le Parc, qui a
ne avec les frontières de l'Hongrie

J. A. Delsenbach fecit.

JOHANN BERNHARD FISCHER VON ER-
LACH (1656–1723). First project for the
imperial summer palace of Schönbrunn.
c. 1690. From *Entwurff einer Histori-
schen Architectur . . .*, Vienna, 1721,
Book IV, plate II

The great residence was one of
the most imposing subjects of
High and Late Baroque archi-
tecture. It was constantly varied.
Quite often, because plans called
for exaggerated buildings of fan-
tastic proportions, they remained
unbuilt, although sometimes the
plans were carried out in a reduced
form, with dimensions more ap-
propriate to actual needs. Johann
Bernhard Fischer von Erlach had
conceived his grandiose project
for a new Versailles at Schön-
brunn, near Vienna, as early as
1690. Bernini's design for the
Louvre and the flat terraced roofs
of Italian palaces have been com-
bined to form an imperial palace
that was to be a showplace for
gigantic processions. Later, a
second, more modest, design ap-
peared. Schönbrunn never be-
came the main imperial palace, as
Fischer had obviously intended;
it remained a summer residence.

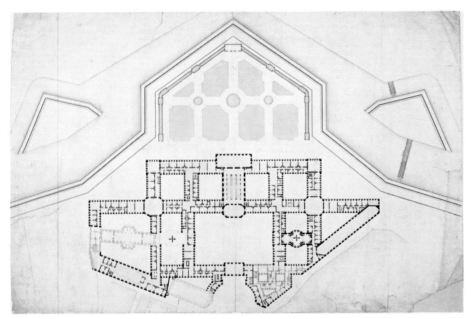

BALTHASAR NEUMANN (1687 –1753). The so-called Great Project for the Vienna Hofburg. Floor plan of the upper story. Pen and ink wash, $18^3/_4'' \times 26^5/_8''$. 1746–47. Kunstbibliothek, Berlin, Hdz. 4726

The Viennese residence of the Emperor and Empress remained the Hofburg, archaic and irregular in construction, even though it was really no longer appropriate to the imperial standing. Under Maria Theresa, serious thoughts were given to the construction of a new imperial palace. The design created by the Würzburg architect Balthasar Neumann was, however, much too expensive even to be considered. Neumann was obviously drawing upon the Louvre designs of Claude Perrault (see page 59), which he surely must have seen during his student years in Paris. At the center of the enormous complex was to be a stair hall that could be entered from either side, from the garden or from the courtyard, and would penetrate the entire central portion of the palace like the nave of a church—an idea that expresses the Baroque spirit of movement in its most obvious form. The façade, curving toward the market place, is echoed in the Michaelerfront of the Hofburg by Joseph Emanuel Fischer von Erlach as it stands today.

NICODEMUS TESSIN THE YOUNGER (1654–1728). Royal Palace, Stockholm. Begun 1697

BARTOLOMEO FRANCESCO RASTRELLI (1700–71). Winter Palace, Leningrad. Begun 1755, completed 1817

Architects now no longer journeyed solely to Italy in search of new ideas—they went first of all to France. Nicodemus Tessin the Younger, architect to Charles XII of Sweden, had spent much time in Paris and had closely studied Claude Perrault's plans for the Louvre before he built the Royal Palace in Stockholm. Perrault's classicism is also expressed by the clear, imposing forms with which Tessin sought to express the might of his sovereign.

In the Leningrad Winter Palace, built by Bartolomeo Francesco Rastrelli for the Czarina Elizabeth of Russia, one can still perceive the influence of the Louvre in the enormous extension of the front—even though the details, in the style of the time, are based on other models. Rastrelli was the son of a Florentine master builder who had been brought to Russia by Peter the Great. Thus, it is not surprising that, in its particulars, the Leningrad palace has more of the spirit of the Italian Baroque than of the *clarté* of French architecture.

Architecture in England continued for a long time to be dependent on the Gothic: one can sense the medieval spirit even in sixteenth-century buildings. It was Inigo Jones who suddenly introduced a new tone into English architecture. On his two visits to Italy, he spent his time—aside from Rome—primarily in Venice and Vicenza. There he saw buildings by Palladio and could compare them with the forms he had already studied in Palladio's treatise on architecture. It was he who founded the tradition of English "Palladianism"—a style that was long to remain the dominant one for imposing buildings in England. In 1615, Jones was appointed Surveyor General of the King's Works. In 1616, the Queen, Anne of Denmark, asked him to build a small villa in Greenwich. Jones used features of Palladian villas—an open loggia with columns on the upper story and a flat roof—and it seems that Italy has been transported to the banks of the Thames. However, the proportions have been adapted so that "The Queen's House," despite its obvious derivation from Palladian models, remains in its

SIR CHRISTOPHER WREN (1632–1723). The Royal Naval Hospital, Greenwich. ▶
Begun 1696. South side. In the foreground, the Queen's House by Inigo Jones

82

◄ INIGO JONES (1573–1652). Banqueting
House, Whitehall, London. 1619–22

JONES. The Queen's House,
Greenwich. 1617–18 and 1629–35

restraint a typically English building. For the Banqueting House of Whitehall Palace, Jones also borrowed from Palladian models. But where Palladio would have used engaged columns two stories high, reaching the entire height of the building, Jones gives each story its own order of columns, crowns the entire building with a balustrade, and gives it a cool tranquillity that is scarcely to be found in works by Palladio.

At the end of the seventeenth century, Sir Christopher Wren planned and began a great complex of buildings near the Queen's House in Greenwich—not as a royal palace, but as a hospital for the Royal Navy. Since the construction of the Invalides in Paris, such majestic "hospitals," of imposing dimensions, had provided a welcome opportunity for kings to give visible proof to their subjects of the care that they provided for pensioned soldiers of their armies.

EDWARD PIERCE (c. 1635–95). Portrait bust of Sir Christopher Wren. 1673. Marble, life-size. Ashmolean Museum, Oxford

The portrait bust of Sir Christopher Wren by Edward Pierce is, in its audacious pose, reminiscent of Bernini's bust of Louis XIV. Pierce does not, of course, give the royal architect the aura of an all-powerful ruler, as Bernini had done for the Sun King (see page 67), but the free draping of the mantle and the slightly turned head are faintly suggestive of Italy. Pierce never left England, but his teacher, John Bushnell, had studied in Italy and was the first to free English sculpture from its dependence on traditional Gothic forms. Not until Pierce, however, was the new Baroque style fully realized in English sculpture.

Wren was initially concerned with pure science—he taught astronomy in London and Oxford. Yet in 1662, we suddenly find him active as an architect. Although his designs show a strong Italian influence, Wren was never in Italy; he gained his architectural education from theoretical works and from a trip to France, where he talked at length with French architects and studied many buildings. In 1665, he met Bernini in Paris and was allowed a brief look at his sketches for the Louvre. But Wren was more deeply influenced by Jules Hardouin-Mansart and the French style of the *grand siècle* than by the great Italian master of the Baroque.

A decisive event in Wren's life was the Great Fire of 1666, which destroyed 13,200 houses and 87 churches in London. A mere six days after the catastrophe, Wren presented King Charles II with an ambitious project for rebuilding the city. The houses were to be divided into blocks, on a generous scale, by broad avenues that were to radiate from a central point in the manner of Versailles. The plan was never carried out; but it was decided to rebuild London out of fireproof materials—brick and stone. St. Paul's Cathedral, which had been in a dilapidated state even before the fire, was torn down in 1671–72 and completely rebuilt to Wren's design. The great dome over the crossing is modeled on Bramante's design for the dome of St. Peter's in Rome. The drum is entirely surrounded by a gallery ornamented with columns. The form of Michelangelo's dome, as it was actually built in Rome, does appear in some of Wren's preliminary sketches, but was abandoned in favor

WREN. St. Paul's Cathedral, London. Façade. 1675–1710

of the pure Renaissance forms of Bramante. This distinguishes the architecture of St. Paul's, despite all classical similarities, from that of Inigo Jones: Jones derives from Palladio, that is, the late sixteenth-century architecture of northern Italy; Wren's work is more related to the High Renaissance in Rome.

JOHN WOOD THE YOUNGER. (1728–81). The Royal Crescent, Bath. 1767–75

One of the most curious city layouts of the seventeenth century arose in Bath, England. Sir Christopher Wren's ingenious plans for the rebuilding of London were never carried out, but in Bath, John Wood the Elder, supported by enterprising private real estate owners, executed an impressive plan that is almost without equal, especially in its intellectual background. Bath was a small town of no special significance when it was discovered around 1725 by London society as a fashionable spa. It had, in fact, been a spa as early as Roman times. Numerous bath buildings and temples from the Roman period have since been excavated. John Wood the Elder had, of course, never seen any of these Roman ruins, but he was familiar with the tradition that Bath had a history reaching into Antiquity. He decided that, on the traditional site of the Roman city, he would erect a city with buildings in the Antique style—a circus and a forum were to be built. A circus meant solely for sporting events was, however, senseless for the small town, so Wood built a great circular arena of private residences. Three streets ran into the center of the circle, but nowhere were the streets exactly opposite one another, so that the closed feeling of the circus was retained. Wood died in 1754, but his son of the same name took over the project and continued it. He planned a second circus, this time in the oval form of the Colosseum. It was to be divided into two half-ovals by a broad avenue, but only one half, the Royal Crescent, was actually built. The wish to give new life to Antiquity was certainly a basic motive for this unusual complex of buildings; but in aerial view, it becomes clear that the designs of French parks were of equal importance in determining the layout. In his plan for London, Wren had laid out the avenues like park promenades. Here in Bath, the intimate circular areas surrounded by shrubbery and the long views cut through the parks in the form of radiating lines are formed by the stone façades of houses rather than by neatly clipped hedges. John Wood the Elder had subdivided his house fronts with three orders of engaged columns, one above the other.

His son used the system of exterior decoration that was to be the model for great English buildings throughout the eighteenth and nineteenth centuries: around the entire crescent, above the ground floor, colossal engaged columns span both upper stories and thereby unify them. Their uninterrupted rhythm gives the Royal Crescent an impressive stature and, despite its modest dimensions, a feeling of monumentality.

JOHN WOOD THE ELDER. (1704–54). The Circus and the surrounding new town layout, Bath. Begun 1754

GERRIT ADRIAENSZ. BERCKHEYDE (1638–98). *The Dam in Amsterdam, Looking toward the Town Hall* (now the Royal Palace). 1693. Oil on canvas, $20^1/_2 \times 24^3/_4''$. Rijksmuseum, Amsterdam

Town Hall, Amsterdam. Ground plan

On October 28, 1648, immediately after the Peace of Westphalia, which guaranteed the independence of the United Provinces of the Netherlands, the foundation stone for a new town hall was laid in Amsterdam. Plans had already been worked out by Jacob van Campen. Now that peace had finally been achieved, the new building, with its dimensions enlarged from the original plan, was erected in honor of the peace and of the young nation's liberal institutions; it was also to be a symbol of the power and prosperity of the city. Unlike the great royal residences elsewhere in Europe, the Amsterdam Town Hall was the work of a free bourgeoisie. A wealth of sculptural decoration alludes repeatedly to the ideal qualities of a citizen—virtues stressed in the Roman Republic. The sculpture also serves to glorify Amsterdam as mistress of the seas and of distant lands. In 1602, the Netherlands East India Company had been

formed; in 1621, a Dutch West Indies trade company was founded as well. Dutch colonies arose in America, Africa, and the Far East, and great wealth flowed into the mother country. All this is symbolized in the sculptural decoration of the Town Hall—for example, in the representation of Mercury, the god of trade and commerce. Jacob van Campen, like Inigo Jones, had been to Italy. He, too, had been impressed by the buildings of Palladio. But rather than using columns in the manner of Italian villas, he placed the Ionic and Corinthian orders one above the other, and transformed the grandeur of Palladio into a cool, stately gravity. The floor plan, in classical regularity, shows enormous halls and galleries grouped about two interior courtyards. In the center is the Burgerzaal, a vast barrel-vaulted hall, where great receptions and fetes were given. Van Campen's contemporaries declared the Town Hall to be the Eighth Wonder of the World.

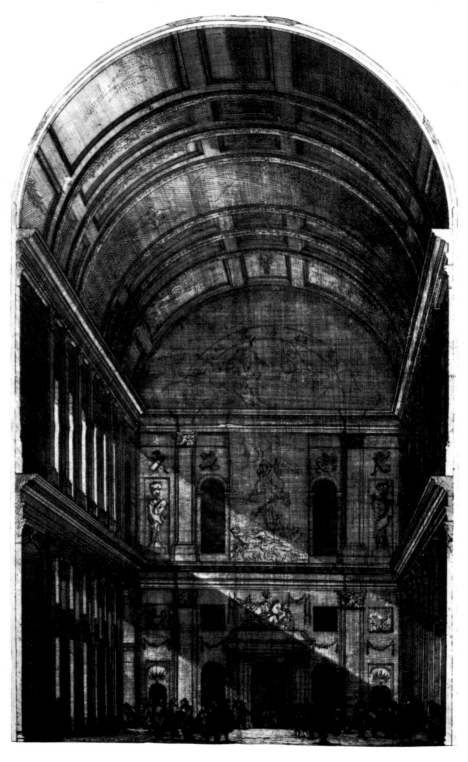

JACOB VAN CAMPEN (1595–1657). Burgerzaal in the Town Hall (now Royal Palace), Amsterdam. Begun 1648. Copper engraving from Jacob van Campen, *Afbeelding van't Stadt Huys van Amsterdam*, Amsterdam, 1664, plate R

ARTUS QUELLIN THE ELDER (1609–68). *Africa. Bozetto* (model) of a group on the west pediment of the Amsterdam Town Hall. Mid-seventeenth century. Terra cotta, height 21¹⁄₄″. Rijksmuseum, Amsterdam

FERDINAND BOL (1616–80).
*Portrait of the Sculptor Artus
Quellin* (?). 1663. Oil on
canvas, 48⁷/₈ × 39³/₈″. Rijks-
museum, Amsterdam

It is certain that the general design for the sculptural decoration of the Amsterdam Town Hall was the work of Jacob van Campen himself. The execution of the individual pieces, however, was in the hands of an Antwerp sculptor, Artus Quellin the Elder. Quellin had grown up in Antwerp, in Flanders, in contact with Rubens' circle, and had also been to Italy, where he had had the chance to see and appreciate at least the early works of Bernini. One can sense his southern background in the sculptures—for example, in the group representing Africa on the west pediment of the Town Hall, where the soft swelling of the limbs and the painterly handling of forms introduce the Baroque spirit into the austere total composition.

Ferdinand Bol, although himself from Holland, obviously understood the free temperament of his sitter. He represented Quellin as a vital, expansive personality, a man familiar with the worldly society that centered about Rubens.

HENDRICK DE KEYSER (1565–1621). Stock Exchange, Amsterdam. Begun 1608. View into the courtyard. Painting by Emanuel de Witte (1617–92). 1653. Oil on wood, 19¼ × 18¾". Van der Vorm Institute, Rotterdam

Rubens House, Antwerp. Enlarged by Peter Paul Rubens, 1611–18. Engraving by Jacobus Harrewijn (1662–1732), 1684

Maison Hibvenie a Anvers *Dit l Gostel Rubens. 1 6 8 4.*

There was already a good deal of building activity in Amsterdam, brought about by the city's growing prosperity, before the erection of the Town Hall. Hendrick de Keyser had begun work on the Amsterdam Stock Exchange, on a commission from the city magistrates, in 1608, after making an expense-paid trip to London specially to study the Stock Exchange there. He had acquired his knowledge of the Late Renaissance forms that appear in his design for the Exchange, not in Italy—which he had never visited—but indirectly, through Flanders, where engravings of this style of architecture and ornamentation were widely distributed.

Peter Paul Rubens, the most gifted Flemish master of the Baroque, who was to leave a permanent mark upon European painting, sculpture, and even architecture, spent eight years in Italy at the very beginning of his career. He was born in 1577 in Siegen in Germany, where his father had emigrated for religious reasons. After the death of his father, the family returned to Antwerp. Contrary to the wishes of his mother, Rubens succeeded in obtaining permission to become apprenticed to a painter. In 1598, he was already a Master of the Guild of St. Luke. In 1600, he went to Italy; there he first came in contact with Venetian painting, and studied Tintoretto and especially the later works of Titian. Shortly afterward, he entered the service of the Duke of Mantua, and on his many official missions came to know Rome and, more particularly, Spain, where he was sent in the service of the Duke. Finally, in 1608, he returned to Antwerp and the following year married Isabella Brant, daughter of the town clerk of Antwerp. In 1611, he bought a house with some land, and from then until 1618 he enlarged the house to accommodate his studio and his numerous students. The plans for the stately addition to the house were his own. While still in Italy, he had taken an interest in Late Renaissance architecture, especially that of northern Italy. The architectural forms of that period can be seen in his own house, the courtyard and garden architecture of which derive, not from Palladio, but from the richly decorated façades of houses in Lombardy and Genoa.

Rubens. *Helena Fourment with Her First Son Franciscus.* c. 1635. Oil on wood, 57$^1/_8$ × 40". Alte Pinakothek, Munich

Peter Paul Rubens (1577–1640). *The Lamentation of Christ.* c. 1612. Oil on oak wood, 13$^3/_8$ × 10$^5/_8$". State Museums, Berlin (West)

Perhaps while still in Italy, but certainly not long after his return to Antwerp, Rubens painted this *Lamentation of Christ*. In this small, sketchily executed panel, he was still completely under the influence of the Italian Mannerists. The great areas of darkness, against which the harshly lit body and the group of mourning women stand out in sharp relief, are faintly reminiscent of Caravaggio's use of light, although the intensity with which he depicts sorrow is Rubens' own. The more Rubens found his own style, the more the function of light changed in his work. In this painting, the contrast between light and darkness is used solely to emphasize the drama of the scene. But within the first decade after Rubens' return to his native land, the shadows in his paintings gradually lighten, the colors grow more luminous in themselves, instead of through contrast with the dark areas; human bodies are surrounded with light, so that they seem to breathe in a luminous atmosphere. Here, in his portrait of Helena Fourment, whom he married four years after the death of his beloved first wife, one can see how Rubens uses light to lend enchantment to his figures, how the thin substance of the woman's dress almost seems to dissolve in light—a treatment that shows the brilliant artist at the height of his powers.

RUBENS and JAN BRUEGHEL THE ELDER (1568–1625). *Adam and Eve in Paradise*. c. 1620. Oil on wood, 29^1/$_8$ × 44^7/$_8$″. Mauritshuis, The Hague

Rubens left behind a remarkably large *oeuvre*. It is therefore understandable that he could not singlehandedly paint the entire surface of each of his pictures, many of which are of gigantic size. He was surrounded by a great troop of students and assistants who comprised his "workshop" and who helped to accomplish the numerous commissions that poured in from all sides because of the widespread fame of the artist. Regular contracts were drawn up which specified to what extent the master himself would execute the work, to what extent he would entrust it to particular assistants, or whether Rubens had to paint a picture in its entirety. But the workshop was not the only place where artists collaborated to produce paintings; Rubens also executed works with other masters in the modern sense of the word teamwork. In *Adam and Eve in Paradise*, Rubens painted the figures and Jan Brueghel the Elder did the landscape and the animals. Both signed the work. This was not really a novelty in Rubens' milieu; among seventeenth-century Dutch painters were a number of specialists in particular areas, such as hunting scenes with dead animals, still lifes with fruit or flowers, or landscapes. In many pictures of that period, one can distinguish the hand of various specialists in different areas of the painting—even when the contributing artists have not all signed the work as Rubens and Brueghel did.

Next to the special quality of his light, movement is the attribute that most distinguishes Rubens' works from those of the majority of his contemporaries. The human body in motion—often at the high point of a dramatic action—is the subject that attracts Rubens again and again. In *The Battle of the Amazons*, he is not content merely to let the movement pulse through single figures; the entire picture is like a whirlwind formed of human and animal bodies. Individual forms lose their significance, dissolved into one vast mass of motion. Even the elements, the water, and the clouds, have been drawn into the action. Here, Rubens depicts the original battle of the sexes, raised to a titanic scale and with a clear symbolic content, as it is fought between the Greeks and Amazons before the city of Troy. In representing subjects drawn from Antiquity, Rubens was not dependent for information on contemporary translations or paraphrases of the classical originals. He had studied Latin and Greek in his youth and was considered unusually well educated for his time and for his social position as an artist. This education also enabled him successfully to carry out various diplomatic missions in the service of the Stadholder of the Southern Netherlands. As a special ambassador, he traveled to the Spanish and English courts, and with his warm personality displayed rare diplomatic skill.

RUBENS. *The Battle of the Amazons*. c. 1615. Oil on wood, 47⅝ × 65¼". Alte Pinakothek, Munich

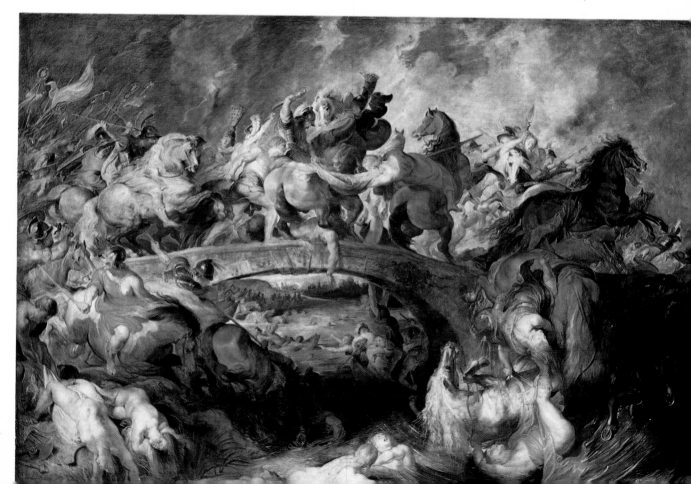

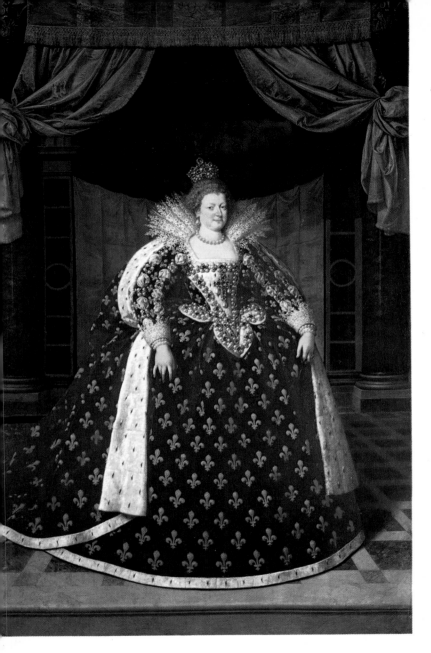

RUBENS. *The Landing of Marie de Médicis at Marseilles.* 1622–25. Oil on canvas, 12′ 11 1/8″ × 9′ 8 1/4″. The Louvre, Paris ▶

◀ FRANS POURBUS THE YOUNGER (1569–1622). *Portrait of Marie de Médicis, Queen of France.* c. 1609–10. Oil on canvas, 10′ 2 7/8″ × 6′ 7/8″. The Louvre, Paris

In order to show just how individual Rubens was, two paintings of Marie de Médicis, the wife of King Henry IV of France, are juxtaposed here. Frans Pourbus the Younger was, like Rubens, Flemish. Like Rubens, he went to Italy—in fact, he was even active at the court of Mantua at the same time as Rubens. Yet Pourbus had assimilated the influence of Italian Mannerist painting in a totally different way from Rubens. Of course, one cannot compare the two paintings directly. Pourbus was painting the Queen in her robes of state, in a pose that emphasized her role as Queen and powerful regent for her son, Louis XIII, who was still a minor. In Rubens' painting (one of a cycle on the life of Marie de Médicis), she is the center of a large-scale allegorical scene in which even the gods of Antiquity play subservient roles to her. Neptune with his sea-gods and water-nymphs draws toward land the ship on which the bride is hurrying toward her bridegroom in France. Above her, Fame proclaims her renown. The way man is incorporated into the animate nature of Antiquity and put on an equal plane with the gods and personifications of the elements bespeaks the vital and, in the Antique sense of the word, unified world as it was seen by this universal artist. In 1622, Rubens had received a commission to decorate the gallery in the newly constructed Palais du Luxembourg in Paris. The theme of the twenty-one paintings which make up the cycle was the highlights of the life of the Queen: her birth and education in Florence; her journey to her royal bridegroom, the King of France, whose tragic death by a rebel's dagger cast the first shadow upon her life; her regency for her son (from whom she had to flee after he had ascended the throne); and the reconciliation—all are included in the cycle, which concludes with a great apotheosis of the Queen.

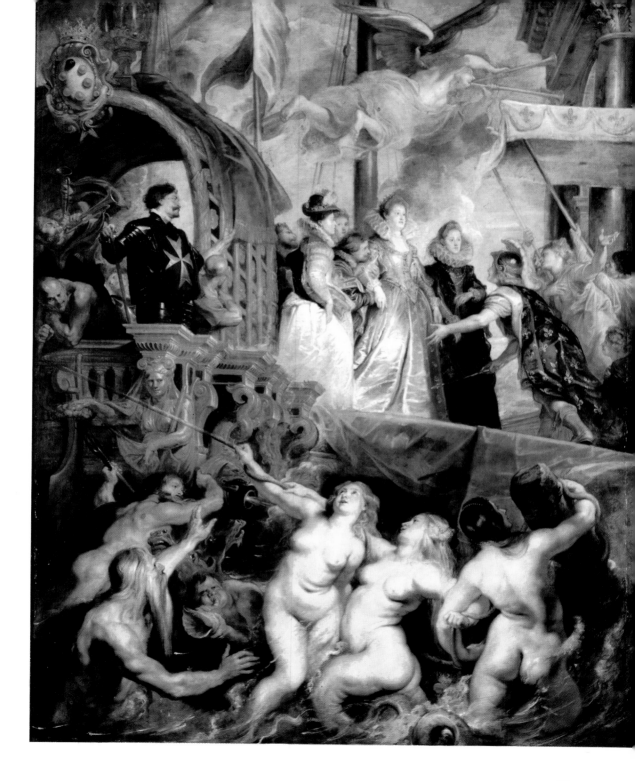

ANTOON VAN DYCK (1599–1641). *Susanna and the Elders*. c. 1622. Oil on canvas, 76³/₈ × 56¹/₂″. Alte Pinakothek, Munich

Rubens' most important pupil was Antoon van Dyck, who came from a wealthy Antwerp merchant family. At sixteen, he already had his own workshop, but in 1617 he became an assistant once more—in Rubens' studio. The following year he became a Master of the Guild of St. Luke. As an accomplished master, he worked quite often in the workshop of his great teacher; one can distinctly see his hand in some of the latter's paintings. Despite the sincere friendship that bound him to the vital and scintillating Rubens, Van Dyck was a very different kind of person, a fact that is also obvious in his work. The mood in most of his paintings is more delicate, more restrained. The contrast between light and shade comes to the fore again; the intermediate hues become prominent; there is a different feeling for the human body, a different relationship between clothes and flesh color. Even in a painting like *Susanna and the Elders*, where the old man rushing out of the bushes, with his cloak blowing dramatically about him, is still emphasized in the manner of Rubens—even here one can see, in Susanna's naked limbs and the rust-red velvet, the artist's completely different approach to his subject. The body is no longer determined by its shimmering surface, as in the famous mother-of-pearl tones of Rubens; it is represented as bodily substance and sharply contrasted with the darkness of the crumpled velvet.

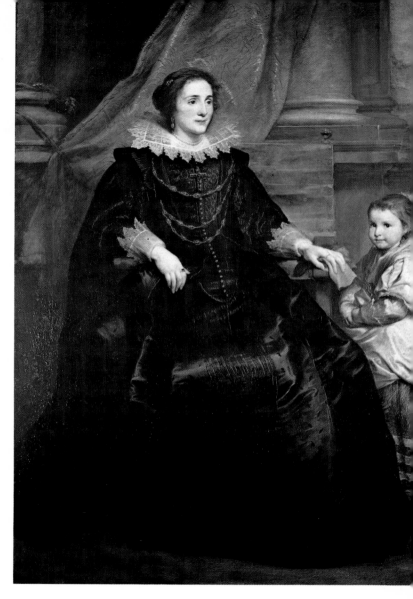

VAN DYCK. *Portrait of a Lady with Her Daughter.*
c. 1627–32. Oil on canvas, 80¹/₄ × 53¹/₈″. The
Louvre, Paris

Apart from his religious paintings, it was Van Dyck's portraits, especially, that won him international fame. Twice he was summoned to England, first in 1620, and then, after a trip to Italy and a brief residence in Antwerp, again in 1632, this time as court painter to Charles I. Rubens, too, had been a court painter, to the Stadholder of the Southern Netherlands, yet he had never resided at the court— never even in the same city as his sovereign. Van Dyck lived in the courtly milieu. The King even let him build his own house in Blackfriars and a summer house in Eltham. Soon after his arrival, he was knighted. The courtly society idolized him, not least because of his good looks. His own courteous and adaptable nature gave him the ability to sense the personality of the person sitting for him. In this painting of a lady with a young girl, the pose states clearly that the woman is the child's mother, although she is gazing into the distance rather than at her daughter. The child's innocent face looks out of the picture with a calm unself-consciousness. This work displays a mastery of portraiture that can only be compared with the work of Velázquez, where human and individual qualities also break through the formality of the composition.

Toward the end of his life, Van Dyck's star faded. Courtly life in England had made him arrogant and presumptuous. When, in 1640, he hurried to Antwerp immediately after the death of Rubens to claim his place as leader of the Flemish painters, he was received coolly, even repulsed. He returned to England and died shortly afterward. He is buried in St. Paul's Cathedral in London.

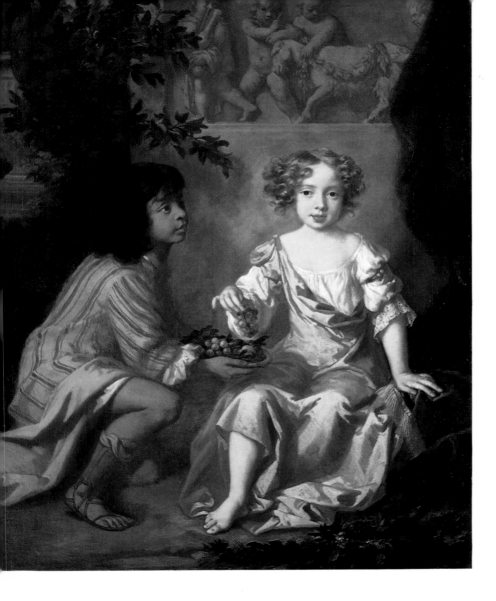

Sir Peter Lely (Pieter van der Faes) (1618–80). *Lady Barbara Fitzroy* (born 1672). Oil on canvas, 48³/₈ × 38⁵/₈″. City Art Gallery, York

Long after the death of Van Dyck, English painting continued to be influenced by his sensitivity and elegance. Sir Peter Lely, a foreigner like Van Dyck— he was born in Soest, Germany, to a Dutch family, and studied in Holland— became court painter to Charles II in 1661, after the Restoration of the English monarchy. Lely, whose real name was Pieter van der Faes, was primarily a portrait painter. His fame in English society during his lifetime almost exceeded that of Van Dyck. During his early period, which was somewhat dull in style, his paintings had a certain bourgeois quality that can also be seen in his portraits of the royal family, but his style became more refined as he grew older. There appear a delicacy of color and overrefinement of gesture that hint at the facile quality of painting in the century to come. In this picture of the tiny Lady Barbara Fitzroy, the young lady's small form has a delicacy that is sharply contrasted with the dark, humble, almost animal-like servant. The scene has a bucolic atmosphere, and not only because of the child's casual dress and her gesture with the grapes; the classical relief with the dallying putti and the he-goat in the background also contributes to the feeling of a landscape of Antiquity. Yet all this remains, as in the later Rococo, within a courtly and elegant world.

FRANS HALS (c. 1580–1666).
Boy Holding a Flute. c. 1625.
Oil on canvas, $24^3/_8 \times 21^1/_2''$.
State Museums, Berlin (West)

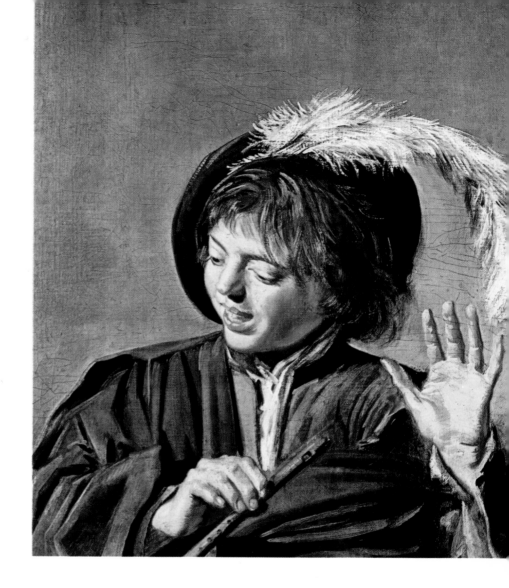

Frans Hals was quite un-like Lely. His family came from Mechelen (Malines) in the Southern Provinces of the Netherlands. His father, a cloth maker, emigrated to the United Provinces, settling in Haarlem. It is not certain when Frans was born, but he is thought to have been about eighty-six when he died, in 1666. More important than the date of his birth, however, is that Flemish blood flowed in his veins, that one of the greatest masters of the northern Netherlands was Flemish by temperament. It is often said that the Flemish painters preferred lively action, while the Dutch, on the other hand, chose to paint peaceful domestic situations. Such generalizations about the art of an entire country can only be true in the most superficial sense, yet an unaccustomed vigor and immediacy does first appear in Dutch painting in the work of Frans Hals—qualities one may well ascribe to his Flemish origin. What makes his work unusual for the time is his bold realism and freedom from the conventions of portraiture; he does not hesitate to depict ugliness. Here, in his portrait of a boy with a flute, Hals has chosen a model who has been endowed by nature with all the charms of youth and vitality. The paint is applied with a coarse brush; the discontinuous strokes of color are harshly juxtaposed. The informal, sketchlike quality of Hals's paintings is a further indication of his unfettered temperament and is especially prominent in his genre pictures—portraits of young people singing and making music, or of drinkers and gypsies.

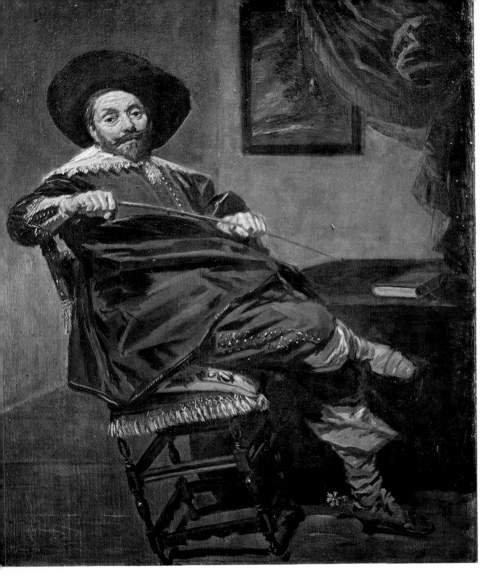

ADRIAEN BROUWER (1605–1638). ▶
Hearing. c. 1630. Oil on wood, $9^5/_8 \times 7^3/_4''$. Alte Pinakothek, Munich

HALS. *Portrait of Willem van Heythuyzen.* c. 1637–39. Oil on wood, $18^1/_2 \times 14^5/_8''$. Musées Royaux des Beaux-Arts, Brussels

Not only in his paintings of simple people, but in his portrait of the prosperous merchant Willem van Heythuyzen as well, it is obvious that Frans Hals prefers to catch the essence of a moment rather than to represent a static condition. The chair that is precariously tipped back; the leg that is casually thrown over the other, but which, in the next moment, must be put to the floor in order to preserve the gentleman's balance— here, expressed in its own individual fashion, is one of the most fundamental features of the Baroque: movement, the instantaneous and transitory element. The men and women whom Hals painted can be compared in their vitality with the figures of Rubens, more exuberant than life itself—only the world in which they live is different. Rubens' pictures are filled with radiant colors and joyful life; with Hals, black, gray, olive green, and an occasional strong red or blue are the dominant hues. The difference in color is related to a difference in the way people are portrayed; in spite of all the merry high spirits of Hals's figures, they seem gloomy and overshadowed by a feeling of melancholy in comparison with those of Rubens.

Like Frans Hals, Adriaen Brouwer came from the Southern Netherlands. In his case, it is known for certain that he was born there and came to Haarlem via Antwerp. In Haarlem, he met Hals and adopted his keen realism. Far from idealizing the peasants he painted, he showed them with all their shortcomings, often ugly, distorted almost to the point of caricature. Yet his paintings of everyday life are not merely genre scenes; as was the fashion then, their content is usually allegorical, such as representations of the five senses or of the four elements. Individual paintings are thus frequently grouped together into small cycles.

DAVID TENIERS THE YOUNGER (1610–90). *The Temptation of Saint Anthony*. c. 1640–50. Oil on canvas, 31$^1/_8$ × 43$^1/_4$″. The Prado, Madrid

David Teniers the Younger, like Brouwer, initially became famous for his scenes of country folk, but his nature was entirely different from that of his contemporary. His subjects are more sympathetic, his choice of colors more elegant. The temptation of St. Anthony was a popular theme among artists of the period, for it gave the artist a chance to introduce seductive elements into his work, and to combine them with demonic apparitions. In Teniers' version of the story, the saint's cave is peopled with weird monsters of the sort that have appeared again and again in Dutch painting since the time of Hieronymus Bosch. The Devil, in the guise of an elegant cavalier, enters with the beautiful seductress. Teniers worked first in his native city, Antwerp, where he came in close contact with Rubens. In spite of the very different kinds of subjects chosen by the two artists, and although their entire outlook was dissimilar, one can often detect in Teniers' use of color the influence of the great master.

In 1651, Teniers became court painter to the Stadholder of the Southern Netherlands, moved to the court, and lived for the rest of his life in Brussels. The Archduke treasured him not only as a painter; he considered him a connoisseur and appointed him curator of his important collection. Teniers made, in effect, an inventory of these treasures by copying them with the utmost accuracy in his "gallery pictures." In this way, he could put to good use his ability to copy the works of other masters—something he had often done in his youth in order to earn money. Almost every painting in the collection, hung in rows one above the other, can be identified. Today these "gallery pictures" serve as authentic evidence for the origin of famous paintings that now hang in such diverse places as Vienna, Munich, or Madrid. But their art-historical value is not all that these paintings have to recommend them; they give us a glimpse into the world of the princely art collector, the patron, who invested his wealth in works of art that even then, to some extent, had achieved world recognition. There is none of the cold atmosphere of a museum here; on the table can be clearly seen sketches or engravings which are being examined. This is the world of the connoisseur who has a genuine appreciation of his possessions.

TENIERS THE YOUNGER. *Archduke Leopold Wilhelm's Picture Gallery in Brussels.* After 1651. Oil on canvas, $48^3/_8 \times 64^1/_8$". Kunsthistorisches Museum, Vienna

REMBRANDT HARMENSZ. VAN RIJN (1609–69). *Self-Portrait.* c. 1629. Pen-and-wash drawing on paper, 5 × 3³/₄″. British Museum, London

Rembrandt was the greatest paint-er of the northern Netherlands; his work was characteristically Dutch, but he far outgrew the art of his native land. By Dutch painting one understands the careful presentation of tranquil domestic scenes, with a variety of artists specializing in a single aspect of the art—genre scenes, landscapes, or architectural studies. All these subjects appear in Rembrandt's work, but as part of a unified cosmic vision that transcends any mere specialty. Rembrandt's constant theme is man, deeply suffering or rejoicing, man who may keep his feelings entirely to himself or who may direct a searching glance outward at the world. And since man can best understand and probe his own emotions, a series of self-portraits extends throughout Rembrandt's life. He represented him-self more frequently than any other great painter. A pen-and-wash sketch of the artist at twenty-two, impetuously set down as though he were alarmed at his own appearance, is already indicative of the power of his self-criticism. The features are almost those of a boy, although Rembrandt was already a successful master and was employing his first journeymen. Born in Leiden, the son of a miller, he was encouraged to move to Amsterdam around 1632, after study in his native city and his first successes there. In Amsterdam, he married

REMBRANDT. *Self-Portrait as Democritus.* c. 1668. Oil on canvas, 32¼ × 25⅝". Wallraf-Richartz Museum, Cologne

the wealthy daughter of the patrician house of Van Uylenburgh, his beloved Saskia. His fortune seemed assured; he acquired a house, surrounded himself with art treasures, and became the most highly esteemed painter in the city. But in 1642, his adored wife died, leaving him a year-old son, Titus. Not only his personal life fell apart; his greatest work, the so-called *Night Watch*, failed to please because it was too unusual in conception. He was so far in debt that he was almost sent to prison. His possessions, including his collection of paintings, were auctioned. His faithful companion, Hendrickje Stoffels, cared for him and his son, and saved him from the worst by setting up an art-dealing business with Titus, to which Rembrandt was to give everything he produced in exchange for bed and board. But the old man became more and more cut off from society. Hendrickje died in 1662, Titus in 1668. Rembrandt himself died in 1669. Around 1667–68, he painted himself, ostensibly as an old philosopher, rich in experience and wisdom, who could smile serenely at the strokes of fate. Yet, in the coarse brushwork of the features, there is a trembling quality that faintly suggests the madness of Lear, whom the unmerciful battering of fate causes to lose his reason.

REMBRANDT. *The Holy Family with Angels.* 1645. Oil on canvas, 46¹/₈ × 35⁷/₈″. The Hermitage, Leningrad

REMBRANDT. *The Resurrection.* 1639. Oil on canvas, transferred to wood, 36³/₄ × 27″. Alte Pinakothek, Munich

When Rembrandt painted Biblical scenes, he did not clothe his figures in showy attire as the early Dutch painters had done, making their pictures almost like representations of court ceremonies; he almost always set the scene in a wholly familiar, everyday atmosphere and used the faces of ordinary men as models. Were it not for the choir of angels that breaks into the scene from above, one would hardly know that this family group in a carpenter's workshop is supposed to represent the Holy Family. In this way, Rembrandt made the Biblical story meaningful to men of his own time. The viewer is meant to identify himself with this event of long ago in order to have a real understanding of what took place. He must love the child with Mary, suffer with Christ—and not, as in the early Dutch paintings, merely gaze reverently as the story unfolds in a splendid, courtly milieu.

Superficially, Rembrandt's chiaroscuro would seem to be derived from Caravaggio (see pages 30, 31). Rembrandt's teacher, Pieter Lastman, had been in Italy and had assimilated the Italian influence in his own way. Rembrandt distinguishes himself from all other "Caravaggists" in Holland, however, through the spirituality with which he endows the contrast between light and dark. There is seldom a definite source of light in his pictures, as there is, for example, in Honthorst's candlelight paintings (see page 36). Often Rembrandt's light descends like a bolt of lightning from heaven, as a sign of God's intervention in earthly affairs. Here, in this painting of the Resurrection, the brightness does not radiate from the angel, but surrounds his ethereal body as a heavenly aura. As the Resurrected Christ slowly awakes to an unearthly, spiritual life, He rises as a body of light from the tomb.

REMBRANDT. *The Return of the Prodigal Son.* c. 1669. Oil on canvas, 8′ 7¹/₈″ × 6′ 8³/₄″. The Hermitage, Leningrad

REMBRANDT. *The Parting of David and Jonathan.* 1642. Oil on wood, 28³/₄ × 24¹/₄″. The Hermitage, Leningrad

Very frequently, Rembrandt's real theme is not whatever happens to be taking place in the external world, but the emotional relationship between men. Particularly in the nineteenth century, he was often called "the painter of inwardness." To a twentieth-century person such a phrase may easily sound sentimental, but it does capture an essential feature of Rembrandt's art. Man's inner life is more important than the "story." In this painting, the real subject is not the dramatic event of David's escape from Saul, but the grief that both David and Saul's son Jonathan feel over the separation. The gestures and poses of both men express strong emotion and raise the Biblical story to the level of a universally valid human situation.

In *The Return of the Prodigal Son*, a very late work of Rembrandt's, spiritual depth and profound emotion reach their highest intensity through the solemnity of the representation. Not only the father and son, but also the servants who are standing nearby, appear to be absorbed in their thoughts, entirely engrossed in the event. The divine grace that forgives the repentant sinner is depicted by Rembrandt in this interpretation of the parable of the Prodigal Son in a deeply moving and powerfully human way.

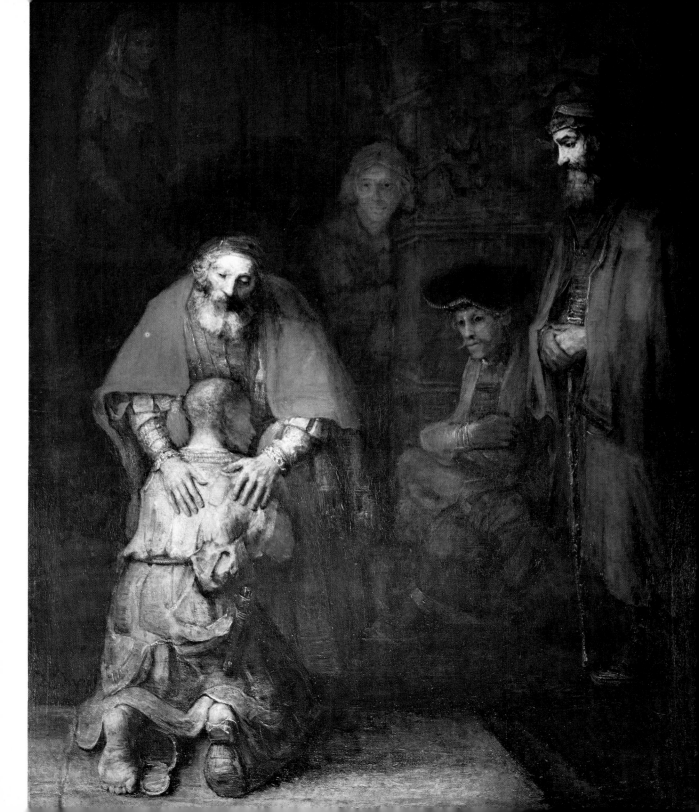

Rembrandt seldom painted mythological subjects. He was, of course, familiar with the legends of Antiquity; as a boy he had had seven years of humanist education and, since his parents had originally intended him to be a scholar, had enrolled at Leiden University before he came to be apprenticed to the painter Jacob Isaacsz. van Swanenburgh. Purely secular themes or Biblical stories were, however, far more attractive to him than the myths of Antiquity. When he did choose mythological themes, he generally composed them quite willfully and, like many other Dutch painters, broke the iconographical tradition that had been transmitted to the North from Italy. Danaë is not shown here, as was the usual practice, at the moment in which she is visited by Zeus in the form of a golden shower. Rather, we see the moment before the god's appearance, which she awaits with longing and expectation. Here, too, the human situation, the attitude of anticipation, seems to interest Rembrandt far more than the actual myth. Only the tiny cupid who appears in the ornament of the canopy above the bed assures us that this is truly a representation of a scene from classical mythology.

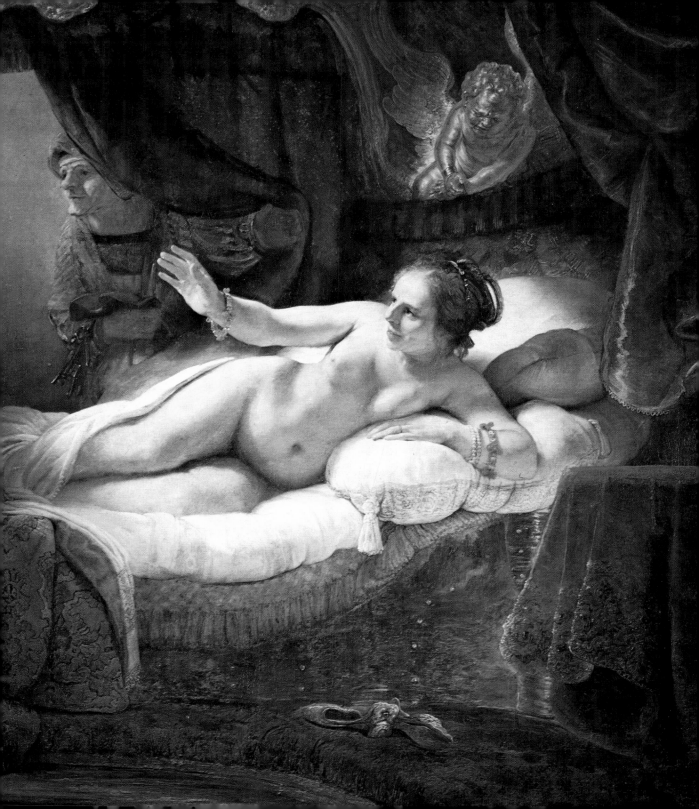

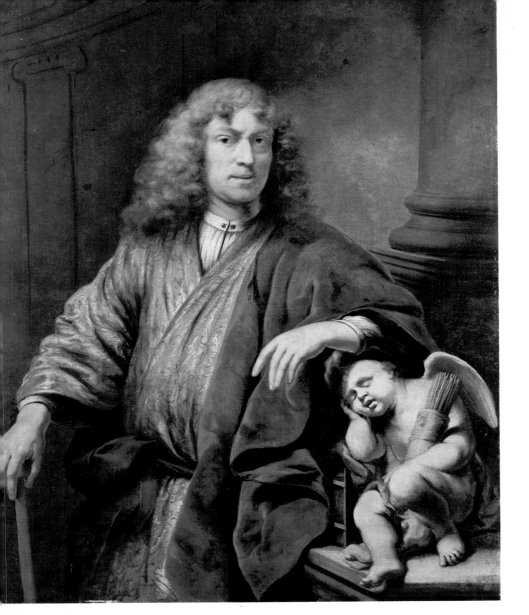

BOL. *Self-Portrait* (?). Oil on canvas, 50³/₈ × 41″. Rijksmuseum, Amsterdam

In his early period, Rembrandt had a whole series of students, some of whom imitated his coloring and use of light astonishingly well. Later, of course, as his fortunes ebbed, there was no further mention of such a studio. Ferdinand Bol came into Rembrandt's workshop shortly after the latter's move to Amsterdam. He was known primarily as a portrait painter and was so popular that he could afford to settle in the most fashionable quarter of Amsterdam. At first, he followed his admired master's example so closely that some of his paintings were thought to be by Rembrandt. Later, with his increasing success, his style became more superficial, more pompous, more flattering. We have already seen one example of his work in the portrait of Artus Quellin the Elder (see page 91). Bol had come in close contact with Quellin during work on the Amsterdam Town Hall, for which, like Rembrandt, he had been commissioned to produce the paintings that were an essential part of the decoration of the new official building.

CAREL FABRITIUS (1622–54). *The Goldfinch.* 1654. Oil on wood, 13¹/₄ × 8⁷/₈″. Maurits-huis, The Hague

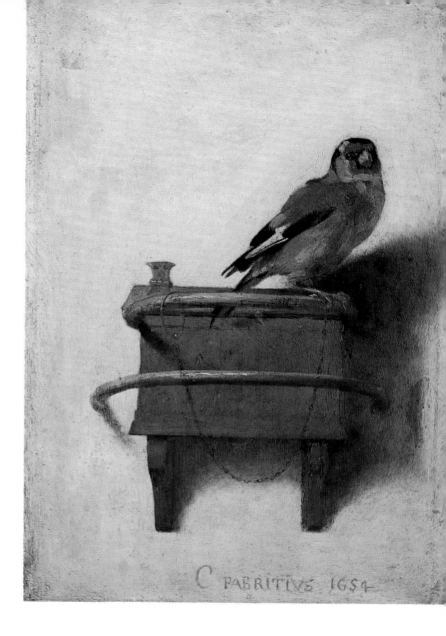

Another pupil of Rembrandt's, Carel Fabritius, was in the master's studio at the beginning of the 1640s, and therefore experienced at first hand the catastrophes that so decisively altered the life of his teacher. As far as his style is concerned, Fabritius had cut himself off from Rembrandt early; in his paintings, as in this picture of a captive goldfinch, for instance, the dark background that was so vital to Rembrandt has completely vanished. Rembrandt's mysterious, mystical light no longer surrounds and transforms objects. A uniform brightness fills the picture area and, as a complete reversal of Rembrandt's style, dark figures and objects appear against a light background. This method seems coolly realistic, yet in the tranquillity of Fabritius' pictures there is a poetic quality that gives small objects in particular a captivating charm. Fabritius died young; he was killed in the explosion of a powder magazine at Delft at the age of thirty-two.

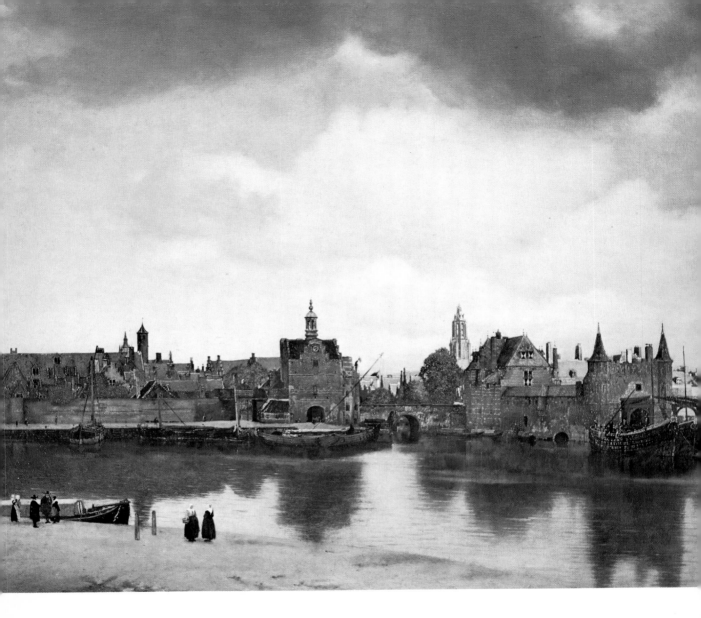

It is only comparatively recently that Jan Vermeer van Delft has been recognized as one of the greatest Dutch masters of the seventeenth century. In his own day, he was hardly ever mentioned; and for about two centuries after his death he was considered just one painter among many, until, with the growth of Impressionism in France, he finally achieved fame. The tranquil and concentrated light that surrounds objects and awakens their surfaces to an intense, vibrant life—that was the quality in his paintings that allowed those whose eyes were conditioned by the Impressionist paintings of the late nineteenth century to discover Vermeer's extraordinary ability. He did not paint many pictures out of doors; most of his works were interiors. At first glance, in his *View of Delft*, he seems to have reproduced every tiny feature of the houses, gates, and bridges of his native city with minute exactitude. The work seems to be nothing more than an exact topographical

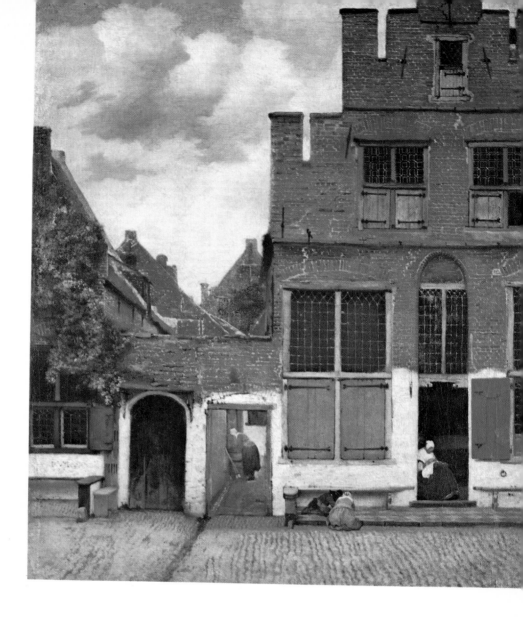

JAN VERMEER VAN DELFT (1632–75). *View of Delft* (looking across the Rotterdam Canal). c. 1658. Oil on canvas, 38⁷/₈ × 46³/₈″. Mauritshuis, The Hague

VERMEER. *A Street in Delft*. c. 1658. Oil on canvas, 21³/₈ × 17³/₈″. Rijksmuseum, Amsterdam

illustration—and yet it is far more. Just as a portrait is not merely the reproduction of a person's physical appearance but, if it is a good portrait, an attempt to illuminate his inner nature, so Vermeer does not simply record details; through the lighting, the reflections in the water, and the interplay of sunlit or shadowy areas, he endows the scene with so much restrained feeling that the very essence of Delft—where he was born, lived, and died—seems to have been made palpable. Much has been written about the "pointillism" of his short, soft brush strokes—on the walls of the houses, for instance, or on the hull of the ship. In fact, Vermeer's method of applying these points of light is totally different from the way in which painters of the late nineteenth century used their small spots of color; but the effect, in the end, is similar: the air seems to have a soft vibrance and the scene, despite all its serenity, is full of life and atmosphere. The people who chat quietly or do their work, like the woman sewing in the doorway open to the street, are absorbed into the tranquil mood. They are not actors in a drama; they are part of a world in which stones, trees, and human beings are self-contained and all within a harmonious order.

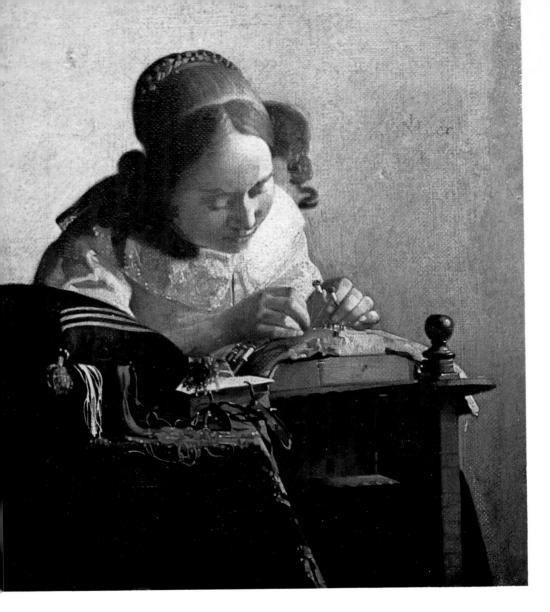

VERMEER. *A Woman Drinking with a Man*. c. 1665. Oil on canvas, 25⁵/₈ × 30¹/₄″. State Museums, Berlin (West) ▶

VERMEER. *The Lace Maker*. c. 1664. Oil on canvas, 9¹/₂ × 8¹/₄″. The Louvre, Paris

Even in interiors, where light cannot envelop objects as it can out of doors, but must be conducted through a window or from some other source, Vermeer succeeded in representing figures and objects as though surrounded by a luminous atmosphere. He did so through an extremely refined technique of coloring: he made the light from the window reflect off the opposite wall, which almost always remains indistinct thereby lightening the shadows so much that they simply become darker tones of the colors in those parts of the painting on which the light falls. Here, too, one is reminded of the colored shadows of the Impressionists, or of the color theory worked out by late nineteenth-century French artists.

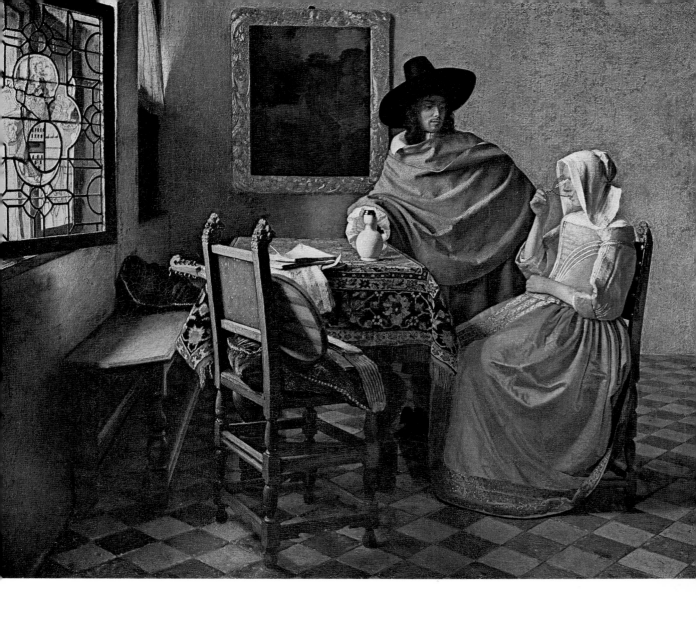

Vermeer's light, which plays about his figures and produces an incomparable luster on the surface of silken fabrics, creates an atmosphere of harmonious peace that envelops human beings as well as objects. In these interiors, no "scene" or action is being represented. The quiet fellowship of two people, or the appearance of a young woman bending over her work in deep concentration—these are not brief, fleeting moments captured by the artist's brush. The essence of Dutch painting is often defined as the representation of enduring situations, in contrast to the lively scenes of action produced by the Flemish masters. In this sense, Vermeer could be called the Dutch painter par excellence.

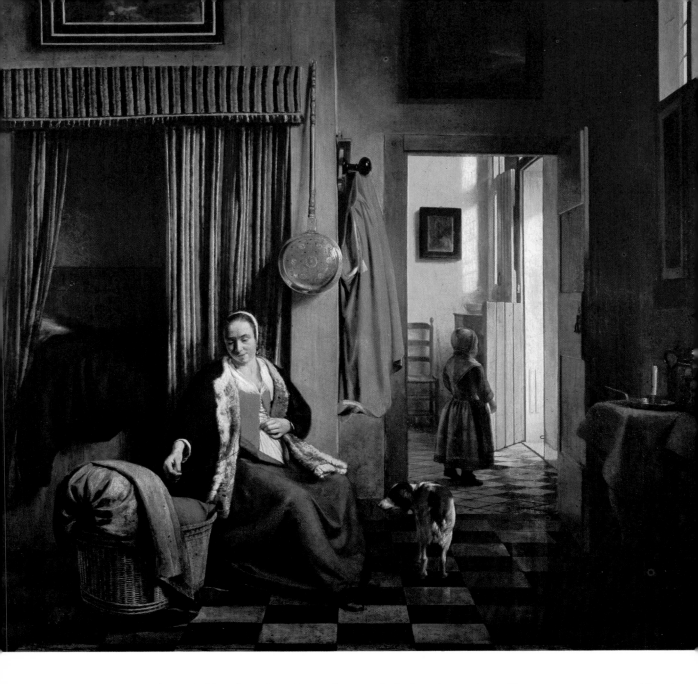

Like Vermeer, Pieter de Hooch preferred to paint people in interior settings. Here, too, are scenes without any special significance—peaceful representations of bourgeois life. Above all, the routine of the housewife is lovingly depicted in innumerable variations: the mother at her child's cradle, the mistress of the house as she tells the maid what to buy at market—these are subjects that appear again and again in the paintings of Pieter de Hooch. Usually there is not—as in Vermeer's work—a single room uniformly flooded with light;

PIETER DE HOOCH (1629–c. 1684). *Mother beside a Cradle.* c. 1659–60. Oil on canvas, 36¼ × 39⅜″. State Museums, Berlin (West)

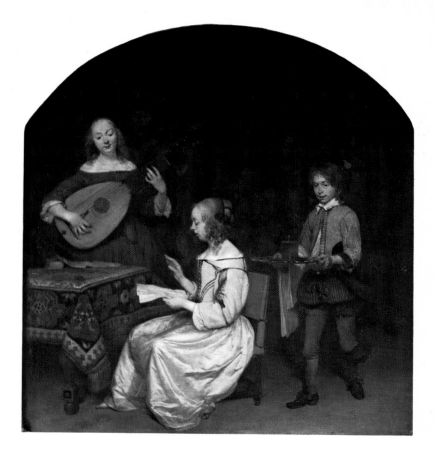

GERARD TER BORCH (1617–81). *The Concert.* c. 1657. Oil on wood, 18½ × 16⅞″. The Louvre, Paris

de Hooch complicates the rendering of light by painting a view through the main room into anterooms or alcoves, with figures distributed throughout the various rooms. Because of the elaborate spatial construction, the warm color tones are constantly interrupted. This makes de Hooch's pictures more intimate—one could almost say, more human—than those interiors of Vermeer that are coolly illuminated by a magic abundance of light.

Pieter de Hooch and Vermeer were both members of the Guild of St. Luke in Delft, but Gerard ter Borch lived in the small town of Deventer—that is, outside the great artistic centers of Holland. He traveled extensively, however, and knew not only Italy and France, but Spain and England as well. Something of this worldliness is unmistakable in his pictures. His subjects are not exactly taken from the nobility, yet they seem too elegant to be bourgeois. Most of them are expensively dressed. Silken materials, with their subdued sheen, or velvet and fur inspired Ter Borch to create the most subtle nuances with the most refined handling of color. Many times he chose as his subject a small group of people playing musical instruments or singing together. Yet, these all had more of the *conversation galante* than of any absorption in music. It was a merry world, but one portrayed with dignity.

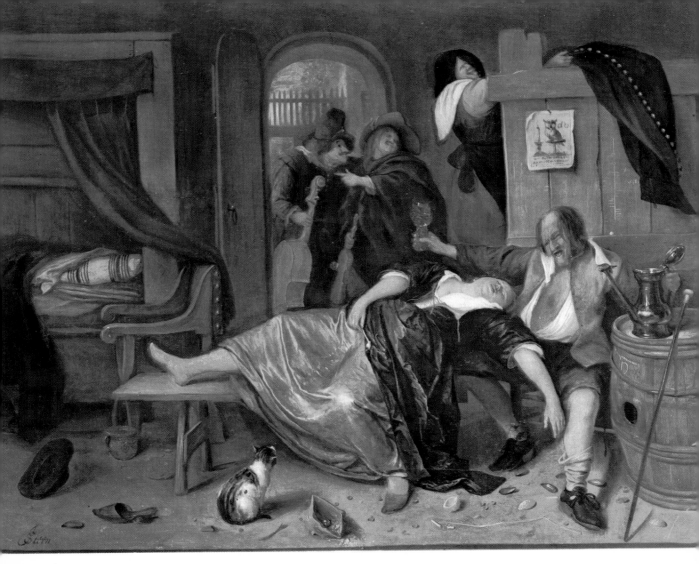

JAN STEEN (1625/26–79). *After the Drinking Bout.* c. 1661–70. Oil on oak wood, 20³/₄ × 25¹/₄″. Rijksmuseum, Amsterdam

An entirely different world bursts forth from Jan Steen's *After the Drinking Bout.* He had a temperament similar to that of Adriaen Brouwer, but Steen's drinkers were simple city folk rather than peasants. Steen was the great humorist among Dutch painters who exposed a situation by exaggerating its grotesque elements. He was an educated man who had been enrolled, at least for a time, at the University of Leiden. Allegorical allusions abound in his work, clarifying or emphasizing the content of the paintings. Here it is the owl, the bird of drunkenness, which appears on a sheet of paper tacked to the wall. Jan Steen was also a brewer and tavern keeper; thus he was in an ideal situation to make studies for his numerous paintings of inns and, with the ironic detachment of sobriety, to portray with humor the grotesque antics of drunken men.

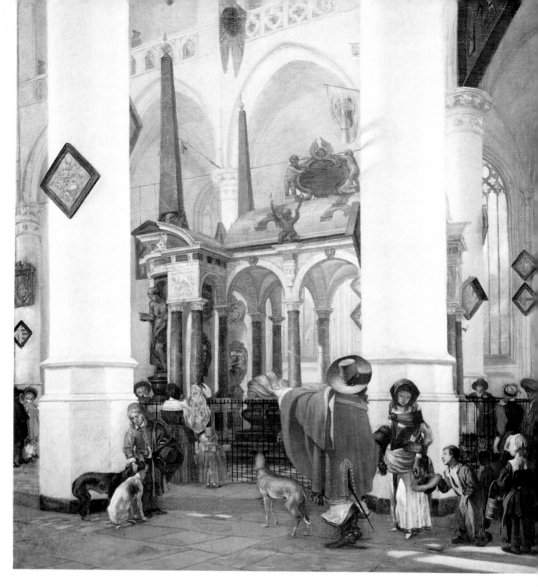

EMANUEL DE WITTE
(1616/18–92). *The Nieuwe
Kerk, Delft* (looking toward the tomb of William of Orange). 1656.
Oil on canvas, 38$\frac{1}{8}$ ×
33$\frac{1}{2}$". Palais des Beaux-Arts, Lille

Architectural representations had a long tradition in the Netherlands. In the first half of the fifteenth century, the brothers Van Eyck did studies of church interiors. However, if at that time there should be a Madonna standing in the middle of a Gothic cathedral, such a scene was still to be interpreted entirely in the medieval sense as an allegory of the Heavenly Jerusalem and of the church as God's Earthly Kingdom. Such complicated allusions were far from the thoughts of seventeenth-century Dutch painters when they chose to represent a church interior. Emanuel de Witte painted the Nieuwe Kerk in Delft as a faithful study of the existing building. Yet he departed from the minute, as it were purely topographical, reproduction of reality that was customary among many of his contemporaries, and, by breaking up the areas of light and presenting complicated views, created a cool, but at the same time poetic, atmosphere. Human figures are important in his paintings as a means of giving an idea of the size of the buildings and as a device for creating depth of perspective through the gradations of color in their clothing.

HERCULES SEGHERS (1589/90–after 1635). *Landscape with a Traveler.*
After 1631. Etching, 6 × 8⅛″. Rijksprentenkabinet, Amsterdam

Landscape occupies a prominent place in the rich variety of seventeenth-century Dutch painting. Until the Renaissance, landscape—man's earthly surroundings—was tolerated only as a background for saints or holy scenes. Medieval man did not consider this world as worthy to be represented, and thereby immortalized, unless as a symbol of Paradise. The Renaissance brought a change in attitudes. The world was recognized as a creation of God and was depicted in all its beauty—although it was still far from being represented as it was in the nineteenth century, as the artist's impression of a fleeting moment, done under brief, transitory lighting conditions, such as the Impressionists frequently painted. In the Renaissance, one did not paint out of doors, but took one's sketches home and composed a landscape in the studio. The scenes thus created were not pictures of particular landscapes; they were idealized representations of the world. Thus, Adam Elsheimer made a large grove into a showplace for mythological scenes (see page 23), or Jan Brueghel the

Elder made a forest into a likeness of Paradise (see page 96). Like them, Hercules Seghers seldom painted actual landscapes. Dramatic scenes of mountains and plains make up his panoramic views. Sunlight strikes certain spots, setting them in opposition to the dark, shadowed areas. Man has become very small, insignificant, scarcely visible. In Seghers' unique etchings (he experimented more with graphic techniques than any other artist of his time), man almost completely vanishes among the tangled, broken lines. The earthly landscape looks like the surface of the moon. Seghers used a peculiar, grainy stroke that made his etchings even more fantastic, since the completed surface permitted hardly any differentiation between rocks, plants, or grass. According to contemporary tradition, Seghers was a very melancholy man. This is very easy to believe when one looks at such works as the *Landscape with a Traveler*. Here, man is overwhelmed by his monstrous surroundings and stands, a defenseless creature, in the face of the menacing landscape. The traveler can scarcely manage to find his way through this jumble of rocks; the world, life itself, is a cruel threat to human existence. Dutch painting is frequently filled with allegorical allusions, whether in still lifes or in genre pictures; therefore such an interpretation of this etching is certainly permissible.

SEGHERS. *Landscape*. After 1631. Oil on wood, $21^5/_8 \times 39^3/_8$". Uffizi Gallery, Florence

Salomon van Ruysdael (1600/03–70). *River Landscape with Fishermen*. 1645. Oil on wood, 25^1/$_4$ × 36^1/$_2$″. Kunsthalle, Hamburg

While Hercules Seghers' landscapes are for the most part fantasies whose individual components are drawn from reality but which, taken as a whole, form an unreal, exaggerated world, the wide vistas in the paintings of Salomon van Ruysdael are, at the very least, very close to reality. Often they are *vedute* in the actual sense of the word—that is, portraits of particular cities. Ruysdael favored a diagonal scheme of composition, particularly in his river landscapes. The shoreline recedes obliquely into the distance, expressing the expanse of the Dutch plains with a calm lyricism. Strong vertical accents are used to counter the horizontals; for instance, in this painting, the group of trees, although they are loose and feathery, form a central point, joining the surface of the water to the sky. The humidity of the Dutch climate and the dusky atmosphere are rendered with the most refined nuances of color, lying like a poetic veil over the scene. Quietly occupied with fishing, man is also a part of the composition.

Jacob van Ruisdael, the nephew of Salomon (although he spelled his name differently), painted in a very different style from his uncle. Salomon's works are dominated by nature, which is represented as peaceful, with only inconspicuous activity. In Jacob's pictures, trees, water, and clouds become means of expressing the drama that takes place in nature—for instance, through the changes in cloud formations. Monumentality and tension characterize the painting. The powerful living oak which reaches high into the sky and almost touches the upper edge of the painting and the withered trunk which will soon fall into the water are objects that, by their contrast, seem to emphasize each other, even without considering the allusion to life and death.

JACOB VAN RUISDAEL (1628/29–82). *Oak Forest on a Lake with Water Lilies.* c. 1660. Oil on canvas, 44$^7/_8$ × 55$^1/_2$". State Museums, Berlin (West)

The real subject of *The Jewish Graveyard* is again the *vanitas* theme; the entire painting is a unique *memento mori*. The decaying graves, the ruins in the background, the withered tree, the water flowing between cracked sarcophagi—all this speaks of the transience of earthly things. The individual objects are elevated from the real world into a sphere of the universally valid, beyond the fate of any individual man—even beyond human life. Although these objects are taken from the world of men, they seem only to emphasize the ephemeral quality of this world. It is this aspect that appealed to nineteenth-century German Romantics, especially to Caspar David Friedrich with his drawings of cemeteries and ruined churches in the snow.

RUISDAEL. *The Jewish Graveyard.* c. 1654. Oil on canvas, 33¹/₈ × 37³/₈". State Picture Gallery, Dresden

HENDRIK AVERCAMP (1585–1634). *Winter Landscape.*
Oil on canvas, diameter 7¹/₄″. Kunsthalle, Hamburg

The winter scene was a specialty of Dutch landscape artists. In this picture by Hendrik Avercamp, however, the landscape—that is, the panorama of the city—plays a subordinate role. Like the winter scenes of Pieter Brueghel the Elder and Jan Brueghel the Elder, who depicted all kinds of merrymaking on the ice with loving exactitude, Avercamp shows a number of people enjoying themselves on a frozen canal near the city. The scene is bright and crisp; the activity of the many figures painted in strong, vibrant colors is a delight to look at.

JAN VAN GOYEN (1596–1656). *View of the City of Arnhem*. 1646.
Oil on canvas, 35³/₈ × 41³/₈″. State Museums, Berlin (West)

Another variation of the Dutch landscape is the sweeping, panoramic scene that contains a view of a city.
Jan van Goyen shows the vast Dutch plains spread out under a sky that fills almost two-thirds of the picture.
The city is embedded in the landscape; the towers provide the only vertical accents against the line of the
horizon. One's eye is not led obliquely into the depths of the picture; rather, the perspective of the plain itself
allows one to roam into seemingly endless space. It throws a significant light on the condition of the art trade
in Holland during the seventeenth century that even a master like Van Goyen was not only a painter, but also
a picture dealer and auctioneer and a speculator in tulip bulbs, land, and houses.

MEINDERT HOBBEMA (1638–1709). *The Ruins of the Castle of Brede-rode*. 1667. Oil on canvas, $32^1/_4 \times 41^3/_4''$. National Gallery, London

Meindert Hobbema was a pupil of Jacob van Ruisdael, but only at the beginning of his career did he follow the methods of his teacher; later, he freed himself entirely from Ruisdael's style. Above all, he avoided any enigmatic qualities or allegorical allusions. His landscapes are open, his trees feathery and light; they no longer have the monumental, often wild character of Ruisdael's work. In this late painting of the ruins of the Bre-derode castle, the ruin occupies the center of the picture, much as it does in Ruisdael's *The Jewish Graveyard*. But here it is not meant as a symbol of impermanence; it adds a romantic accent to the landscape without disturbing the prevailing cheerfulness. The water birds in the foreground emphasize the down-to-earth quality of the scene; because of this characteristic, the picture approaches genre painting. Hobbema, too, did not live from painting alone. In 1668, when he was about thirty, he married an employee of the mayor of Amsterdam and himself became an excise officer. From that time on, he seldom again took up his brush.

JAN HACKAERT (1628–99). *The Chase*. Oil on canvas, 39 × 47¹/₄″. National Gallery, London. The figures are attributed to Nicolaes Berchem (1620–83)

Of the many set pieces of Dutch painting, yet another is the hunting scene. Jan Hackaert was well-traveled; he had visited Switzerland and Italy, and had caught the beauty of the Umbrian landscape in many of his works. A little of the golden light of Italy can be felt in *The Chase*, even though the scene takes place in the damp, swampy forests of his native country. Hackaert draws the observer directly into the twilight area among the trees, whose branches reach to the very top of the picture, allowing the sky to be seen only as it shimmers through the delicate foliage. The hunters and animals are probably by Nicolaes Berchem, who had also spent several years in Italy, where he had specialized in painting different human types and country folk with animals. Later, he filled his own landscapes and those of other painters with whom he was friendly with lively figures.

HENDRIK CORNELISZ. VROOM (1566–1640). *The Naval Battle of Gibraltar, April 25, 1607*
(explosion of the Spanish flagship). Oil on canvas, 54$\frac{1}{8}$ × 74″. Rijksmuseum, Amsterdam

Hendrik Cornelisz. Vroom is known as the father of Dutch marine painting. Pictures of the sea, of storms, and of shipwrecks had, of course, been done before, but Vroom was the first to specialize in this subject. In his painting of the naval battle of Gibraltar in 1607, in which the Dutch admiral Jan van Heemskerk destroyed the Spanish fleet, the sea itself plays a minor role. The fighting ships, especially the exploding Spanish flagship with men and objects being hurled through the air, are depicted in minute detail, occupying almost the entire picture area. Vroom had traveled around Europe as a tapestry designer before finally settling in his native city, Haarlem, and becoming famous as a painter of marine scenes.

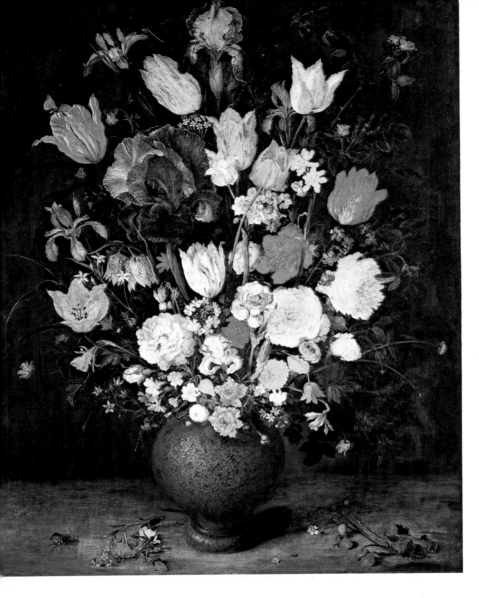

JAN BRUEGHEL THE ELDER (1568–1625). *Vase with Flowers*. First quarter of seventeenth century. Oil on oak wood, 25⅝ × 19¼". National Gallery, Prague

Dutch still life has a long tradition; even in the Biblical pictures of the early fifteenth-century painters, small, everyday objects like an open book, a vase of flowers, or fruit—often with some symbolic relationship to the sacred figures who were the subject of the painting—enlivened the scene and pointed toward the world of the Dutch bourgeoisie. In the seventeenth century, these objects, which had formerly constituted only a small detail of the picture, were raised to the status of subjects in themselves. The enjoyment of natural beauty—the fine details of a flower, the dull shimmer of light on birds' feathers or on the surface of dishes—gave rise to a new kind of picture that spread from the Netherlands throughout Europe. Most of these still lifes also have

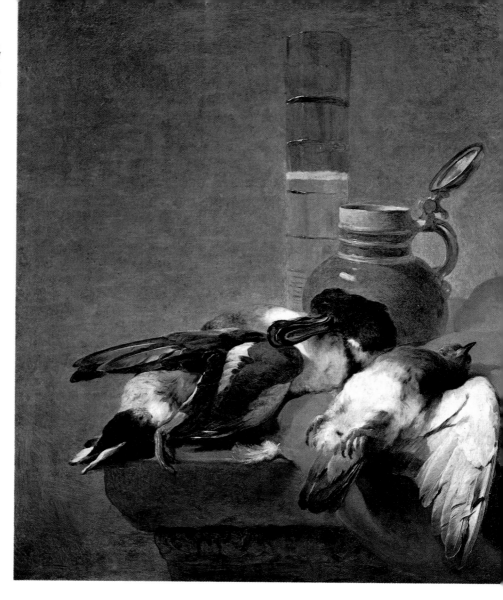

JAN BAPTIST WEENIX (1621–60?).
*Still Life with Dead Fowl, Jug, and
Glass.* c. 1650. Oil on canvas,
$26^1/_4 \times 21^5/_8$". Alte Pinakothek,
Munich

an allegorical meaning—usually the transience of all earthly things. A fallen tree, a dead animal, or an insect on a piece of paper were there to remind the onlooker of the unreliability of worldly fortune. The flower painting plays a very important role in the Netherlands. An anecdote tells of how this genre originated because a rich lady, unable to procure a particularly costly kind of flower that she wanted, asked an artist to paint her one. There is certainly a grain of truth in this story, since most floral studies were painted in order to preserve the splendor of a bouquet or the beauty of particular blossoms after the flowers themselves had wilted.

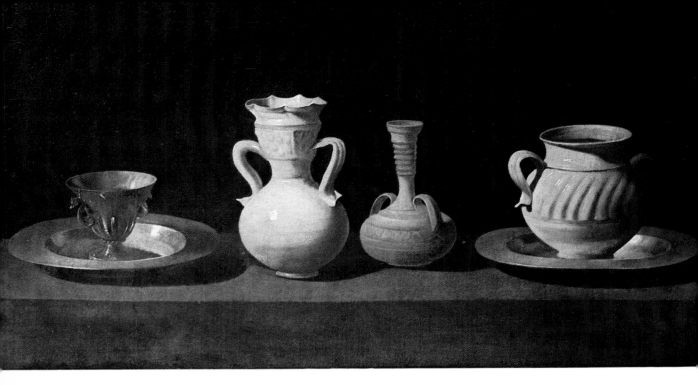

ZURBARÁN. *Still Life*. Oil on canvas, $18^{1}/_{8} \times 33^{1}/_{8}$". The Prado, Madrid

ADAM VAN VIANEN (c. 1569–1627). Silver ewer. c. 1620. Height $11^{3}/_{4}$". Rijksmuseum, ▶
Amsterdam

Willem Kalf was not so much interested in representing fruit as in studying the light that played on its surfaces, on the ornamented surface of the precious ewer, and on the richly decorated stand of the glass (facing page). The flowing decoration of the silver pitcher seems to form uncanny grimaces in which the secret life of objects is fascinatingly represented. This ornamentation, however exaggerated, was not a fantasy of the painter; a ewer by Adam van Vianen shows such similar forms that one can assume Kalf used an actual piece by the famous Dutch goldsmith as a model.

◀ Francisco de Zurbarán conceived his still lifes quite differently. Through Dutch influence, this kind of picture had also come into fashion in Spain. In contrast to the Northern artists, however, the great painter from Seville eliminated any sort of atmosphere from his work: the four vessels stand soberly on the table, their roundness defined by a strong light. They seem frozen into an almost stereometric composition, without any of the warm feeling for the surface of an object that made Dutch still lifes so enchanting.

WILLEM KALF (1619–93). *Still Life.* c. 1660. Oil on canvas, $28^{1}/_{4} \times 24^{3}/_{8}$". Rijksmuseum, Amsterdam

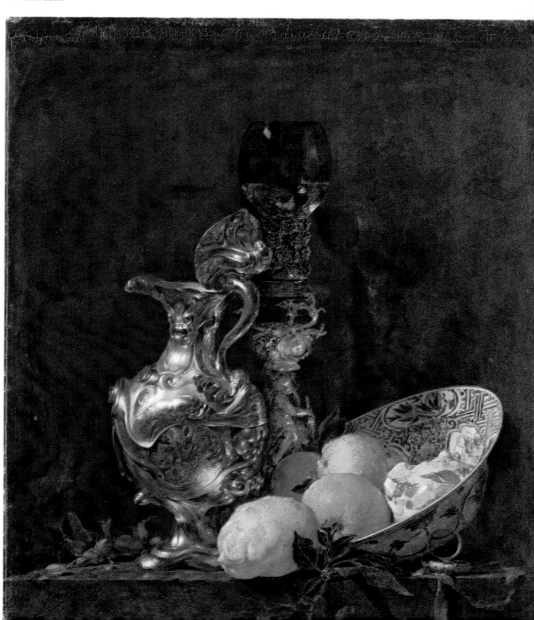

JACOPO CERUTI (active 1720–50). *Still Life with Crawfish*. Oil on canvas, 16⁷/₈ × 23¹/₄". Brera Gallery, Milan

Still life had an independent tradition in Italy. Earlier, Caravaggio had painted baskets of fruit in which the forms and surfaces of individual fruits were drawn with botanical exactitude. Northern influences were frequently incorporated into the Italian feeling for form. The Lombard Jacopo Ceruti painted his still life with crawfish, bread, and glassware very differently than a Dutch painter would have. Outline is dominant here, rather than the effects of light on the surface of objects. This picture evokes no sensual or tactile joy; there is none of the innate luster of objects that appears in Dutch still lifes. Two decanters are almost ominously pale against the dark background. The hard bread and sharply drawn crawfish do not suggest the pleasure of an enjoyable meal. They are simply objects that are viewed with detachment and set down as such on the canvas. While Ceruti does avoid the total sobriety of Zurbarán, he is nearer to the Spanish artist's concept of form than to the gleaming splendor of Kalf.

JEAN-BAPTISTE-SIMÉON CHARDIN (1699–1779). *The Ray*. 1728.
Oil on canvas, 44⁷/₈ × 57¹/₂″. The Louvre, Paris

A wholly new note is struck in *The Ray* by Jean-Baptiste-Siméon Chardin. In France, still life was ranked by the Academy as the least important category of painting. Respect for the genre was significantly increased because of Chardin. Although he had never been a student at the Academy, Chardin was immediately accepted for membership as a result of this picture, painted when he was twenty-nine years old. At first glance, Chardin seems to be working within the old Dutch tradition of the *vanitas* allegory. Yet he goes far beyond the concept of allegory: in this picture, the cruel law of nature—eat or be eaten—becomes a gruesome vision. The greed of the cat, which, with arched back, creeps up on the oysters like a beast of prey; the uncanny, almost human face of the mangled ray, which seems to cry out accusingly, demonically, against the cruelty of the world— these are no longer soberly registered objects within the immediate circle of man, tranquil and reassuring; they are symbols of the threatening forces that surround man or are latent in him.

PAUL FRANCKE (1537/38–1615). Church of St. Mary, Wolfenbüttel. North side. 1604–23

In Germany, artistic development in the Catholic south was being influenced by the Italian Baroque as early as the beginning of the seventeenth century, while in the Protestant north, Gothic traditions lingered—especially in architecture. At the very beginning of the seventeenth century, Duke Julius Heinrich of Brunswick-Wolfenbüttel had Paul Francke build the church of St. Mary in Wolfenbüttel, which was the seat of his court. This church is one of the most important Protestant architectural works of the period between the Reformation and the Thirty Years War. In general, it is modeled on Late Gothic hall-churches of the Netherlands and North Germany. The row of gables on the side and the windows with pointed arches are part of the Gothic heritage; but the style of the new era appears in the Corinthian columns and the cornices of these same gables. In the scrollwork ornamentation, one can see the influence of pattern books which were widely distributed in Germany at the end of the sixteenth and beginning of the seventeenth centuries. These were derived from the classical architectural theory of Vitruvius, but became fused with the overelaborate, complicated, interlaced ornamentation that represented a continuation of Late Gothic forms.

SANTINO SOLARI (1576–1646). Interior of Salzburg Cathedral. 1614–28

The most important religious building in southern Germany built before the Thirty Years War, Salzburg Cathedral, is not a mixture of styles like the church at Wolfenbüttel. After fire destroyed the old Romanesque building in 1602, Archbishop Wolf Dietrich von Raitenau first commissioned Vincenzo Scamozzi, who was then traveling through Salzburg, to design a new cathedral. Scamozzi's plan was rejected on account of its cost. In 1614, Wolf Dietrich's successor, Archbishop Marx Sittich, turned the construction of the new cathedral over to another Italian, Santino Solari, an architect from the Lugano region. It was thus that an early Italian Baroque building came to be erected on South German territory. It was to exert great influence on southern German architecture in the years to come.

LUDWIG MÜNSTERMANN (c. 1570/80–c. 1637/38). *Hercules.* First or second decade of the seventeenth century. Sandstone, height 53$\frac{1}{2}$". Focke Museum, Bremen

There were few sculptors of any importance in northern Germany in the period between the Reformation and the Thirty Years War. One of the greatest, but also one of the most idiosyncratic, was Ludwig Münstermann. Little is known about his life. He is known to have lived first in Bremen, later in Hamburg, but he worked chiefly in the small village churches of the Oldenburg district. The expressive power and spiritual intensity of his figures, however, raise him far above the rank of a local artist. One can still see the Gothic heritage in his elongated bodies, but the incorporeal figures of Mannerism also influenced his work. His sculpture has something of the sketchlike quality of the last, unfinished works of Michelangelo, although Münstermann, who had never been to Italy, certainly did not know these. He worked entirely within the tradition of his own region; his only contact with the major European artistic developments of the time was through pattern books. The deep melancholy, the skepticism about life, and the secluded quality of Northern mysticism seem once more to be concentrated in one man's work—Münstermann's—before the outbreak of the terrible Thirty Years War in Germany.

GEORG PETEL (1601/2–34). Salt-cellar. In relief: *The Triumph of Venus, with Triton and Three Nymphs.* c. 1627–28. Ivory, height 12⅝". Royal Palace, Stockholm

Georg Petel, the son of a Weilheim sculptor—that is, a native of the region that produced the most and best stuccoworkers and wood carvers in southern Germany—is the complete opposite of the North German master, Münstermann. Petel traveled to Italy, visiting Genoa and Rome, and worked for a time in the southern Netherlands. He was friendly with Rubens, and was deeply impressed by the latter's art with its expression of sensual joy. Later, Petel lived in Augsburg, where he died when still young. His early death deprived Germany of one of her most promising early Baroque sculptors. Petel worked in the most varied mediums, in large formats and small. One of his favorite materials was ivory, which he used primarily to make crucifixes. He also carved this soft, supple material into precious table pieces, like this salt-cellar, on which he depicts the triumph of Venus' birth from the sea in compact, voluptuous forms. It is very likely that Petel made this particular piece for Rubens himself; at any rate, it was definitely owned by Rubens and was brought to Stockholm by Queen Christina, who obtained it from the artist's estate. Thus, Catholic South Germany looked to Italy for sculptural as well as architectural inspiration, but could also draw upon work being done in the Catholic provinces of the Netherlands. Ideas from both areas were brought together to produce masterly pieces of sculpture.

HUBERT GERHARD (c. 1540/ ▶
50–1620). *Mars, Venus, and
Cupid,* for a fountain at
Schloss Kirchheim. c. 1585.
Bronze, height 80³/₄″. Bayerisches Nationalmuseum,
Munich

ELIAS HOLL (1573–1646). Town Hall, Augsburg. 1614–20. Rear façade

After the discovery of America, Augsburg had achieved enormous prosperity. The city's merchants had become active in world trade as soon as the overseas markets were opened. The Fugger and Welser families, for all practical purposes, ruled the city; but they were not exclusively preoccupied with money. For generations they had been art patrons on a princely scale, even when their wealth was no longer sufficient to assure them political power. At the end of the sixteenth century, Count Hans Fugger summoned Hubert Gerhard, a pupil of Giovanni Bologna, from Amsterdam to his Schloss Kirchheim, near Mindelheim, and gave him a commission for a fountain modeled after the great Italian examples. Gerhard's central group—Mars and Venus in a provocative embrace, with Cupid at their feet—introduced Italian sensuality and Dutch worldliness, such as was also characteristic of Rubens, into South German art.

At the beginning of the seventeenth century, the citizens of Augsburg decided to tear down their old, Gothic town hall and build a new one that would be an appropriate expression of the city's power and wealth. Elias Holl, a native of Augsburg, who had accompanied a rich merchant on a journey to Venice, where he had seen the buildings of Palladio and the Venetian palazzi, brilliantly translated his impressions into the German formal idiom. His Town Hall retains many Gothic features, such as the great stress on height, but it is not as if decoration in the new style had merely been imposed, as external ornamentation, upon a Gothic building. Without decoration, through the placement of windows that emphasizes the center, the building gives an impression of tranquillity, refinement, and strength. Shortly before the Thirty Years War, the spirit of the new Italian architecture was the stimulus for the creation of this impressive structure, with a character all its own, in an influential area of Germany.

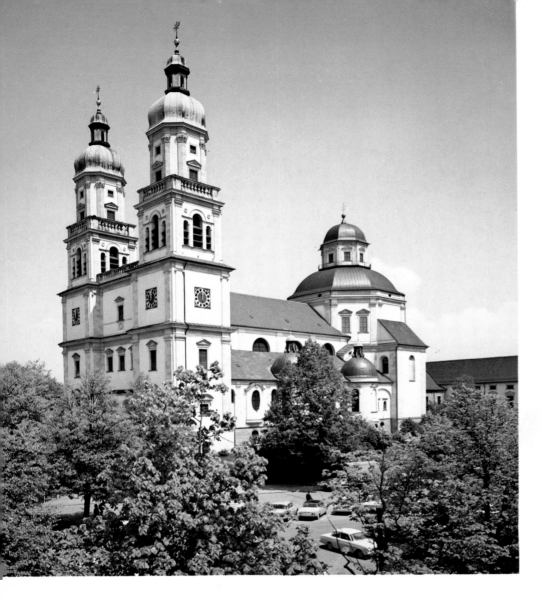

MICHAEL BEER (before 1611–66) and JOHANN SERRO (active 1640–70). Abbey Church of St. Lorenz (now Parish Church), Kempten. 1652 –66. Towers enlarged 1900

The thirty-year religious war almost completely extinguished artistic life in Germany. The armies had reached as far as the Alps and had razed the town of Kempten in Swabia, with its Benedictine monastery, St. Lorenz. Two years after the Peace of Westphalia, which brought an end to the war in 1648, pillaging bands of soldiers still swept through the Algäu. But in 1652, the enterprising Prince-Abbot Roman Giel von Gielsberg decided to rebuild the monastery and the abbey church. It was the first major new building to be constructed after the war in southern Germany. The Prince-Abbot was well-traveled, had often visited Rome, and knew the Italian Baroque churches very well from personal observation. He first called upon Michael Beer, a master from the Bregenz forest, and later Johann Serro from Neuburg on the Danube, but for the most part the church seems to have received its unusual character from the Prince-Abbot himself, who personally took part in its planning. The church, with its twin-towered façade, is impressively situated above a broad square, which can be reached

from the church by a large exterior staircase. Salzburg Cathedral, also designed at the beginning of the century by an Italian master builder, similarly has a twin-towered façade. In Kempten, however, the towers, placed close together, and the small central area are more reminiscent of a Romanesque church façade in Germany—an example of the way native feeling for form imposes itself upon foreign ideas. The church is composed of two unrelated parts: a nave with side aisles forms a sort of prelude to a high, octagonal, centrally planned building with a dome resting on four freestanding pillars. This area was for the monks, who were strictly segregated from the laity in the nave. The lower gallery of the dome is placed diagonally across the concluding arch of the nave in an entirely unorganic fashion. Seen from the outside, however, the building appears unified. The drum and the dome—especially after the neo-Baroque additions made in 1900—appear as a central cupola such as was often used in Italy and South Germany to emphasize the crossing and counterbalance the towers.

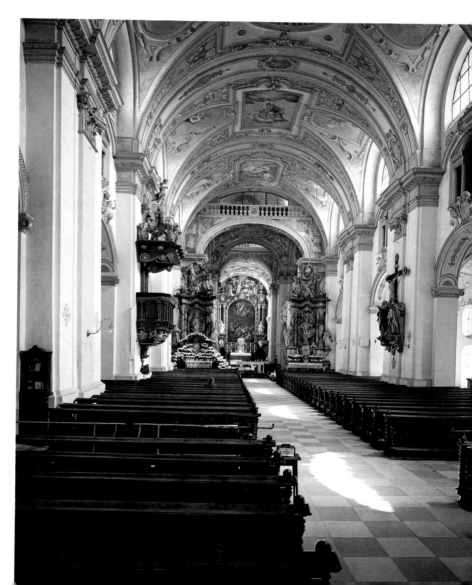

Abbey Church of St. Lorenz, Kempten. Interior, looking toward the chancel. Stuccowork by Zuccalli (see page 236)

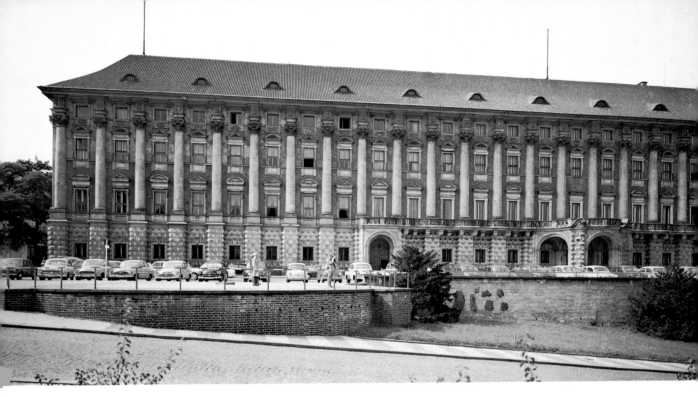

Francesco Caratti (d. 1679). Černín Palace, Prague. Begun 1667. Façade

In Bohemia, individual noble families that had fought on the side of the Emperor in the Thirty Years War had risen to positions of great political power. Full of self-confidence, Wallenstein, the commander of the imperial forces, had begun a palace in Prague in 1621—that is, in the middle of the war—that rivaled the imperial buildings in Vienna. After the war, other families emulated him. In 1666, Count Humprecht Hermann Černín, who had a distinguished career at the Viennese court behind him, acquired a building site on the Hradčany in Prague. In 1668, he commissioned Francesco Caratti from Bissone on Lake Lugano to build a town palace in the style of those in Rome, but on an even larger scale. Above all, he wanted it to be bigger than the residence of the Emperor, the so-called Leopold Range of the Vienna Hofburg, a building of imposing dimensions. His architect was thus encouraged to design a palace with a façade of twenty-nine window bays. This gigantic façade was constructed with engaged columns that not only reached the height of two full stories but also stood on projecting bases on the ground floor. The building thus carries out, fully and consistently and with impressive force, a motif that originally came from Palladian palaces. A Černín family tradition relates that the Emperor, when he visited the new palace, was extremely angry at its size; he understood only too well the challenge implicit in the extravagant dimensions which proclaimed that one of his subjects dared to live in greater luxury than the Emperor himself. Thus can architecture become fraught with political implications. The interior of the palace was never finished. The Černín family soon found the task of completing the enormous building to be a heavy burden. In 1747–50, as was the taste at that time, a projecting portal was added at the center to interrupt the regularity of the façade. In the nineteenth century, the palace was sold to the state.

In contrast to the Černín Palace, the Villa Troja near Prague is, in its external contours, a finely designed building with a distinctly French character. Jean-Baptiste Mathey, the architect who built the palace in 1679–96 for Wenzel Adalbert, Count of Sternberg, was a native of Dijon. In this country house, the French plan of three wings is introduced into Bohemia. Although the two side pavilions project only two bays in front of the main portion of the building, they clearly demarcate an open space for the outdoor staircase with its extravagant sculptural decoration. In France, the courtyard formed by the three wings was open on the entrance side as a *cour d'honneur* for the visitors. Here in Prague, the garden front is articulated in this way, thus preserving the intimate character of a country home. From the entrance front, the building appears quiet and dignified; only from the private world of the garden can it be seen to have lively variety. The three-story central pavilion is joined to the side pavilions, which are at right angles to it, by low connecting wings. Two towers give special emphasis to the sides. Each portion of the building has its own, separate roof. Thus, a rhythm is created through the gradation in height and subordination to the central pavilion, gracefully carrying out a genuine Baroque theme.

JEAN-BAPTISTE MATHEY (1630–95). Villa Troja, near Prague. 1679–96. Garden front

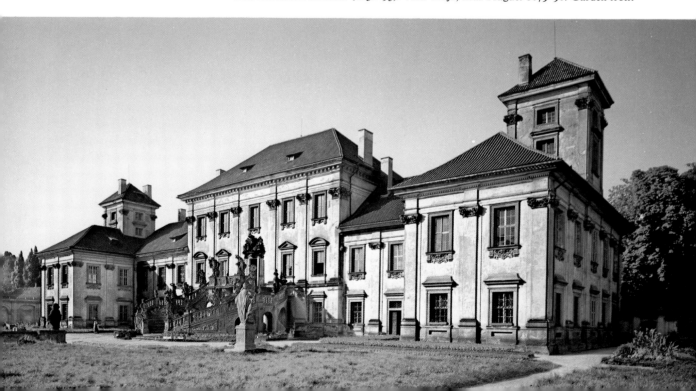

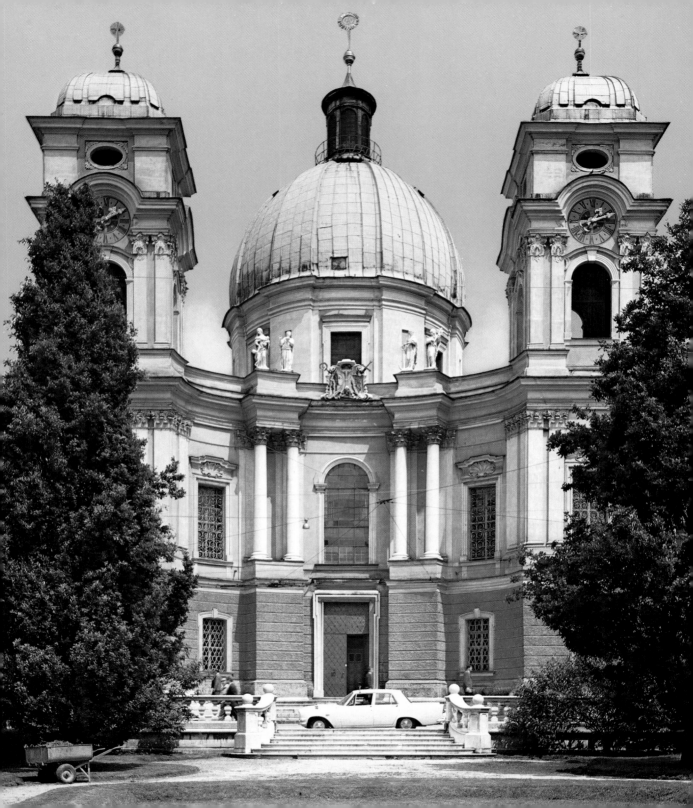

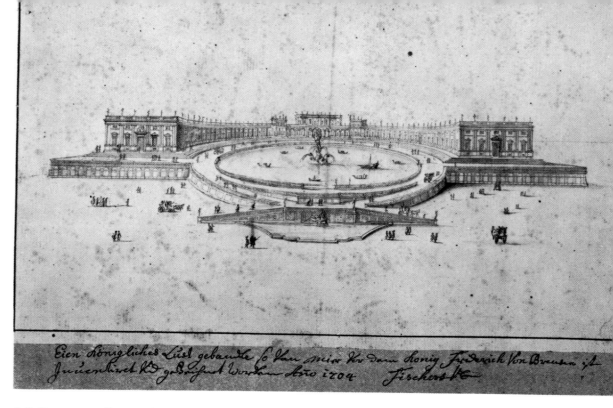

*Eien königliches Liesl gebaute Plan mir für dem König Friedrich Von Breusen ist
Inventirct und gebaut worden Anno 1704 Fischer H*

J. B. FISCHER VON ERLACH. Sketch for a "Royal Pleasure Palace." 1704. Bister pen
drawing with light blue-gray wash, $7^{1}/_{4} \times 12''$. *Codex Montenuovo.* Albertina, Vienna

Johann Bernhard Fischer von Erlach, the great Austrian Baroque architect, was in Rome in his youth. He is
thought to have been a pupil of Bernini; but he also learned by studying the works of Borromini and the other
Roman builders. Thus, fundamental problems of the Roman Baroque constantly resound through his work.
In his first church, the Holy Trinity Church in Salzburg, Fischer created a new variation of concave and convex
forms that move against each other—already represented by Pietro da Cortona in S. Maria della Pace
(see page 14). The concave curve of the façade is played against the oval of the high drum and dome. The
design also represents a further development of Borromini's façade of S. Agnese on the Piazza Navona in
Rome (see pages 54–55). We have already seen how Fischer had based his sketch for an imperial palace at
Schönbrunn on Bernini's first designs for the Louvre (see pages 78–79); in that design, too, curves are played
against each other. In 1701, Frederick, Elector of Brandenburg, was crowned the first King of Prussia. In 1704,
Fischer went to Berlin to submit his design for a pleasure palace to the new King. It was a daring venture.
Andreas Schlüter was the recognized leading architectural personality there. Nevertheless, Fischer, with the
aid of a letter of introduction from the Emperor, attempted to gain a foothold in Berlin. His design was a
variation of the one for Schönbrunn. In the center is a gigantic circular fountain with the wide, armlike wings
of the palace curving around it. A broad system of ramps conducts the visitor along a carefully contrived
circuitous route to the entrance. In the same way as at Versailles, architecture was to be used to express the
power of the ruler. The design found no favor in Berlin; both its scale and the attitudes it expressed seemed
inappropriate to the young monarchy.

◀ J. B. FISCHER VON ERLACH. Holy Trinity Church, Salzburg. 1694–1702. Façade

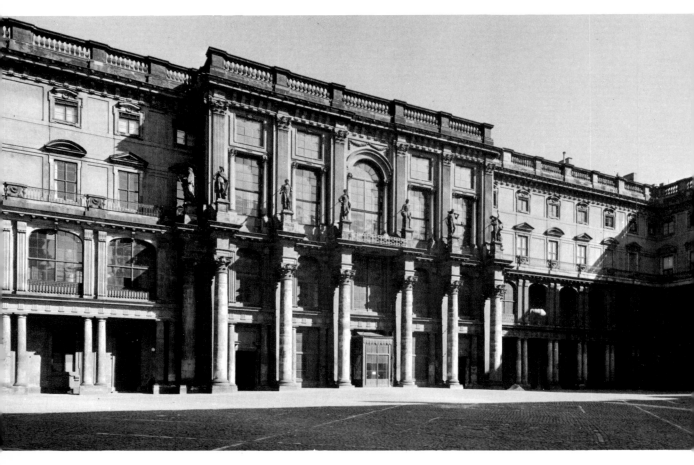

SCHLÜTER. Courtyard and east façade of the Royal Palace, Berlin.
1698–1706. Damaged in World War II and demolished in 1950

In Berlin, Andreas Schlüter began an extensive reconstruction and enlargement of the Royal Palace in 1698. Little is known of Schlüter's artistic apprenticeship or of his youth, but one may safely assume that he made educational journeys to Italy and France. It is impossible to overlook the influence of the Roman Baroque palaces on the Elector's palace in Berlin; but Schlüter modified Roman ideas, giving them a severity and a ceremonial character, so that the resulting building expressed, brilliantly and with clear dignity, the absolute authority of the new monarchy. Schlüter was primarily a sculptor (see page 77), a fact that can be seen in his architecture—for instance, in this façade, where the group of windows over the entrance combines with the powerful columns to form a sculptural unity.

Fischer von Erlach came to terms with Schlüter's architecture in his own way. He was certainly deeply impressed with the magnificence of Schlüter's style; it came very close to his own feeling for the majesty and

J. B. Fischer von Erlach. Clam-Gallas
Palace, Prague. Begun 1707. Portal.
Atlantes by Mathias Braun (1684–1738)

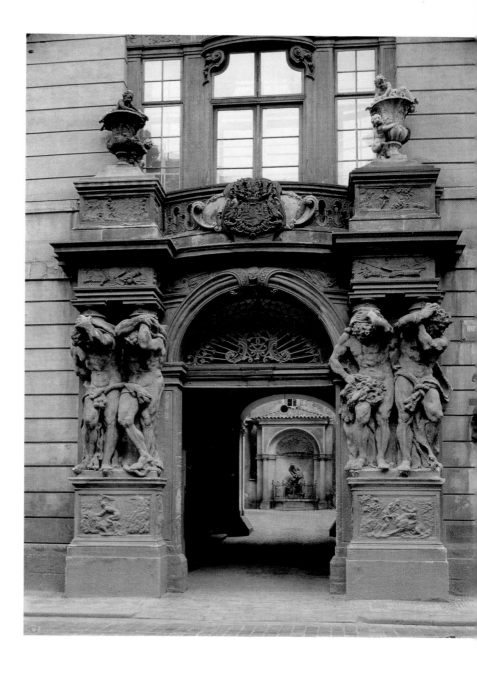

expressive potential of architecture. When, in 1707, he received a commission from Count Clam-Gallas in Prague for a town palace there, he appropriated certain of Schlüter's motifs, particularly in the portal. But he transformed Prussian severity into a more human intimacy through the lively groups of Atlantes, the fine ornamentation, and the curve of the arch, replacing the forceful gravity of the Berlin palace with a measure of Viennese pomp.

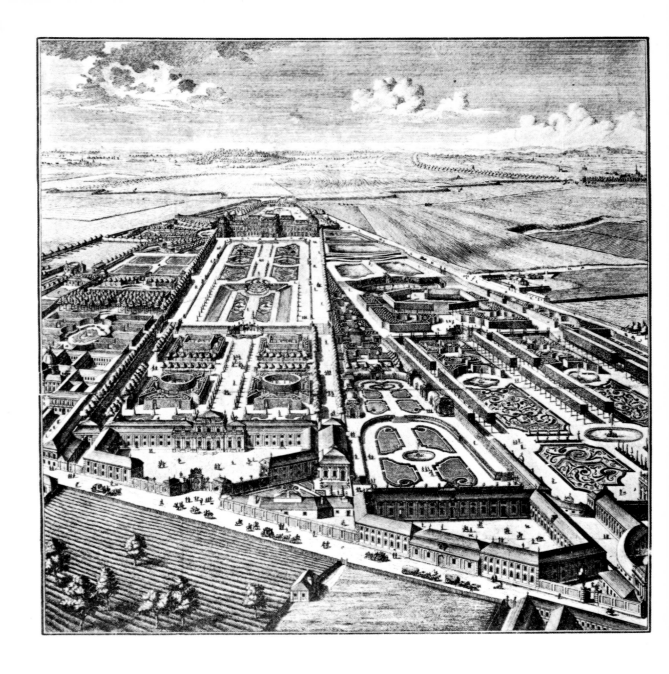

JOHANN LUCAS VON HILDEBRANDT (1668–1745). Belvedere, Vienna. View of the garden of Prince Eugene of Savoy and the adjoining gardens. Engraved by Johann August Corvinus, after Salomon Kleiner and Jeremias Jacob Sedelmayr. From *Eigent-Vorstellung der vortrefflichen und kostbaren Kaiserlichen Bibliothek*, 1737, Book I, plate 3

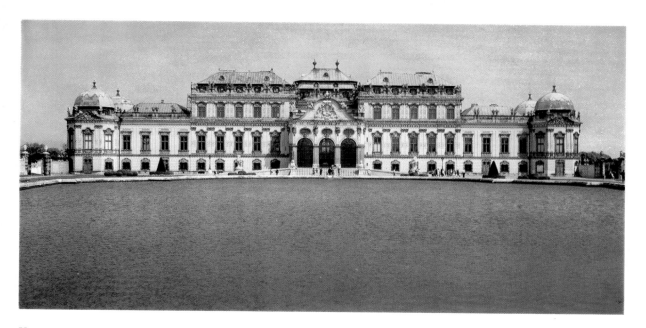

HILDEBRANDT. Upper Belvedere (garden palace of Prince Eugene of Savoy), Vienna. 1721–23. View toward the main entrance

Fischer von Erlach's great rival was Johann Lucas von Hildebrandt. Like Fischer, he was educated in Italy, and like him was in the Emperor's service, but he could not succeed against Fischer in the great building projects of the court. Even after Fischer's death, his son, Joseph Emanuel Fischer von Erlach, was entrusted with the completion of his father's buildings and with all new projects, and Hildebrandt's designs were passed over. However, he did find a patron in the imperial field marshal and conqueror of the Turks, Eugene of Savoy, who gave him the opportunity to display his great abilities, particularly as an architect of palaces. In 1693, Prince Eugene had acquired a long, narrow stretch of land extending up a hill in front of the gates of Vienna, at Rennweg. At the lower end of the property, Hildebrandt built for him a small garden palace, the Lower Belvedere, and a garden with terraces and fountains. In 1721, Hildebrandt was commissioned to erect a large, splendid building on the highest part of the site, commanding a wide view over the city. Like a fairy-tale castle, the façade of the Upper Belvedere rises above a great artificial pool at the upper entrance and is reflected in the moving mirror of the water. One cannot go directly to the entrance hall; one pauses first in admiration, before entering in a roundabout fashion to the right or left of the reflecting pool. As one draws near, the changing, oblique architectural views present a series of surprises. The special beauty and charm of this building continues inside: the two arms of the staircase lead up into the *Festsaal*, while the central arm leads down into the open garden. Through the garden gate, one's eye is led through the park to the Lower Belvedere and on over the city to Kahlenberg. Prince Eugene was not only a brilliant general; he was also one of the most cultivated connoisseurs in the Hapsburg Empire. Generous and sensitive in all matters of aesthetics, he gave his architect—whose great talents he recognized—full freedom, so that this masterwork, polished to the last detail of ornamentation, could be completed in the shortest possible time.

GEORG RAPHAEL DONNER (1693–1741). Putto on the stair rails of Schloss Mirabell, Salzburg. 1726–27. Untersberg marble, length c. 36″

DONNER. *The Traun.* Figure from the fountain of ▶ the former Mehlmarkt, now the Neumarkt, Vienna. Completed 1739. Lead, 65³/₄ × 83¹/₂″. Baroque Museum, Vienna

In 1721, Hildebrandt received a commission from the Prince-Bishop of Salzburg to carry out extensive rebuilding of Schloss Mirabell. One of the most enchanting results of this project is the stair hall. The staircase as an embodiment of the idea of movement was a favorite motif of Baroque architects. In Salzburg, the sense of movement is expressed not only in the execution of the staircase; the railings with their stone ornaments take up the theme, rising, breaking, and falling away like waves. But even that is not all; on the steep curves, putti sit, lie, or loll about, carved by Georg Raphael Donner, one of the most important of Austrian Baroque sculptors. Chubby and bursting with life, the childish bodies are shown in innumerable poses and contortions. The decoration of the Salzburg stair well is one of the few works executed by Donner in stone; he usually preferred metal, particularly lead, whose muted silver sheen reflects the finest nuances of light on the softly modeled surface of the body. Lead was the material in which Donner executed a fountain for the Mehlmarkt, now the Neumarkt, commissioned by the city of Vienna (facing page). In the center, Providentia, the allegorical figure of wise foresight and good city government, sits on a high pedestal. At the edge of the basin are personifications of Austria's chief tributaries of the Danube, the Ybbs, Traun, March, and Enns, represented as two men and two women. Here, Donner makes use of a traditional fountain motif. What is surprising, however, is the personification of the Traun. With a lively movement, a young man is in the act of climbing over the rim of the basin; he has already swung one leg up, while the other foot still rests on the ground. By this device, the border of the fountain is broken open and the outside world—where the spectator himself stands—is drawn into the work of art. This is a Baroque motif previously proposed by Bernini in one of his sketches. In many of his works, Donner seems to anticipate the carefully balanced bodily proportions and the noble tranquillity of classicism, but in such a pronounced use of movement, he is clearly very much a master of the Baroque era.

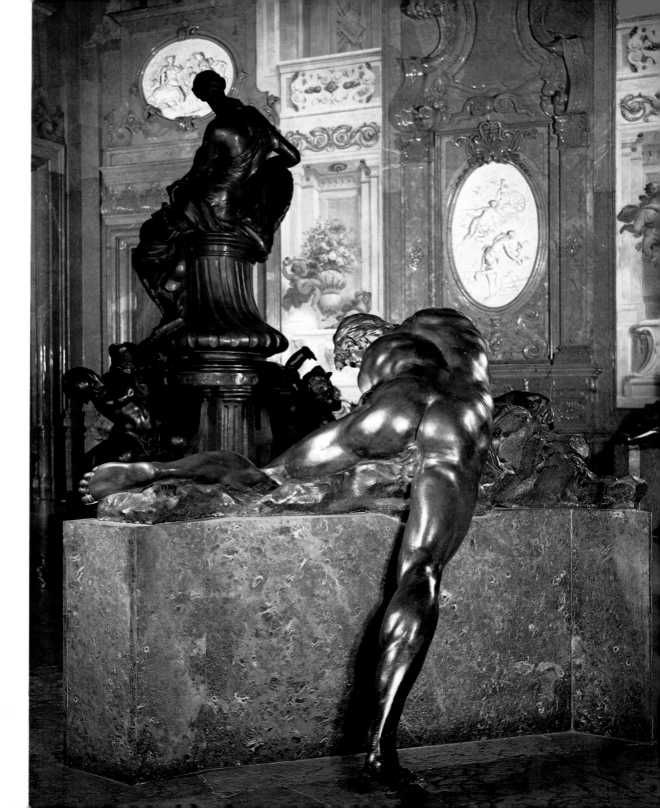

HILDEBRANDT. Benedictine monastery of Göttweig. Begun 1719, never completed. View of the entire complex. Copper engraving by Salomon Kleiner, 1744

When, in 1718, a terrible fire destroyed the monastery of Göttweig, at the outlet of the Wachau, where the Danube flows out into the plain, Abbot Gottfried Bessel turned to Vienna for an architect and commissioned Lucas von Hildebrandt to draw up plans for the rebuilding of it. The monastery is situated on one of the foothills, high above the plain. Hildebrandt's design looks more like a fortress than a monastery—he had originally been a fortifications engineer. Bastions, set on mighty substructures, were to be set in front of the entrance, and the entire complex was to be surrounded by a strong wall. In this project, the idea of the monastery as "God's mountain," an old religious motif, has once again been given an impressive form. Unfortunately, only a very small portion of the design was actually carried out.

The monastery of the Benedictine fathers of Melk, on the Danube, is also situated high above the river valley. Here, the defensive character of the monastery is far less obvious, particularly on the twin-towered façade of the church as it appears from the river. In Melk there had been no fire to make a new building necessary. However, the passion for building—to which not only secular rulers, but also church dignitaries, were susceptible—induced the Abbot, Berthold Dietmayr, to tear down the old church and, in 1702, to commission Jakob Prandtauer to build a new one. Prandtauer was one of the many Austrian architects who, independently of the courtly art in Vienna, gave to the countryside a wealth of magnificent church buildings.

JAKOB PRANDTAUER (1660–1726). Benedictine ▶
monastery of Melk. 1702–38. View from the west

FRANZ ANTON MAULBERTSCH (1724–96). *The Victory of Saint James over the Saracens in the Battle of Clavijo.* 1764. Sketch for a ceiling fresco in the nave of St. Jakob, Schwechat, destroyed by bombs in 1944. Oil on paper, $12^5/_8 \times 18^7/_8$". Österreichische Galerie, Vienna

In the interior of Austrian Baroque churches, a gorgeous display of color and life unfolds, not only in the rich decoration that complements the architecture, but particularly in the ceiling paintings. On the oil sketch for a destroyed fresco in the church of Schwechat, Franz Anton Maulbertsch has created a daring composition dominated by a single diagonal. St. James rises victoriously on a white horse, and the terrified Saracens scatter. An angel flies ahead. The coloring emphasizes both the vehemence of the movement and the audacity of the painting which, in true Baroque fashion, captures a single brief moment—the dramatic high point of an action.

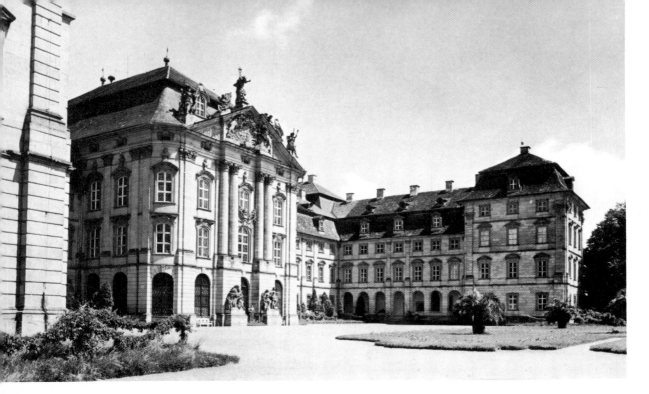

JOHANN DIENTZENHOFER (1663–1726). Schloss Weissenstein, Pommersfelden. 1711–18. View into the *cour d'honneur*

The development of the Baroque in Franconia is inextricably linked with the family of Von Schönborn. Over the years, several important personalities from this family had brought into its possession the archbishoprics of Mainz and Trier and the bishoprics of Würzburg, Bamberg, and Speyer. With Friedrich Carl von Schönborn, the office of Imperial Vice Chancellor in Vienna was added to the list. All these princes were obsessed with building; one sharpened the zeal of another. Yet they undertook only projects that were actually capable of realization; fantastic plans that had been drawn to exaggerated dimensions in order to be more impressive, or plans that could not be completed for financial reasons, were immediately rejected. That is why such a surprising proportion of the building projects of this thoroughly practical, calculating family was carried to completion. The head of the family, Lothar Franz, Elector and Archbishop of Mainz and Prince-Bishop of Bamberg, built, among his other projects, the Schloss Weissenstein at Pommersfelden, near Bamberg, which is still in the possession of the family. He had the plans drawn up by the Bamberg court architect Johann Dientzenhofer, who came from a widely scattered Upper Bavarian family of artists that settled in Bohemia and Franconia. Johann himself had been in Rome and had rebuilt the venerable cathedral of Fulda in Roman Baroque style. For Schloss Weissenstein, however, he chose the French layout of three wings which open majestically to the visitor, forming a court of honor. How much of the final design is actually by Dientzenhofer, or to what degree other architects were called in for consultation or the contractor himself took part in the planning, can only be determined with difficulty. The stair well, which occupies the greater part of the deeply projecting central pavilion, is proudly mentioned in a letter as being designed by Lothar Franz von Schönborn

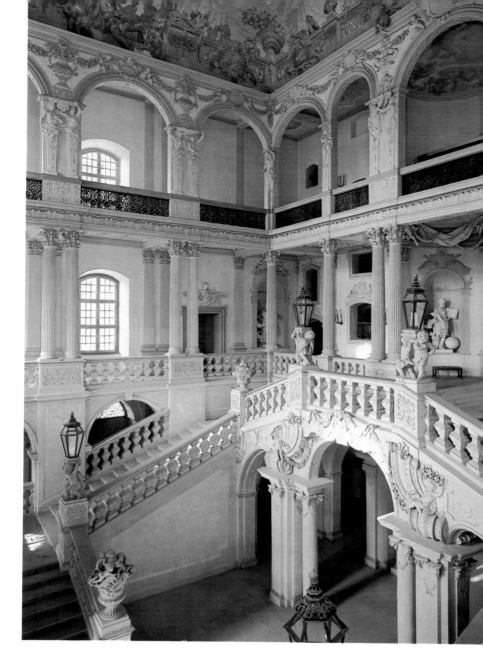

Schloss Weissenstein, Pommersfel-
den. Stair hall, after the design of
Hildebrandt. 1714–19

himself. In fact, his only idea was to have the staircase, located in a prominent part of the palace, lead up to the *Festsaal* on both sides and to continue the stair well up to the roof, so that a three-story stair hall is created. Lothar Franz turned to his nephew Friedrich Carl in Vienna for help in carrying out this plan, and Lucas von Hildebrandt was sent from Vienna to execute it with his usual sensitivity. Light is broken into many areas by the arcaded gallery that surrounds the stair well on three levels and bathes the spacious hall, the ceiling painting, and the fine stuccowork in an atmosphere of great beauty.

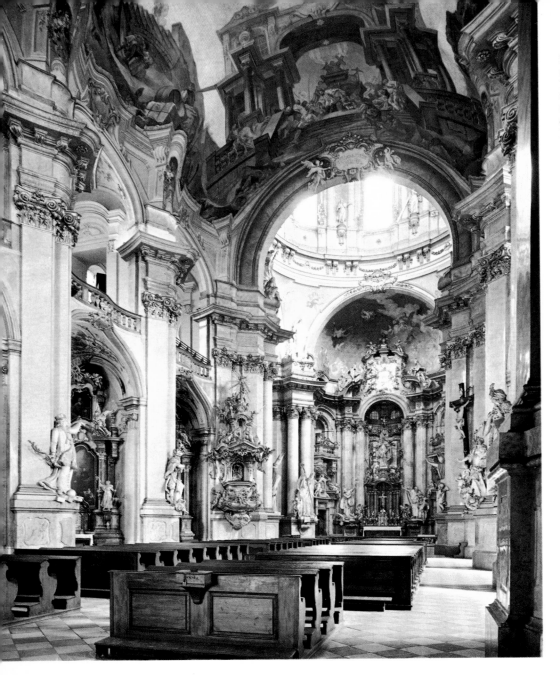

Church of St. Nicholas in the Malá Strana (Little Quarter), Prague. Nave, 1703–11, by Christoph Dientzenhofer (1655–1722); chancel, 1737–52, by Kilian Ignaz Dientzenhofer (1689–1751)

The most outstanding member of the Dientzenhofer family in Bohemia was Johann's brother Christoph. Although he was never in Italy, Christoph Dientzenhofer was able to reinterpret and further develop the innovations of Guarini, whose designs for a church in Prague were well known to him. In the church of St. Nicholas in the Malá Strana, the construction of the dome was originally left visible in stuccoed, twisted ribs, as Guarini had done. Later, these were chipped off and the ceiling made into a single, unified surface to accom-

modate the fresco. The special charm of this church lies in the combination of the nave, full of flowing movement in the vaulting and galleries, with the powerfully soaring chancel which Christoph's son Kilian Ignaz Dientzenhofer added as a centrally planned structure. Entering the church, one moves from the dimly lit nave to the area around the altar, where brilliant light breaks through the windows in the drum of the dome.

Balthasar Neumann worked for several years with Johann Dientzenhofer on the Würzburg Residenz, and thus learned the technique for building domes that had been handed down in the Dientzenhofer family. As the next step in the development of the technique, he detached the dome from the solid exterior wall so that it rested on its own supports, like a baldachin over the nave. In the pilgrimage church of Vierzehnheiligen, the altar is placed in the center of the nave, and the oval space above it is completely surrounded by open galleries. The dome rests on half-columns engaged to piers. The large windows are drawn high up into the roof, so that the interior, filled with light in all its complicated expansions and contractions, seems to breathe in and out like a living organism.

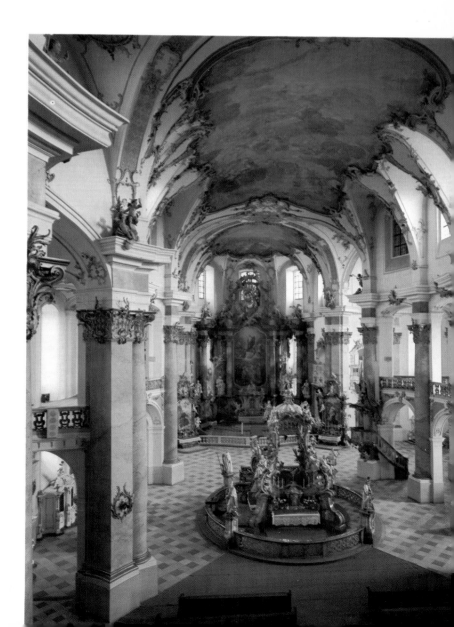

NEUMANN. Pilgrimage church of Vierzehn-heiligen, Franconia. 1743–72. Altar of Mercy after a design by Jakob Michael Küchel

The history of the Würzburg Residenz reflects, more accurately than almost any other eighteenth-century building, the international artistic life of the time. When Johann Philipp Franz von Schönborn became Prince-Bishop of Würzburg in 1719, he wished to transfer his residence to that city from the Marienburg fortress. Plans were drawn up, the basic idea being Balthasar Neumann's. Neumann was born in Eger and had worked himself up from gun-foundry worker to lieutenant of engineers in Würzburg. The plans were sent to Mainz for approval by Lothar Franz von Schönborn and to Vienna, to the contractor's brother. Then Neumann journeyed to Paris, and submitted the plans to Germain Boffrand and Robert de Cotte, the French royal architects. On the way, Neumann saw the Mannheim Palace, just being built, and Boffrand's new palace in

NEUMANN, in consultation with various other architects. Residenz, Würzburg. 1720–53. View of the garden front

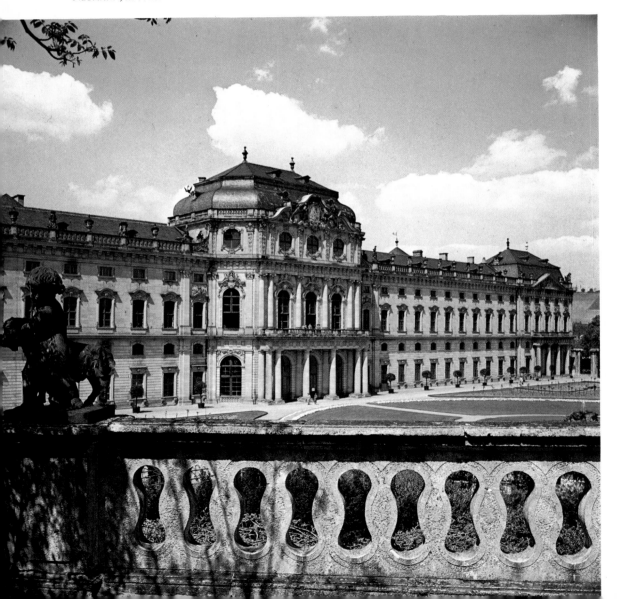

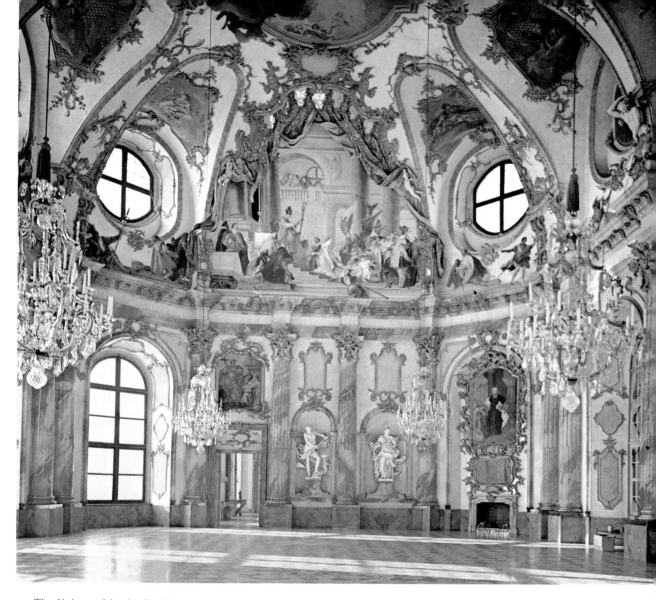

The Kaisersaal in the Residenz, Würzburg. 1737–42. View toward the south wall. Furnished 1749–53. Frescoes by Tiepolo

Lunéville. In 1724, Johann Philipp Franz died. His successor let the project lie, and it was not until 1729, when Friedrich Carl von Schönborn came from Vienna to Würzburg as Prince-Bishop, that the second great construction period of the Residenz began. Lucas von Hildebrandt, Neumann's great rival, was called in. Two opposing temperaments and two antithetical concepts of architecture collided. For Hildebrandt, who was visually very sensitive, a building was formed of the aspects that it presented to the viewer; Neumann wanted to make visible in architecture a clearly organized, structured body. We have Hildebrandt to thank, for instance, for the splendid broken pediment of the Residenz, but Neumann for the compactness of the entire work which, despite all its foreign influence, is a representative building of the Franconian Baroque.

GIOVANNI BATTISTA TIEPOLO (1696–1770). Detail of the ceiling fresco above the north wall of the Kaisersaal in the Residenz, Würzburg. 1751–52

TIEPOLO. *The Martyrdom of Saint Agatha.* c. 1756. ▶ Oil on canvas, 72½ × 51⅝". State Museums, Berlin (West)

Construction of the Würzburg Residenz was completed in 1744, but much was still lacking in the interior. The great ceremonial rooms in particular were only shells, without any stuccowork or paintings to decorate them. In 1746, Friedrich Carl von Schönborn died. Under his successor, who showed little interest in the palace, another pause ensued. Finally, the next Prince-Bishop, Karl Philipp von Greiffenklau, decided to call to Vienna the most famous fresco painter of that time: Giovanni Battista Tiepolo. The great Venetian painter was in the same tradition as Titian and Veronese, a tradition in which colors, the glint of light on costly fabrics, and the mellowness of flesh play a dominant role. Tiepolo carried this forward in the spirit of the eighteenth century, progressively banishing the dark tones from his palette and finally—particularly in his frescoes—bathing his figures in a transparent atmosphere of light. In the altar painting of the *Martyrdom of Saint Agatha*, the luminous reds, blues, and yellows are still placed in contrast to the dark, shaded areas in the middle ground, thus emphasizing the dramatic excitement of the scene. In the ceiling frescoes of the Würzburg Kaisersaal, the colors are drenched with light, even in the largest areas of shadow, and they give a richness and grandeur to the subject. The theme of the frescoes comes from the history of the bishopric. In 1156, Emperor Frederick Barbarossa had married Beatrix of Burgundy in Würzburg, at about the same time as Bishop Herold of Würzburg was given the dukedom of Franconia by the Emperor. Both scenes, at the edges of the hall, are connected by an allegorical central picture: Apollo himself conducts the bride over the clouds on his quadriga to the bridegroom, the *Genius Imperii*, who is seated royally on a high pedestal. In enchanting harmony, the colors of Tiepolo blend with the gilded stucco ornaments of Antonio Bossi and the gifted architecture of Balthasar Neumann to form one of the most beautiful state halls of the eighteenth century.

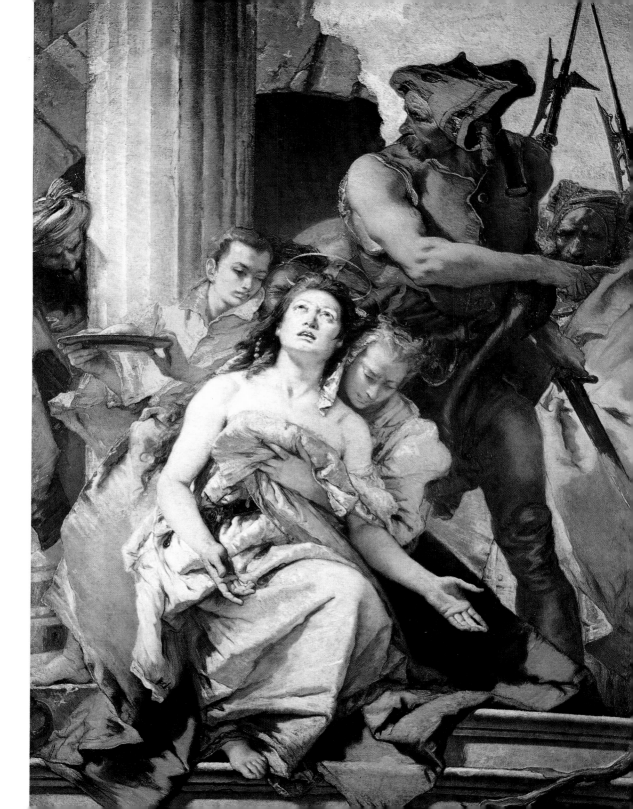

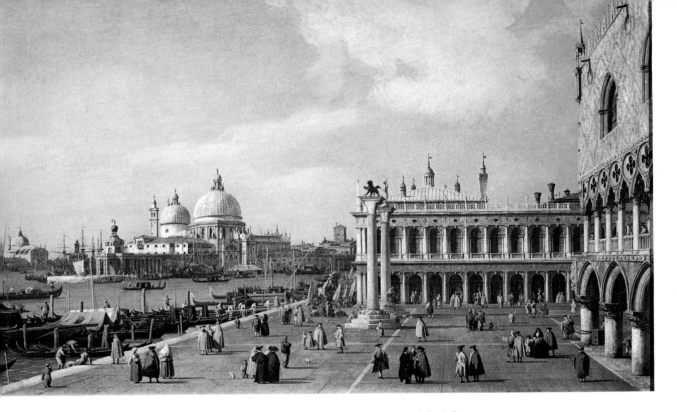

GIOVANNI ANTONIO CANAL, called CANALETTO (1697–1768). *Santa Maria della Salute, Venice* (seen from the Piazzetta). Oil on canvas, 23¹/₄ × 36⁵/₈″. Wallace Collection, London

Vedute painting, that is, the topographically exact rendering of a landscape or a view of a city, was not considered important in Italy—in contrast to the Netherlands—until the eighteenth century. Then, however, it rose to the status of a high art, especially in Venice, and primarily through the work of Giovanni Antonio Canal, known as Canaletto. Canaletto had begun his career as a theatrical designer, a trade he had learned from his father. Later he went to Rome, where he met the Roman *vedutist* Gian Paolo Pannini, and after his return to Venice specialized in painting views of his native city. In 1746, he went to England for a year, having already become famous there through engravings of his pictures. He then returned to Venice, where he died. His work, a song of praise for the beauty of the city of lagoons, is distinguished primarily by its clarity and exactitude. His paintings are bathed in a uniform, transparent light that makes every detail of the buildings recognizable. The figures on his squares and streets are so distributed that their differences in size are an exact measure of the distances in the picture. Canaletto also uses the lines in the paving, in his representation of the Molo, to mark out the exact breadth and depth of the square, giving it added reality. Thus, despite all the liveliness and variety of his richly structured views, there is a certain dryness about his pictures.

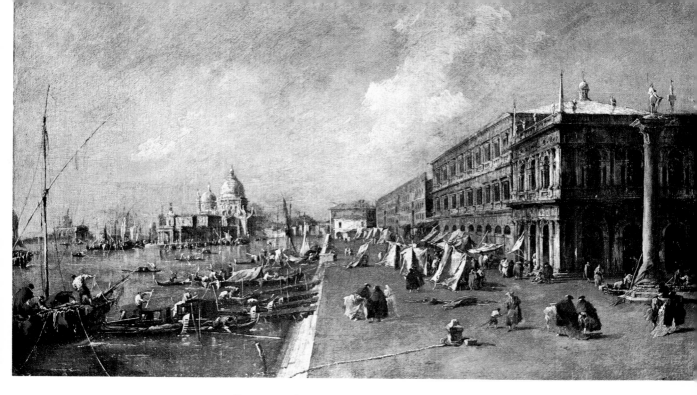

FRANCESCO GUARDI (1712–93). *Santa Maria della Salute, Venice* (seen from the Piazzetta). Oil on canvas, 17³/₄ × 28″. Ca' d'Oro (Galleria Giorgio Franchetti), Venice

Francesco Guardi presents a similar view of the Molo—but in what a different fashion! Light and shadows seem to flit in and out of the scene. The atmosphere is damp, flickering. The men, like the rocking boat, are dabbed on with a loaded brush, so that they seem to be in lively motion. Although Guardi's painting is also based on topographically exact representation, details lose their importance in his work. The picture as a whole is held together by the atmospheric perspective, and the depth of space can be felt even though the eye of the viewer is given no means of measuring it precisely. Guardi's contemporaries did not think very highly of him. True, he was a member of the Academy, but he hardly ever appeared there. He was always in the shadow of Canaletto. While Canaletto represents a continuation of the Renaissance tradition of architectural representation, Guardi already points forward to the kind of painting that, in the nineteenth century, would seek to capture reality by seizing one brief impressionistic moment. Like Guardi, the Impressionists sought to depict the fleeting instant through hurried, almost haphazard brush strokes.

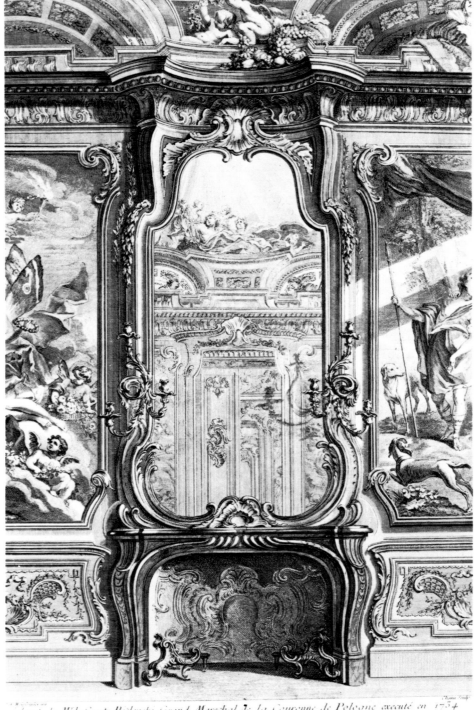

JUSTE-AURÈLE MEISSON-
NIER (1693–1750). De-
sign for the "Cabinet de
Mr. le Comte Bielenski
Grand Maréchal de la
Couronne de Pologne."
1734. Copper engraving
from *Oeuvre de Juste
Aurèle Meissonnier . . .
Première partie Executé
sous la conduitte de l'au-
teur,* Paris, 1723–35, fol.
87. Staatliche Kunstbib-
liothek, Berlin

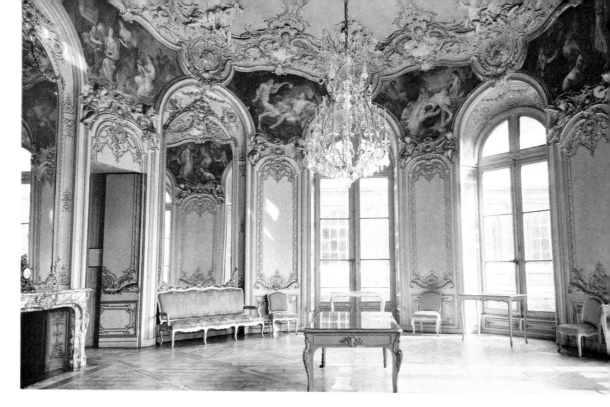

GERMAIN BOFFRAND (1667–1754). Hôtel de Soubise, Paris. Interior of the "Salon de la Princesse." c. 1735

When Louis XIV died in 1715, the *grand siècle*, with its ponderous forms designed to express dignity and grandeur, was over for French art. Particularly in the decoration of interiors, style changed fundamentally. Slender, graceful forms replaced the old oppressive splendor, making interiors lighter in feeling and more comfortable. The new style can be seen at its best in the oval "Salon de la Princesse" in the Hôtel de Soubise in Paris, a late work of Germain Boffrand. Even in the floor plan, all corners that might harbor shadows have been eliminated; the windows are brought all the way down to the floor so that light flows in freely. The ceiling is divided into ornamental panels instead of being burdened with large-scale paintings. The walls are adorned with mirrors, thus seemingly extending the dimensions of the room by introducing surprising perspectives and making it even lighter. Or, as in a design by Juste-Aurèle Meissonnier, mirrors are used to give the effect of an endless series of reflections, so that the room seems to continue into infinity. There are no more pilasters or cornices to make one aware of the actual architectural construction of the room or building. The room almost seems to float, which gives it an unreal, fairy-tale atmosphere.

Meissonnier was best known for his designs for tableware and interior decorations. He was of great importance for the development of South German Rococo on account of his *Livre d'Ornément* of 1734 and other collections of engravings dealing with ornamentation, through which the *rocaille* and a wealth of infinitely versatile forms were transmitted to Germany.

Don Quixote Being Cured of His Madness (detail). Tapestry, from a design by CHARLES-ANTOINE COYPEL (1694–1752). c. 1750–60. 11′ 7³/₄″ × 11′ 5³/₄″. Musée Condé, Chantilly

A new spirit was also apparent in furnishings. Where previously the great gods of Antique mythology had acted out allegories of virtue on ceiling paintings and wall tapestries, now nymphs and satyrs carried on their amorous games. Human folly might also be mocked, as, for instance, in Cervantes' story of the frustrated knight Don Quixote. Charles-Antoine Coypel did a series of illustrations of this picaresque novel as tapestry patterns which met with such an enthusiastic response that they were woven many times. In 1772, Queen Marie Antoinette had a series of four tapestries woven to Coypel's design as a wedding present for her sister, the Archduchess Marie Christine.

Furniture, too, lost its monumental, ostentatious qualities. Now it was meant to make rooms pleasant to live in, to fulfill its purpose comfortably—no longer merely to display the dignity of its owner. Even the name of the piece of furniture that now came into fashion (along with small console tables and *étagères*) contains the whole spirit of the new epoch: the commode. The desk by Abraham and David Roentgen is full of sinuous charm. Its curving legs, which are so carved that they seem to dissolve in ornamentation, require no extra supports. The surfaces bordered by *rocaille* are inlaid with costly materials. On the folding leaf, ingenious use is made of perspective to show a large hall containing a canopied throne. Abraham Roentgen and his son David established a furniture workshop in Neuwied on the Rhine that soon became famous all over Europe.

The desk was prepared for Johann Philipp von Walderdorff, Elector of Trier, whose initials are inlaid on the canopy within the central picture.

Even the monarchy was no longer taken so earnestly and portrayed with such overwhelming dignity. Louis XIV had been glorified in many statues, especially in equestrian monuments. In Louis XV's time, however, it was possible to represent the King as a tiny porcelain figure. He is clothed in a garment reminiscent of Antiquity, but the graceful pose and the soft drapery show that no comparison or identification with Jupiter or Apollo is intended. Here, too, freedom and charm have been victorious over solemn ostentation.

King Louis XV of France. Meissen porcelain, painted and gilded, height 6½″. Model by Kändler (?). Musée National de Céramique, Sèvres

◄ ABRAHAM ROENTGEN (1711–93) and DAVID ROENTGEN (1743–1807). Desk decorated with marquetry. c. 1765. Height 58¼″. Rijksmuseum, Amsterdam

ANTOINE WATTEAU (1684–1721). *Gathering in a Park*.
c. 1717. Oil on canvas, 13 × 18¹/₂". The Louvre, Paris

Antoine Watteau was the first artist of the new style to receive academic honors. When he was accepted into the royal Academy his official title was "Maître des fêtes galantes"—a position that had not previously existed. Not only have the great gods of the *grand siècle* vanished from Watteau's paintings; he does away with the whole convention of using figures from Greco-Roman mythology to explain the meaning of a picture. If an occasional Venus or satyr is still present, it is only in the form of a statue or bust. Man himself is supreme in a world that has been transported from reality to Paradise. These are not real French gardens of the time, in which groups of young people have gathered to play and talk; Watteau's pictures are always set outdoors, yet in a nature that is tamed—one might even say, created—as a human environment. And on this stage is enacted a life of paradisical innocence, without illness or suffering, without poverty, old age, or the passing of time. Yet no wanton amusement is represented, as in the so-called gardens of love by Rubens, with which Watteau's paintings are frequently compared. The atmosphere is certainly saturated with eroticism, yet it is distinguished by its subtlety and restraint; love is like a tremor that passes through man and nature, not the stormwind of passion portrayed by the great Flemish artist.

Again and again Watteau painted the Italian *commedia dell'arte*. Usually entire scenes are represented; man in costume, masked and thereby transferred from the real world to a world of appearances, obviously was a favorite source of inspiration for Watteau, since he produced many variations on this theme. Here, in *Gilles*, a single figure from the comedy is brought to the fore; the other characters are behind what seems to be a bank of earth, and can scarcely be seen. In the eighteenth century, the tragic implications of "Laugh, Pagliacci" still seemed remote. Man was still a creature of God; his place in the scheme of things was still considered self-evident. Yet a gentle melancholy is expressed in the figure of Gilles, and the very objectivity of the painting gives it poignancy and urgency for twentieth-century man.

WATTEAU. *Gilles.* 1721. Oil on canvas, $72^1/_2 \times 58^5/_8$". The Louvre, Paris

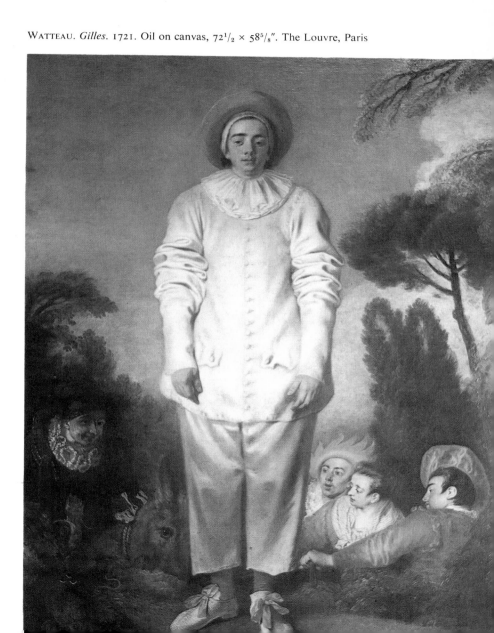

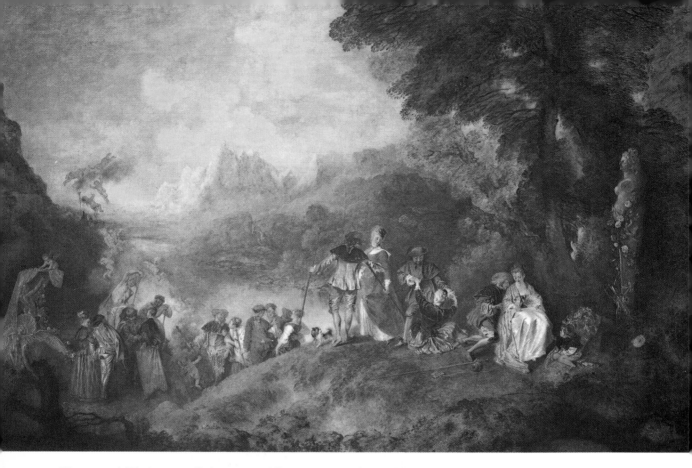

WATTEAU. *A Pilgrimage to Cythera*. 1717. Oil on canvas, 50³/₄ × 76³/₈″. The Louvre, Paris

A Pilgrimage to Cythera was the work Watteau presented to the Academy in 1717 in order to be accepted as a full member. Cythera, the imaginary island of love, is the goal of the couples who are shown here in various stages of love play. From the first approach through bashful hesitation to blissful union, young people are represented in an enchanted landscape that is itself entirely a creation of nature. The costly, iridescent clothes are not meant as an expression of courtly elegance; they symbolize the condition of mind of those for whom the world is entirely composed of beauty and radiant happiness.

While the gods of Antiquity were present only as garden statues in Watteau's works, they still appear frequently in the paintings of François Boucher, who uses them in their traditional roles to make the meaning of his pictures more comprehensible. In his painting of Venus at her toilet, none of the attributes are lacking that a goddess of beauty and love should possess: the gentle doves, associated with her cult; the flowers, shells, and pearls that allude to her birth from the sea; and the three little Cupids who, in a sense, represent her son. However, hardly any essence of divinity remains in this picture; instead, it has the atmosphere of "salon art." In an enchanting blend of colors, a society woman is shown as, absorbed in idle amusement, she sits on a sofa, daydreaming. Here, as with Watteau, is a dream world; but Boucher's world is more capricious, more sensual, and without the melancholy that repeatedly touches Watteau's works.

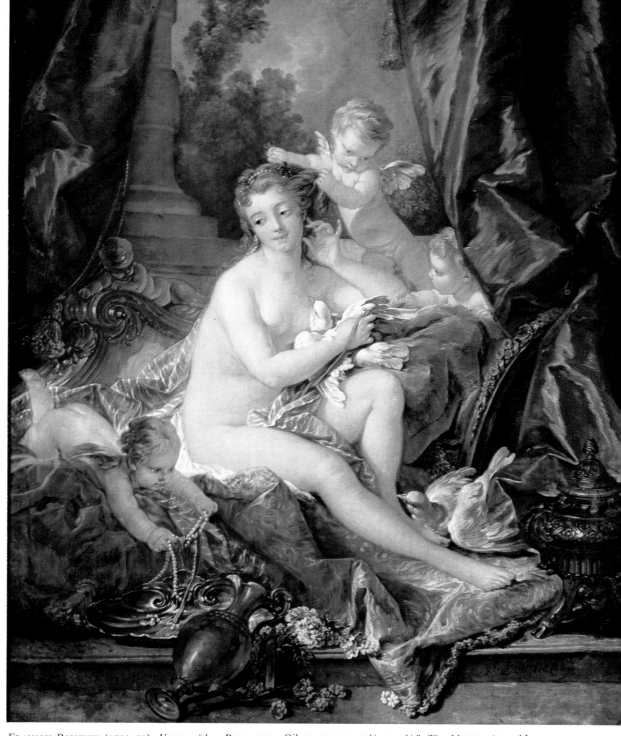

FRANÇOIS BOUCHER (1703–70). *Venus with a Dove*. 1751. Oil on canvas, $42^{1}/_{2} \times 33^{1}/_{2}''$. The Metropolitan Museum of Art, New York

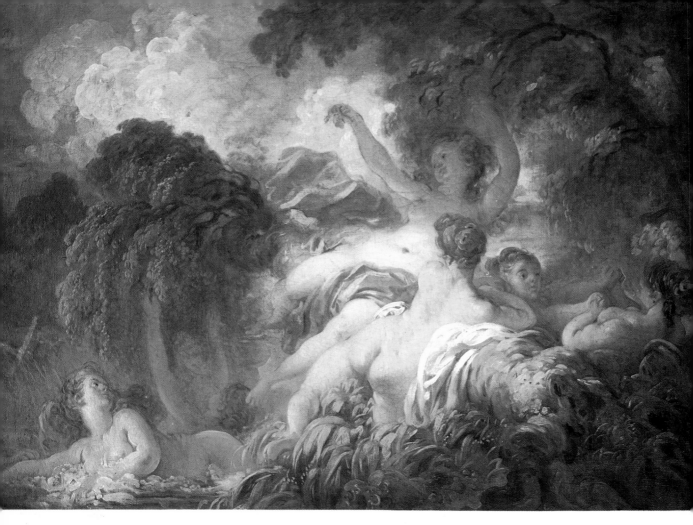

JEAN-HONORÉ FRAGONARD (1732–1806). *The Bathers.*
c. 1765. Oil on canvas, 25^1/$_4$ × 31^1/$_2$". The Louvre, Paris

Like François Boucher, his pupil Jean-Honoré Fragonard painted in the tradition of Watteau, and in his best works Fragonard often comes closer to him than Boucher, even though he was a generation younger than his teacher. Here, too, man belongs to nature, as though born of it, and becomes a part of the landscape. In his early work, *The Bathers*, which he painted before his departure in 1756 for the French Academy in Rome, the girls' bodies twist like plants, and their arms even imitate the branches and trunks of trees. Here one feels—as with Watteau—a hint of the Greek feeling for nature, for trees and bushes with the souls of nymphs which emerge and are then transformed back again. Fragonard's brush stroke is often broad and impetuous, as though the momentary event depicted could only be caught sketchily and spontaneously—an impressionist feature of his work that points forward to the nineteenth century. Auguste Renoir, in particular, was a great admirer of Fragonard and considered him a kindred spirit.

ALEXANDER ROSLIN
(1718–93). *Woman with
a Veil* (the artist's wife).
1768. Oil on canvas,
$25^5/_8 \times 21^1/_4$″. National
Museum, Stockholm

In the work of the great Swedish portrait painter Alexander Roslin, a charming variation of French Rococo
art is revealed. After his student years in Stockholm, Roslin traveled through Germany to Italy, remaining
there for five years. He then went to Paris, becoming a member of the royal Academy. His membership is an
indication of how highly he was regarded as an artist, since for him, as a Protestant, acceptance into the
official institution of the French monarchy was doubly difficult. In his *Woman with a Veil*, the seriousness of
a Northern, bourgeois, phlegmatic world is freely mixed with graceful, gentle coquetry, and melancholy with
the promise of a smile. The way in which Roslin captures the sheen and changing colors of the fabric shows
a mastery acquired from studying the Venetians in Italy and Watteau in France.

CHARDIN. *Girl with a Shuttlecock*. c. 1737. Oil on canvas, $31^7/_8 \times 25^5/_8''$. Uffizi Gallery, Florence

Jean-Baptiste-Siméon Chardin chose his subjects entirely from the bourgeois, everyday world. In a certain sense he is therefore comparable to the seventeenth-century Dutch painters. But his colors are dryer; the light that surrounds his figures is less defined, more diffuse; and his world, despite all its realism, is thus subjected to a pronounced stylization. The placing of this young girl, painted in quiet colors, against a background of almost the same gray-brown removes her from the real, dimensional space of a room and makes her a symbol of childlike contentment with the world. On a copper engraving of this picture by Bernard Lépicié is inscribed: "*Sans souci, sans chagrin, tranquille en mes désirs. Une raquette et un volant forment tous mes plaisirs*" ("Without care, without worries, peaceful in my wishes. A shuttlecock and battledore are all my pleasures").

Jean-Marc Nattier (1685–1766). *Françoise Renée, Marquise d'Antin.* 1738. Oil on canvas, $46^{1}/_{2} \times 37^{3}/_{4}$". Musée Jacquemart-André, Paris

Jean-Marc Nattier, court painter to Louis XV, presents the young Marquise d'Antin quite differently; the young lady, scarcely older than Chardin's girl with the shuttlecock, is seated in an elegant, courtly pose before an open landscape. Nattier gives her a fluttering parrot in one hand, a garland about her body, and flowers in her hair, so that she is almost like a mythological figure. Nattier was highly esteemed by the ladies of society for his fashionable elegance, but also for the flattering mythological character of his portraits. His fame spread beyond France. Peter the Great of Russia invited him to be a portrait painter at his court; Nattier, however, refused this high honor and remained in Paris.

WILLIAM HOGARTH (1697–1764). *Marriage à la Mode,* Scene II: *Breakfast.* Before 1743. Oil on canvas, 27⅝×35⅞″. National Gallery, London

Bourgeois genre painting was modified by an Englishman, William Hogarth, into narrative painting that conveyed a moral message or judgment. In a series of related episodes, he represented such scenes as this from the story of a marriage made only for money, which was therefore bound to have a bad ending. Only a short time after the wedding, the husband comes home in the morning, obviously drunk; a girl's bonnet is hanging out of his pocket. But the young woman, too, has been up all night playing cards. She lolls contentedly about and is clearly not offended at her husband's condition. Engravings of these scenes of social criticism were very popular. For the most part, Hogarth engraved them himself, and did so with considerable skill.

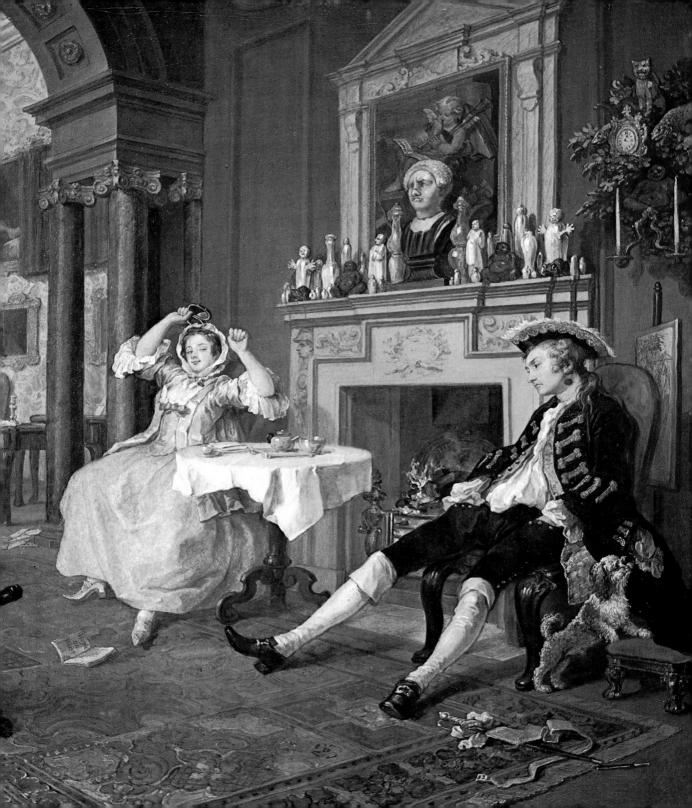

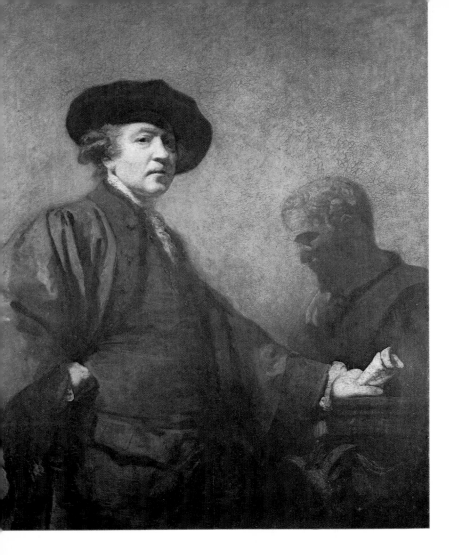

THOMAS GAINSBOROUGH (1727–88). ▶
Mrs. Robinson ("Perdita"). 1781. Oil on
canvas, 90$^{1}/_{8}$ × 58$^{1}/_{4}$". Wallace Collection, London

SIR JOSHUA REYNOLDS (1723–92). *Self-Portrait*. c. 1733. Oil on wood, 50 × 40".
The Royal Academy of Arts, London

Portraiture has played an especially significant role in English painting since the Renaissance. During the sixteenth and seventeenth centuries, almost all the masters in the field were foreigners—Holbein, Kneller, Lely—but the eighteenth century produced, in Sir Joshua Reynolds and Thomas Gainsborough, two outstanding native artists who quickly brought world recognition to English painting. Reynolds had studied the great masters of earlier times during his travels through Italy and France, and later also through the Netherlands. Yet he developed his impressions with such independence that his work appears free from any imitation of foreign schools. As President of the Royal Academy in England, he lectured on theory and aesthetics, but remained until the last years of his life completely unacademic in his work. He died in 1792 at the height of his renown. Three dukes, two marquises, and five other noblemen were pallbearers at his funeral.

Thomas Gainsborough was primarily a painter of landscapes and genre scenes in addition to his portraits of society people. His sensitive portraits of women frequently have an outdoor setting. Here, the dreamy mood of the sitter is reflected in the atmosphere of the English park landscape, foreshadowing the style of nineteenth-century romanticism.

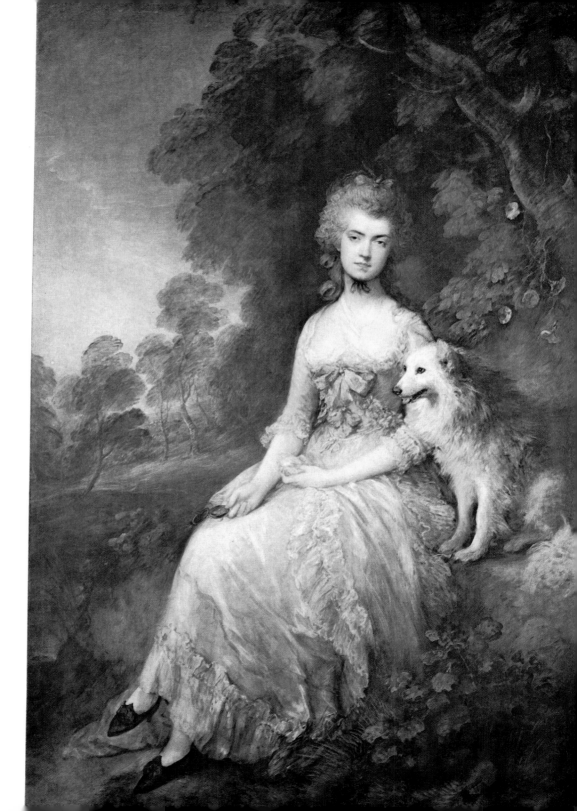

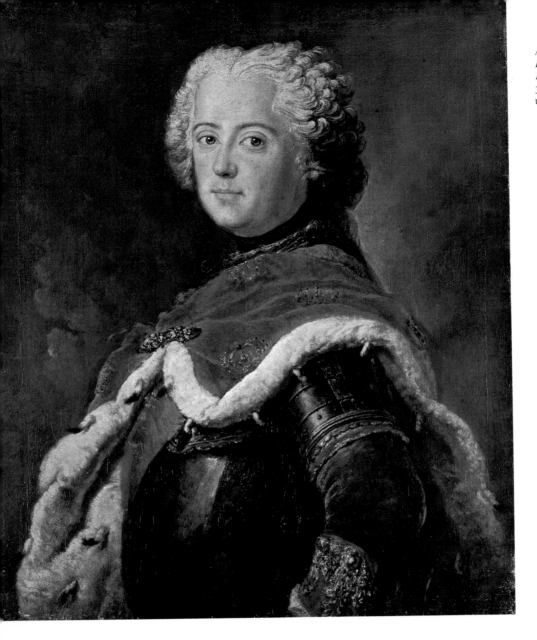

ANTOINE PESNE (1683–1757). *Frederick the Great as Crown Prince*. 1739. Oil on canvas, $30^3/_4 \times 24^3/_4$″. State Museums, Berlin (West)

Under Frederick the Great, Prussia achieved a special position in the art world of the eighteenth century. His great abilities as a general, which were so admired by all his contemporaries, were only one facet of this versatile and gifted monarch. In his private life, he was an extremely sensitive person who had a lively understanding of all the arts. The clear, refined, and elegant French spirit that was expressed in the art, as well as the literature and philosophy, of his western neighbor appealed to him. He therefore surrounded himself with French works of art—he greatly admired Watteau and acquired several pictures by him. While still Crown

JEAN-ANTOINE HOUDON (1741–1828). Portrait statue of Voltaire. c. 1780. Musée Lambinet, Versailles

Prince, he had himself portrayed by the French artist Antoine Pesne, whom he kept at his court until the artist's death. But Frederick the Great's crowning achievement was to attract to his court the great wit and brilliant writer François-Marie-Arouet de Voltaire (1694–1778). However, Voltaire's residence at Sans-Souci lasted only two years. Then the relationship broke up on account of the extremely difficult nature of Voltaire, whom the King repeatedly and most unpleasantly provoked. Later, there was a reconciliation, but both men had realized that an intellectual correspondence—carried on at a certain distance—was more fruitful and less dangerous than having two such forceful and independent personalities residing at the same court. Jean-Antoine Houdon erected a posthumous monument to Voltaire, the great spirit of the French Age of Enlightenment, a daring satirist, and a free and unconventional person. Houdon's Voltaire wears an Antique robe and is seated on a high chair in the manner of the philosophers of Antiquity. The writer's lively facial expression, rendered without idealization, conveys the whole spirit of the era.

A comparison between Versailles, the seat of Louis XIV, and Sans-Souci, Frederick the Great's favorite residence, not only serves to sharpen the distinction between the personalities of the two monarchs, but also between the centuries in which they lived The two palaces were, of course, built with entirely different intentions; Versailles, as seat of the court, had to have room to accommodate the many officials and nobles who constantly surrounded the King, while Sans-Souci is a garden palace where the King could live as a private person, a kind of hermitage which had been built for him as a refuge. Here, he did not have to be concerned with keeping up appearances or with courtly life; he could enjoy the fellowship of a group of chosen friends. The very fact that Louis XIV allowed his entire life, from *lever* to *coucher*, to become a state ceremony, while Frederick permitted himself to be a private person as well as a king, shows how different the two eras were. The comfortable, intimate quality associated with the Rococo replaced the solemn majesty of the Baroque in political life as well as in other realms.

In 1745, Frederick commissioned his architect, Georg Wenceslaus von Knobelsdorff, to build a "pleasure palace on the vineyard." While still Crown Prince, Frederick had enabled Knobelsdorff to make an educational trip to Italy, and after his accession to power in 1740, appointed him Surveyor General of the royal palaces and grounds. The new palace was to have all its rooms on one floor, level with the ground and therefore as closely connected with the garden as possible. Frederick the Great had a very clear idea of what kind of building he wanted, and it was thus unavoidable that he got into more and more heated quarrels with his architect, who was himself strong-willed and inflexible.

WENCESLAUS VON KNOBELSDORFF (1699–1754). Palace of Sans-Souci, Potsdam. 1745–47. Garden façade

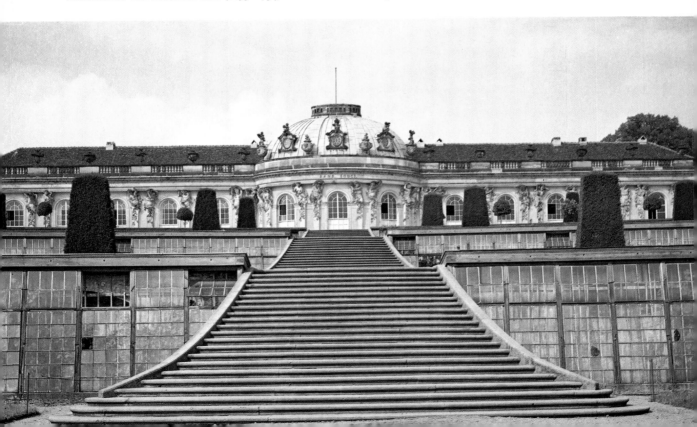

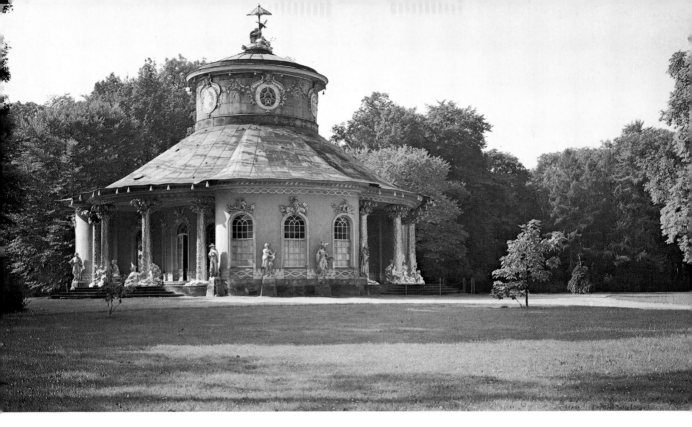

JOHANN GOTTFRIED BÜRING (1723–after 1786). Chinese Teahouse in the park of Sans-Souci, Potsdam. 1754–56. Sculptors: Johann Peter Benkert, Johann Matthias Gottlieb Heymüller, Benjamin Giese

Sans-Souci is difficult to illustrate. If one shows only the façade, the situation of the palace on the upper terrace of the Potsdam vineyard cannot be seen—and that is precisely what is so characteristic of this "little vineyard palace." Yet, if one brings the steps and the substructure of the terraces into view, then the palace with its Atlantes and caryatids seems to be half buried in the earth. Certainly, Frederick had not taken into consideration this aspect—the view from the garden, so to speak. From above, however, this man, who even as a private individual saw the world from the standpoint of a king, could let his eye sweep over the land and draw inspiration from the extensive view.

In the park of Sans-Souci, a number of pavilions were built, as was the fashion at that time. The most unusual of these is the Teahouse, a circular building with an open loggia under a Chinese-style curved roof that is supported by fantastic columns made to resemble treetrunks. Of special interest are the life-size statues, their clothing reflecting the contemporary fad for *chinoiserie*, that crouch in the open loggia and, with their lively gestures, relate the building to the park in an enchantingly graceful manner.

The fashion for *chinoiserie* had the greatest impact on the manufacture of porcelain. More and more Far Eastern porcelain, lacquerwork, and silks had been imported since the seventeenth century, and the high prices paid for these goods provided an incentive for European craftsmen to imitate them as closely as possible. Later, a number of authentic travelogues appeared—illustrated, however, by artists who had never been to the Far East themselves. Thus a bizarre, fairy-tale world was created that incorporated only a few formal elements from reality, but nevertheless breathed the graceful, charming spirit of the new age. In the royal porcelain factory at Meissen, it was Johann Gregor Höroldt (1696–1775), the first professional painter to be employed there, who introduced the Chinese style of decoration. Thanks to a new technique of glazing, he was able to bring magical colors to glowing life. His Chinese genre scenes are distinguished by their capricious delicacy and very fine drawing. Höroldt's spirit is also evident in this shell basin, but here his style is modified by such lively representations of animals—horses, for instance—that this particularly beautiful piece is thought to have been painted by Adam Friedrich von Löwenfinck, who was then an apprentice at Meissen. Since Höroldt forbade individual signatures by any artist, one is forced to attribute works on the basis of stylistic comparisons.

◄ Shell-shaped wash-basin. Painting attributed to Adam Friedrich von Löwenfinck (1714–54). c. 1730. Meissen porcelain, length 18¹/₂″, width 14⁵/₈″. Bayerisches Nationalmuseum, Munich

Augustus the Strong became Elector of Saxony in 1694. The most unique piece of architecture to originate in Dresden under this luxury-loving ruler, who also had excellent taste, was the Zwinger. Wooden structures frequently had to be built to accommodate the great court festivities which, as opportunities to display the wealth and power of the state, were considered important even by the ordinary citizens. Augustus the Strong decided to have a permanent structure for the purpose built in stone. On a strip of land between the inner and outer city fortifications, called the Zwinger, his Surveyor General, Matthäus Daniel Pöppelmann, erected a rectangular court around a large festival area—a series of buildings, unique in Europe, containing game and dance halls, smaller rooms, baths, grottoes, and arcades. Balthasar Permoser, a brilliant Bavarian sculptor, designed the rich sculptural decoration. In 1719, the Zwinger was inaugurated in a "Festival of the Four Elements," celebrating the marriage of Augustus' heir, the Prince-Elector, to the Emperor's daughter, Archduchess Maria Josepha.

MATTHÄUS DANIEL PÖPPELMANN (1662–1736). The Zwinger, Dresden. 1711–22. View toward the Wallpavillon. Sculptural decoration by Balthasar Permoser (see page 196)

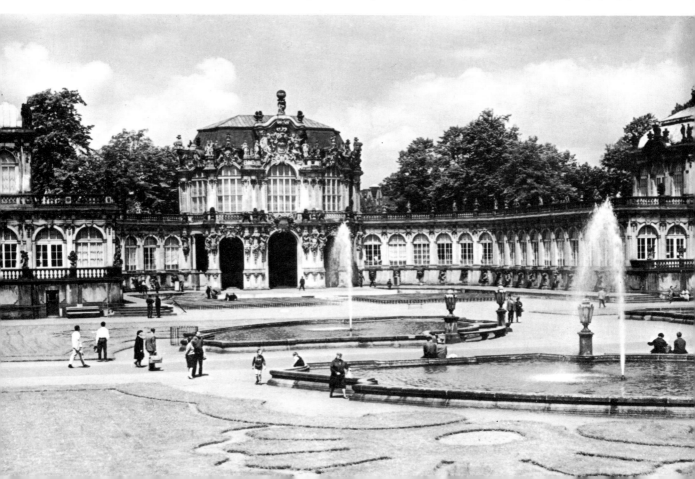

BALTHASAR PERMOSER (1651–1732), attributed. *Autumn,* in the Park of Schloss Hellbrunn, Salzburg. c. 1670. Marble, larger than life-size

Balthasar Permoser was born in 1651 in Kammer bei Otting, in the Chiemgau, Bavaria. At first he studied with a painter; later, in Salzburg, he became apprenticed to a sculptor. Afterward, he acknowledged that a good sculptor also needed training in painting. His painterly conception of sculpture is especially prominent in his decoration for the Zwinger in Dresden; it is to be seen in the soft transformation from light to shadow, the soft contours, and the sensitive modeling of the surface of the body. Permoser spent fourteen years in Italy, where he studied Baroque sculpture as well as the works of Michelangelo and the sculptures of Antiquity. Even when his works were merged, in graceful exuberance, with the splendid architecture of the Zwinger, they retained something of the spirit of the Roman Baroque and of Antiquity. This synthesis was already present in his early work, done at Salzburg, before he had ever been to Italy—at a time, therefore, when he still had to draw upon engravings and copies for inspiration. This figure in the park of Hellbrunn, which is attributed to him, shows a young Bacchus personifying Autumn. Crowned with grapes, one foot resting on a wine cask, he gazes drunkenly at the bunch of grapes he is holding in his upraised right hand. Obviously the artist had Michelangelo's early *Bacchus* in mind when he created this figure, but the work is given a High Baroque flavor through the more pronounced twisting of the body and head.

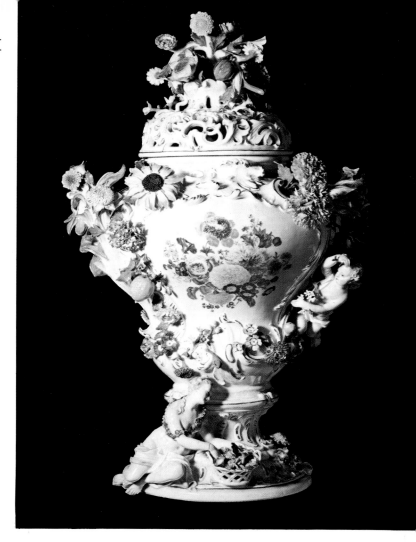

JOHANN JOACHIM KÄNDLER (1706–75). Vase. c. 1755.
Meissen porcelain, height 26³/₈″. Bayerisches National-
museum, Munich

In the sea-shell basin on page 194, we saw a work of the early period of the Meissen porcelain factory. Founded by Augustus the Strong in the spirit of mercantilism of that era, the Saxon porcelain was to bring prosperity to the state and riches to the Elector-King. Around 1730, however, a certain artistic stagnation set in. This did not escape the eye of the King, who was always concerned about his favorite project. What the enterprise most needed was a better-than-average model-maker. Augustus the Strong found such a man in Johann Joachim Kändler, a young sculptor who knew nothing about porcelain when he was appointed to the Meissen factory. However, Kändler had an instinctive ability to adapt to his materials, and mastered porcelain techniques soon after his entry into the factory in 1731. At first, he modeled large figures of animals for the Japanese Palace in Dresden-Neustadt, which Augustus had had specially built for the purpose of housing his porcelain collection. There, 25,215 pieces were said to be exhibited, many of them quite large. It was primarily for this task that the King had personally summoned Kändler to Meissen. In a fortunate coincidence, the artist who exercised the most decisive influence upon Meissen porcelain was therefore connected with the factory at the height of his own personal development. Later, when the *rocaille*, with its light, capricious rhythm, was adopted for tableware, Kändler, with inexhaustible fantasy, designed groups of figures and splendid vases with luxuriant floral decoration that even today ensure the world renown of Meissen porcelain.

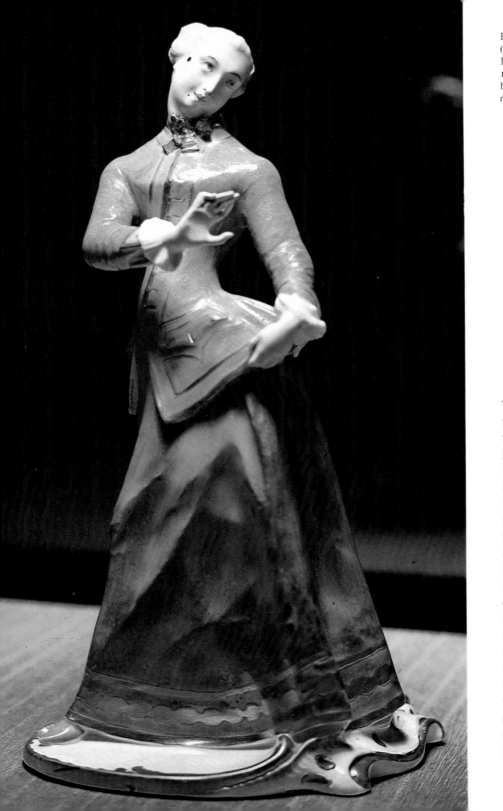

FRANCESCO ANTONIO BUSTELLI (1723–63). *Julia* (figure from the Italian *Commedia dell'arte*). Before 1760. Nymphenburg porcelain, height 8″. Bayerisches National-museum, Munich

The Electorate of Bavaria established its own porcelain factory in 1754. Originally located in a small palace in a suburb of Munich, the factory was moved in 1761, by order of the Elector Max III Joseph, to one of the pavilions in front of the Nymphenburg palace. From then on, it was officially known as Nymphenburg porcelain. What Kändler was to Meissen, Francesco Antonio Bustelli was for Nymphenburg. He was born in Locarno in Switzerland, but very little else is known about his early life or education. He worked barely nine years for the Bavarian factory, and died soon after his fortieth birthday. The figures he created during this brief period, however,

BUSTELLI. *Pantaloon* (figure from the Italian *Commedia dell'arte*). Before 1760. Nymphenburg porcelain, height 7″. Bayerisches Nationalmuseum, Munich

are among the most consummate works of the minor arts of the Rococo. In his characters from the Italian *Commedia dell'arte*, the representation of a lively comic art is stylized with great sensitivity, and the characters are brought to life with a brilliant feeling for the sculptural possibilities of a small format. The complicated twists and turns of the figures make them absolutely demand to be held in the hand. When the individual figures of the actors are placed together, their poses create an interplay of line, movement, and emotion—jealousy, coquetry, love, or sadness—that is charmingly expressed through looks and gestures.

Monstrance, known as the *Turkish Monstrance*. Representation of the Battle of Lepanto of 1571. Goldsmith: Melchior Zeckl. Donated by the congregation of S. Maria de Victoria, Ingolstadt. 1708. Gold and silver, height c. 40″, width c. 30″

In the Catholic Electorate of Bavaria, the grace and brilliance of eighteenth-century art was often placed at the service of a profound piety. Holy objects were glorified by being given costly settings. The so-called *Turkish Monstrance* was donated by the congregation to S. Maria in Ingolstadt. On the rays of the frame surrounding the Host, the entire naval battle of Lepanto, in which the Turks were defeated by the fleets of the Pope, Spain, and Venice, is represented with astonishing technical skill. The ships and their crews are depicted down to the finest detail, including a faithful portrait of Don John of Austria, executed in costly materials with hundreds of jewels. The whole serves to glorify Christ, represented at the center of the monstrance by the Host, and Mary, agent of this victory.

Elector Karl Albrecht of Bavaria donated this life-size votive figure of his son, Max Joseph, to the pilgrimage chapel of Altötting after the recovery of the ten-year-old boy from a severe illness. It is a votive offering that expressed the deep piety of the Bavarian princes in a courtly, elegant manner. Guillielmus de Groff, an artist from Antwerp whom the Bavarian Elector brought to his court at Munich, represented the boy in the full court dress of a Knight of Saint George, in shimmering silver, as he kneels bare-headed before the Madonna.

Orders played an important part in the courtly life of the eighteenth century. In mountings of various colors, with the rich luster of precious stones, they added to the splendor of the costly clothes worn by the prince and his court on festive occasions. The Golden Fleece was an imperial order of the Hapsburgs. Max III Joseph of Bavaria received it on the occasion of the coronation of his father in 1742, bestowed by the Spanish King. In 1765, he had a new decoration made from stones in his treasury.

The Order of the Golden Fleece. Made in 1765 by Johann Staff for the Bavarian Elector Max III Joseph. Diamonds on gold and gilded silver, height 6³/₄″, width 3⁵/₈″. Treasury of the Residenz, Munich

GUILLIELMUS DE GROFF (c. 1680–1742). Votive figure ▶ of the Bavarian Crown Prince Max Joseph. 1737. Silver *repoussé*. Height 37″. Chapel of the pilgrimage church, Altötting

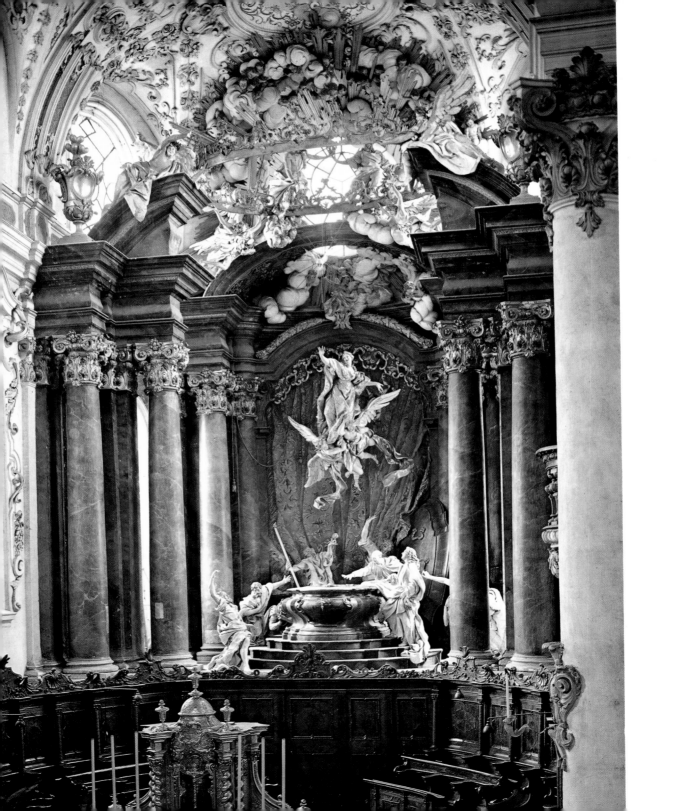

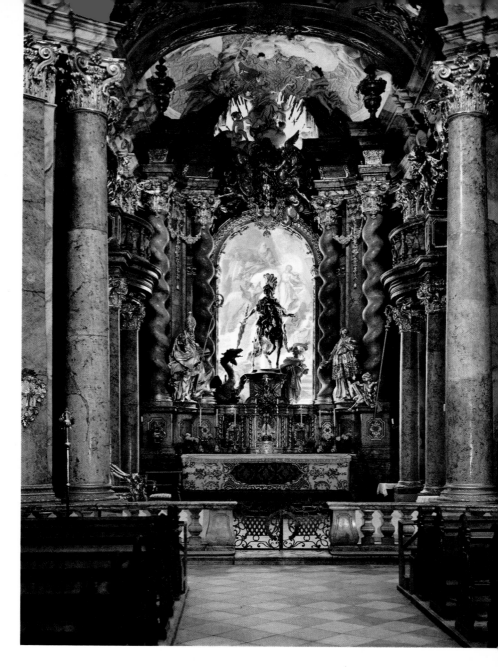

EGID QUIRIN ASAM (1692–1750). *The Assumption of the Virgin.* High altar of the Augustinian monastery church of Rohr. 1718–22

EGID QUIRIN ASAM and COSMAS DAMIAN ASAM (1686–1739). Benedictine abbey church of Weltenburg. Begun in 1716; dedicated in 1718. High altar with St. George by E. Q. Asam. c. 1721

It is often remarked how closely eighteenth-century church decoration is related to the theatrical. However, this resemblance is not to be taken at face value. Dramatic effects are exaggerated —as, for example, in the high altar of the monastery church at Rohr, where a group of apostles looks with terror at Mary's empty grave and the Assumption of the Mother of God—in order to draw the faithful into the event and to awaken in them feelings that go far beyond those of their everyday experience.

The figure of St. George on horseback in the Benedictine abbey church of Weltenburg is meant to achieve a similar effect; the figure rides into the interior of the church as though onto a stage; the use of concentrated light makes the saint appear like a vision out of a radiant background that symbolizes heaven.

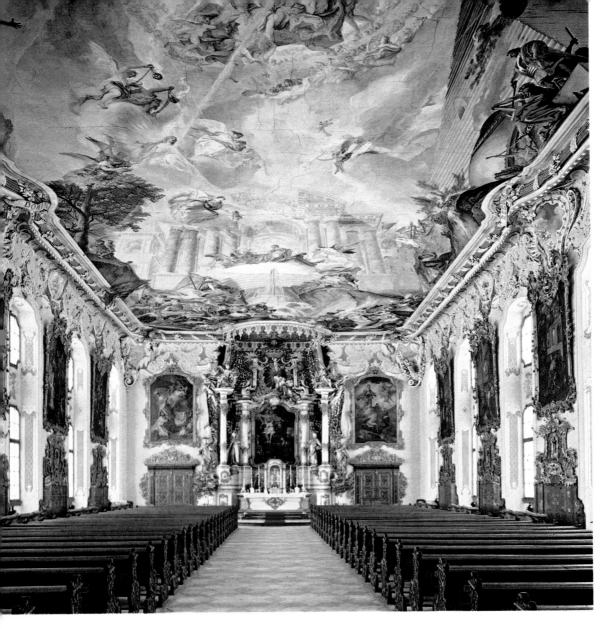

S. Maria de Victoria, Ingolstadt. Ceiling painting by C. D. Asam, *Mary as Mediator of Mercy*. Begun 1732. Interior decoration completed 1759

During the long career of the Asam brothers, Cosmas Damian and Egid Quirin, and through their work, South German Baroque developed into Bavarian Rococo. Born in Upper Bavaria, the brothers were sent to Rome by the Abbot of the Benedictine abbey at Tegernsee, who had recognized their considerable artistic talents. There, the whole richness of Roman Baroque was revealed to them, and became their model and their school. Cosmas Damian, the painter, studied Baroque ceiling painting with its generous scale, use of perspec-

tive, architectural illusionism, and its wide horizons. Egid Quirin, the sculptor, studied the intensely agitated, ingeniously composed sculptures of Bernini. Neither remained limited by the Italian tradition; they carried the illusionism still further and elaborated the painterly concept of a church interior, which had its origin in Italian Baroque churches, until they achieved a painterly and architectonic totality such as Weltenburg Abbey or the so-called Asam church in Munich, that was completely foreign to the Italian idea of form. The interior transcends architectonic boundaries, opening in powerful ceiling frescoes to heavenly visions or, as in Weltenburg, to an area of unearthly light behind the altar. Boundaries between the various mediums are also obliterated: painting merges with sculpture; architecture blends into painting. In the pilgrimage church of S. Maria in Ingolstadt, Cosmas Damian built a gigantic church front over the high altar, in front of which Mary is enthroned on a high stepped platform. This, however, is only the final point of a sacred way symbolized by the ray of light from God the Father in the distance, over Christ and on to the Virgin. The enormous ceiling fresco, forty yards long and fifteen yards wide, is framed with stucco decoration that is obviously from the hand of Egid Quirin.

The use of architectural illusionism was not confined to ceiling paintings, however. In the enormous screens that frequently separated one part of the church from another, deep apses and long, vaulted side aisles seem to materialize. In Weingarten, for example, a complete church, made of the finest wrought iron, rises up before the chancel. In this screen, the laws of perspective are applied with disconcerting *trompe l'oeil* in order to present the effect of a deep, three-dimensional interior.

Benedictine abbey of Weingarten. Rood screen. c. 1735. Artist unknown

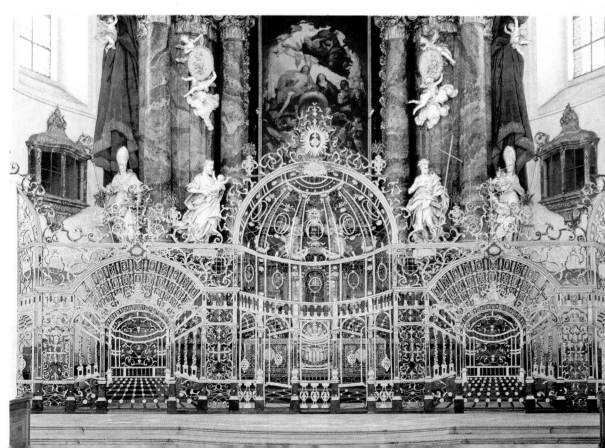

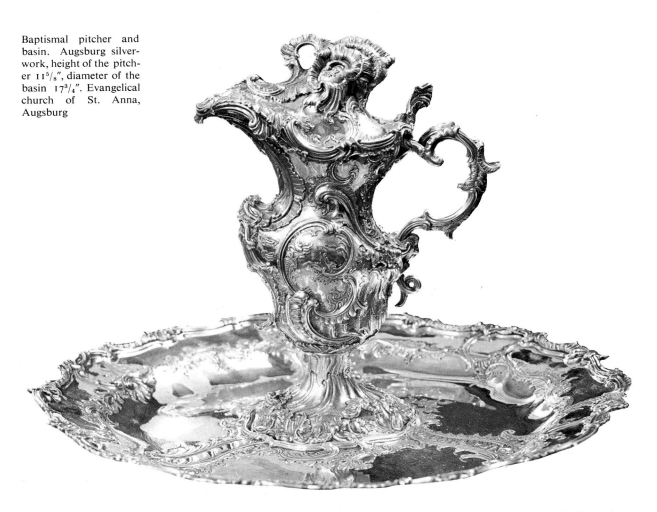

Baptismal pitcher and basin. Augsburg silverwork, height of the pitcher 11⅝″, diameter of the basin 17¾″. Evangelical church of St. Anna, Augsburg

Rocaille, the ornamentation most characteristic of the Rococo, originated in France and reached southern Germany through engravings. With its half-naturalistic, half-abstract shell and plant forms, its bold C- and S-curves, Rococo decoration was adopted in southern Germany not only in interior decoration, as in France, but also for the decoration of façades—for example, in window cartouches and entrance pediments. In the minor arts, too, such as ritual utensils, a new, fantastic richness of ornamentation prevailed. This baptismal pitcher is so elaborately embellished that its original form—basically a water jug—is scarcely recognizable. Ornamentation is no longer merely something that is added, a form of decoration applied to the surface; the *rocaille* itself determines the form of an object.

The chief master of the *rocaille* style in Bavaria was François de Cuvilliés, a native of Hainaut. Elector Max Emanuel of Bavaria had appointed Cuvilliés court dwarf during his exile in the Netherlands, but soon recognized the young man's special gift. The Elector sent him to France to study architecture, and thereby secured for himself one of the most capable architects and most brilliant decorators of the Bavarian court. In the small hunting lodge of Amalienburg, situated in the park of Nymphenburg, Cuvilliés designed rooms of fairy-tale splendor. Using the French style of interior decoration that can be seen at its best in the oval "Salon de la Princesse" of the Hôtel de Soubise (see page 175), he chose a harmonious color scheme of silver and sky-blue

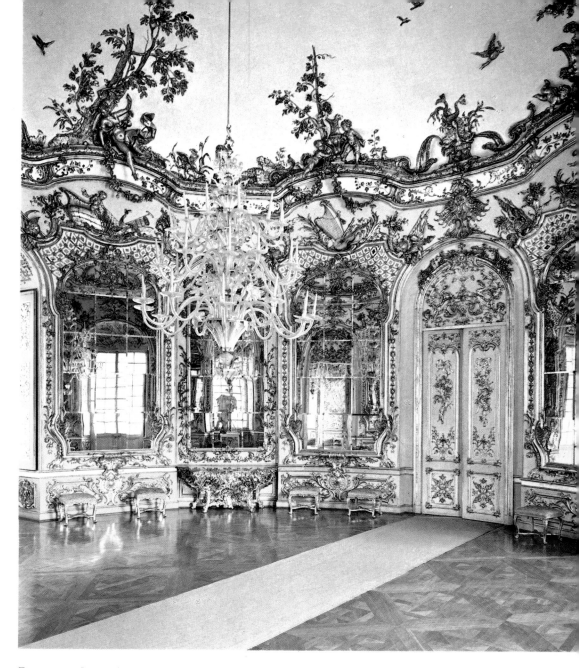

FRANÇOIS DE CUVILLIÉS (1695–1768). Hall of Mirrors, Amalienburg, in the park of Schloss Nymphenburg, Munich. 1734–39. Decoration by Johann Baptist Zimmermann (1680–1758) and Joachim Dietrich (1690–1753)

which, together with the naturalistic plant and animal forms, the Arcadian human figures entwined with abstract ornamental designs, and the many glittering mirrors, creates an atmosphere that transports the visitor from the real world into an enchanted realm.

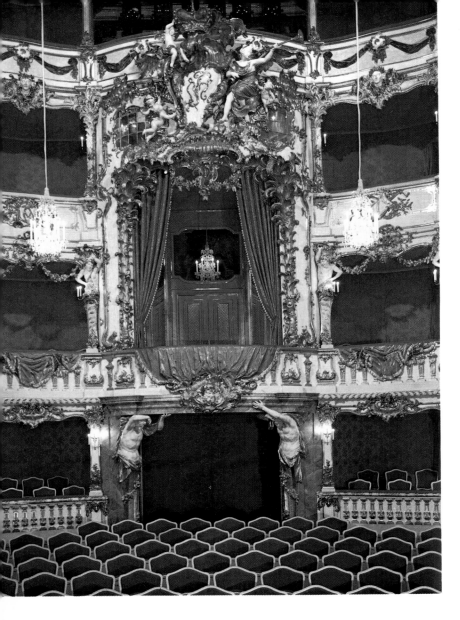

CUVILLIÉS. The old Residenz Theater, Munich. View toward the Prince's box. 1751–53. Sculptural decoration by Johann Baptist Straub (1704–84), stucco by J. B. Zimmermann

In the summer of 1750, Max III Joseph, Elector of Bavaria and son of Max Emanuel, commanded that a new opera house be built in the Residenz complex at Munich. François de Cuvilliés, then at the height of his creative powers, was the architect. Here, in the unreal fantasy world of the theater, the new style, which subtly alters and abstracts from natural forms, could attain its greatest beauty. The auditorium, with its loggias, candelabra, caryatids, and gathered curtains, and the Prince's box in the center, itself becomes the setting for the grand drama of the court. The Prince's place above the parterre is almost like a sacred tabernacle, high above the crowd and framed by curtains that can at any time be drawn to conceal him. The sacred element in the secular world of the court, sharply emphasized during the reign of Louis XIV, is intensified in South German Rococo by the fact that very similar decorative motifs were used in both the courtly and religious milieus.

The model for Cuvilliés' theater—in addition to the inspiration he received from France—was primarily the Baroque Opera House in Bayreuth, built by Giuseppe Galli da Bibiena and his son Carlo in 1744–48 for Margravine Wilhelmina of Bayreuth, sister of Frederick the Great. The Bolognese artistic family of Galli da Bibiena was famous throughout Europe for its theater buildings. From St. Petersburg to Lisbon, from Naples to London, members of this family were busy erecting theaters or designing stage sets. However, the difference between Bayreuth and Munich does not merely lie in the dissimilarity of their decorative styles. While in Bayreuth painting is only incidental to the ornaments and decoration, in Munich every piece of ornamentation is modeled and carved to the last detail. Thus, in Cuvilliés' theater, illusion takes on a half-real, fabulous life, while in Bayreuth it is still only a decorative fantasy.

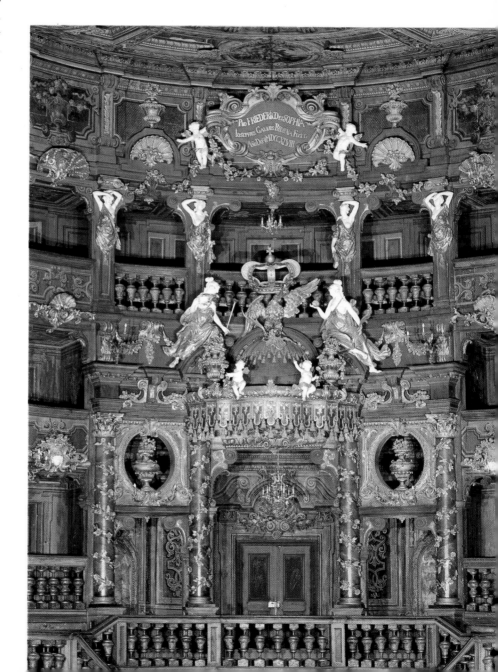

Opera House, Bayreuth. View toward the Prince's loge. Interior decoration by Giuseppe Galli da Bibiena (1695–1756) and his son Carlo (1728–78). c. 1750

The Bavarian-Swabian Rococo was not confined to the courtly milieu, nor to the most important churches and monasteries. This light, festive style, assuming ever new and fantastic forms, penetrated into the world of the rural parish churches and pilgrimage churches and there had its most exquisite flowering. "Die Wies," near Steingaden in Upper Bavaria, is one such jewel of church Rococo, set in the middle of the lonely Bavarian foothills of the Alps. Here, Dominikus Zimmermann and his brother Johann Baptist created a unified work of art in which painting, stucco decoration, and sculpture fuse with the fluid architecture—which itself seems to dissolve in ornament—in one magnificent, mystical accord. The church houses a painting, highly revered by

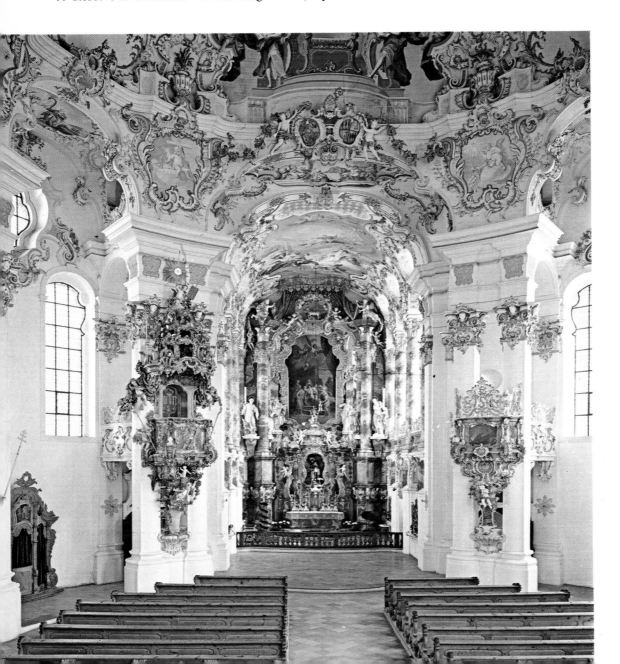

Pilgrimage church "Die Wies." Pulpit

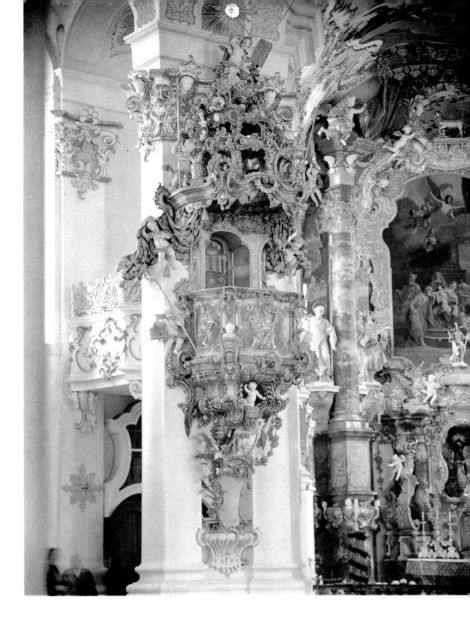

◄ DOMINIKUS ZIMMERMANN (1685–1766). Pilgrimage church known as "Die Wies," Upper Bavaria. View toward the high altar. Stuccowork and painting by J. B. Zimmermann 1745–54

pilgrims, of Christ being scourged. Around this picture is built a great iconographic program of frescoes and figures that extends from the repentance and atonement of the sinner to the moment before the Last Judgment. Unlike Weltenburg, where the Asam brothers strove to transport the faithful into an ecstatic vision, the visitor to "Die Wies" is immediately surrounded by an aura of light that itself draws him into the celestial event. In the pulpit, the *rocaille*—which has already transformed the arcades before the choir loft into completely fluid structures—becomes a frenzied mass of mobile forms. At the base of the pulpit, water flows with bizarre naturalism from the shells and fishes' heads.

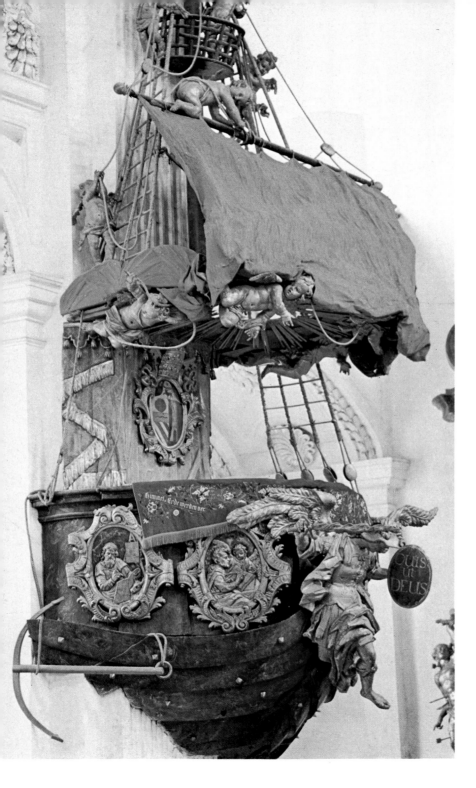

IGNAZ GÜNTHER (1725–75). *The Annunciation*. 1764. Linden-wood, height 63″. Former Augustinian monastery church of St. Peter and Paul, Weyarn

The motif of water had frequently been associated with the pulpit: the Church was seen as the Ship of St. Peter, from which the word of God was proclaimed. At Irsee in Swabia, a ship in full sail with angels clambering about the rigging as members of the crew, has a double meaning: it is both an allegory of the Ship of the Church, and an allusion to the naval victory of Lepanto, in which the Turks were decisively defeated in 1571 (see page 200). The ship of the victorious Christian League is at the same time a symbol of the triumphant Christian Church.

Parish church, Irsee. Pulpit in the form of a ship. c. 1724–25. Artist unknown

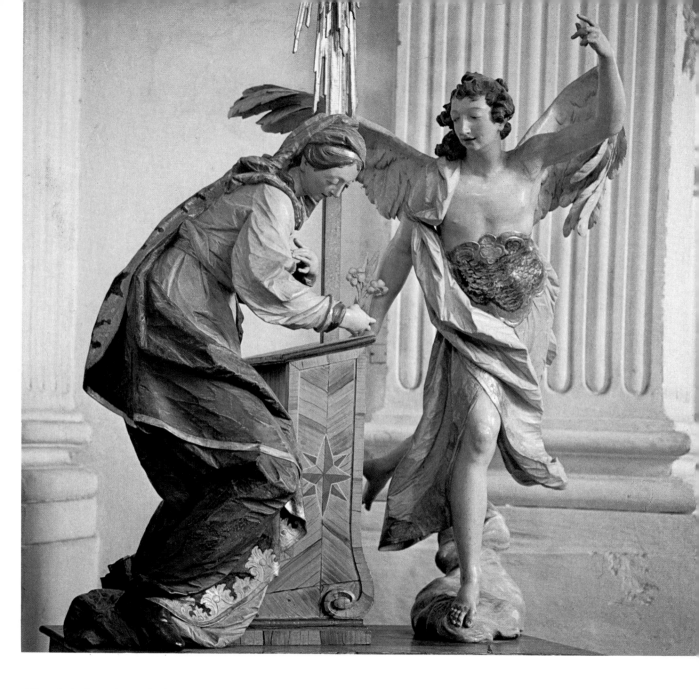

Shortly before the end of the Rococo, Bavarian Rococo sculpture culminated in the work of Ignaz Günther, reaching a quality that was scarcely to be expected in so late a stylistic phase. Günther, who was educated, not in Italy, but in Vienna, adopted the elongated body proportions of Mannerism and translated them into the exceedingly refined, dynamic curves of the Rococo. His figures, ecstatic and devout, express the popular piety that in Bavaria allowed heavenly and earthly splendor to be united in a sensually appealing way.

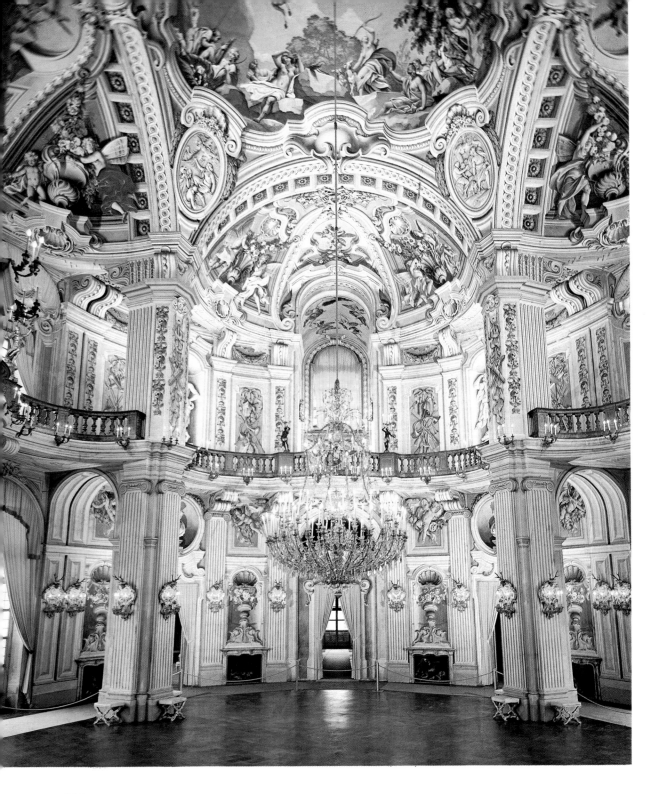

FILIPPO JUVARRA (1678–1736). Stupinigi Palace, near Turin. Interior view of the main hall. Completed 1733

BERNARDO VITTONE (1704/5–70). S. Chiara, Brà. Begun 1742. View into the dome

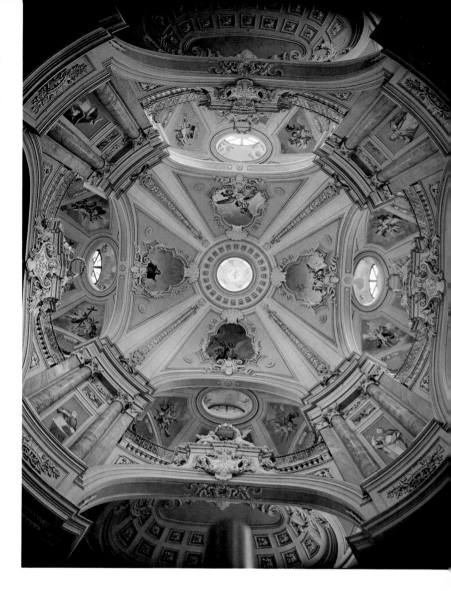

Genuine Rococo was never indigenous to Italy. The decoration of interiors remained monumental even in the eighteenth century, and architecture never freed itself from static laws, as it had in South German Rococo. Yet forms did emerge—particularly in Piedmont in northern Italy, where Guarini's works exerted an influence—that emphasized dynamic lines of force instead of clearly distinguishing between the supporting members of a building and those parts of it that constituted the weight or load. Thus, Filippo Juvarra, who was born in Sicily but created his major works at the royal court of Savoy, arrived at architectural solutions that were astonishingly similar to those of Balthasar Neumann (see page 167). As in Neumann's work, freestanding piers are used; those in the main hall of the Stupinigi Palace, near Turin, are separated from the wall by a passageway, and seem to have a natural upward thrust. The curve of the gallery railing seems to resemble those in South German and Bohemian church interiors, although the extent to which Juvarra was familiar with the architecture of those regions remains to be investigated.

Bernardo Vittone studied the works of both Juvarra and Guarini; he also edited a collection of Guarini's engravings, *Architettura civile...*, which appeared posthumously in 1737 (see page 57). Vittone's churches are almost all located in small Piedmontese towns, so that this excellent and unusual architect has only recently come to be appreciated. In the dome of S. Chiara at Brà, Vittone manages to combine Juvarra's forms with Guarini's complicated handling of light, creating a spatial effect that in many features resembles the work of Kilian Ignaz Dientzenhofer in Prague. Dientzenhofer, too, was obviously familiar with Guarini's designs. Thus, surprisingly similar architectural forms were created independently in different parts of Europe, as an outgrowth of the genius of the great North Italian architect.

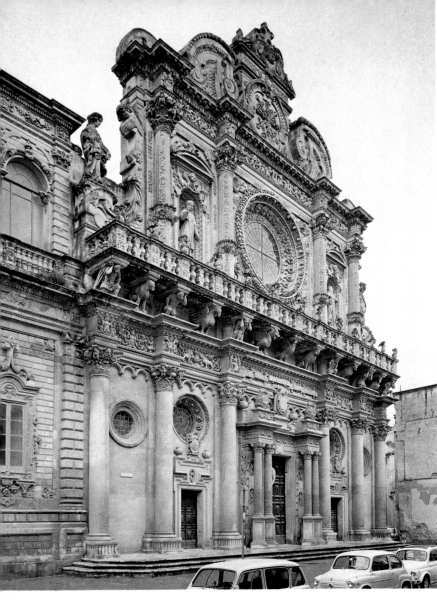

Rosario Gagliardi (active 1721–70). Monasterio del Salvatore, Noto. View of the façade and belvedere. Mid-eighteenth century

S. Croce (Chiesa dei Celestini), Lecce. Façade. Begun 1582 by Gabriele Riccardi, completed 1646 by Cesare Penna. The adjoining façade of the former Convento dei Celestini begun 1659 by Giuseppe Zimbalo, completed 1695

For centuries, Apulia was united with Naples and Sicily under Spanish rule. Thus, a Baroque style developed in southern Italy which, although often making use of inspiration from North Italian artists, had a quality all its own and was related to the Spanish Baroque. What this style has in common with the Spanish is (as in the so-called plateresque style of the sixteenth century) that ornamentation seems to be imposed upon the architectural surface, like silversmiths' work, without being related to the actual structure. In Lecce, the chief center of Apulian Baroque, the decoration of the façades is largely due to the soft, pliant quality of the local stone. Luxurious ornamentation covers the façade of the church of S. Croce so completely—especially in the upper story, which was built at a later date—that scarcely any of the background surface can be seen. On the front of the adjoining former convent, window frames are surrounded by proliferous half-botanical, half-abstract ornamentation.

216

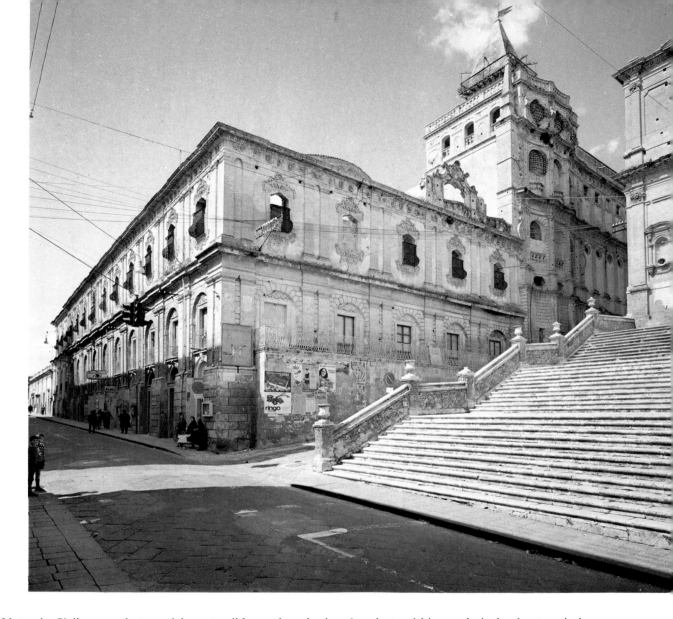

Noto, in Sicily, was destroyed by a terrible earthquake in 1693, but, within a relatively short period, was completely rebuilt according to a unified plan on a site about five miles from that of the old city. In Noto, as in Lecce, ornamentation is of great importance. But here, in the fluid lines of the architecture itself, as, for example, in the alternately concave and convex front of the towerlike belvedere in the monastery of San Salvatore, another source can be recognized: Guarino Guarini came to Messina in 1660 and there created the supple façade of the church of S. Annunziata, later destroyed in the great earthquake. Guarini's architecture had an influence on Sicily well into the eighteenth century. In the ornamentation, too, one can sense the influence of the great North Italian, but here the contours seem soft and organic compared with those, for instance, of the Palazzo Carignano in Turin (see page 56).

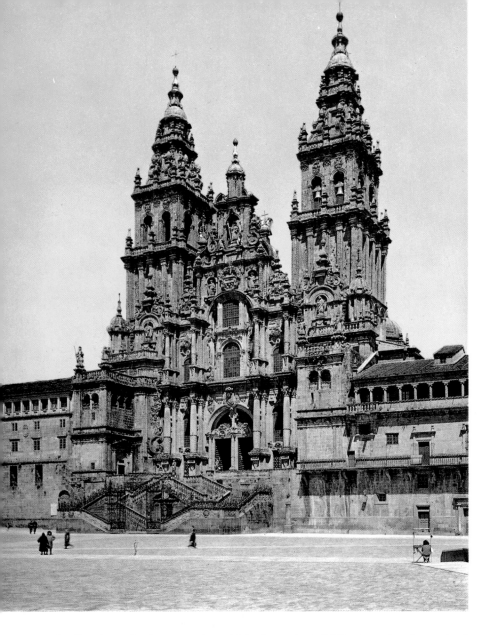

Cathedral of Santiago de Compostela. Façade (the so-called Obradoiro). Begun 1650, completed mid-eighteenth century. Towers by José Peña de Toro, central portion by Domingo de Andrade and Fernando de Casas y Novoa

In Santiago de Compostela, which since the Middle Ages has been the foremost pilgrimage site in Spain, is located one of the most significant works of the Spanish Baroque, the so-called Obradoiro of the cathedral. In 1650, it was decided to add a new, more impressive west front to the old Romanesque cathedral. Although the work was not completed until a hundred years later, the entire front possesses an impressive unity. Here, too, the rich ornamentation covering the façade plays a major role, especially where areas are thrown into deep shadow. The strongly projecting columns, placed one above the other, in the central portion create forceful vertical accents that give the entire façade, despite the extremely rich Baroque decoration, an almost Gothic appearance.

The shadow effects created by deeply modeled ornamentation, the sharply projecting cornices, and the massive three-quarter columns set well in front of the wall are idiosyncrasies of Spanish Baroque architecture. Even in the mid-eighteenth century—that is, when the architect involved was Spanish rather than foreign, particularly Italian—artists continued to use the heavy forms, combining them with rich ornamentation and enlivening their designs by incorporating the changing play of light and shadow. In order to realize just how much eighteenth-century European art varied from country to country and what manifold possibilities it encompassed, one must keep in mind that Andrés García de Quiñones built the court of the Clerecía in Salamanca at approximately the same time as "Die Wies" was being built in Bavaria (see page 210).

ANDRÉS GARCÍA DE QUIÑONES (active from 1720). Clerecía, Salamanca. Courtyard. 1750–55

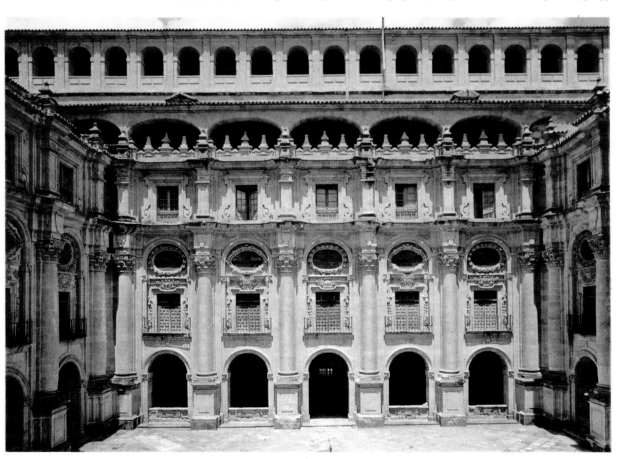

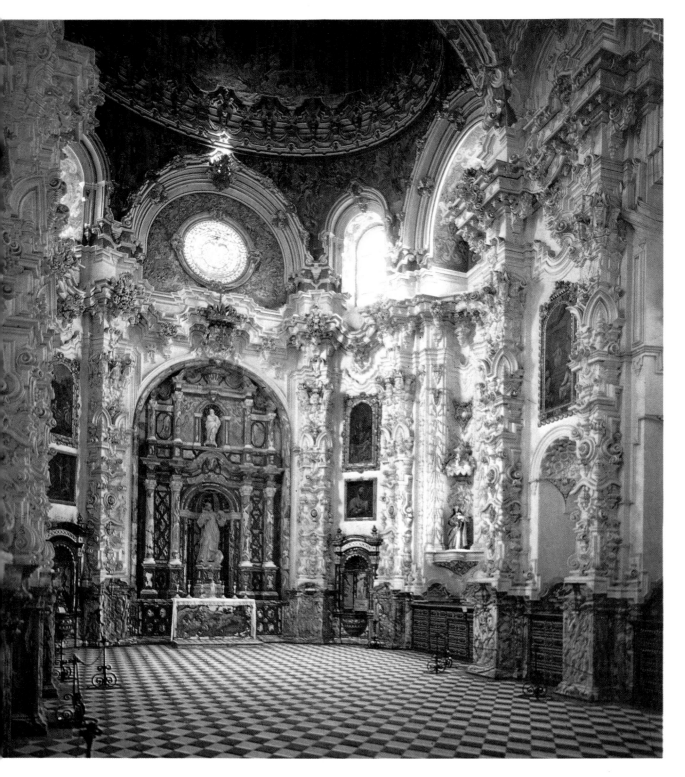

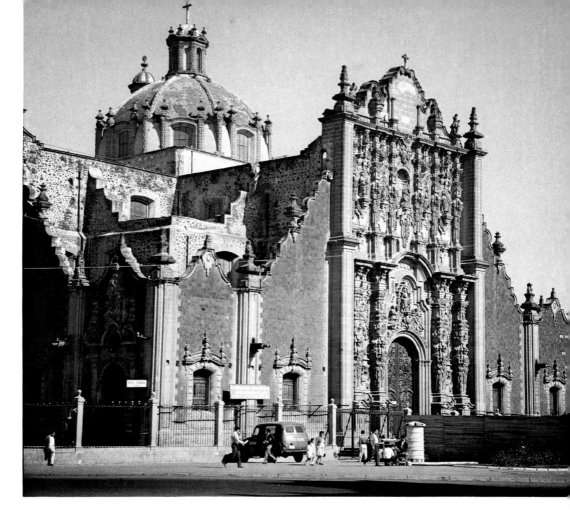

◀ Luis Arévalo, Alfonso Castillo, and José Manuel Vázquez. Sacristy of the Cartuja, Granada. Mostly built 1730–47

Lorenzo Rodríguez (c. 1704–74). Sagrario Metropolitano, Mexico City. Façade. 1749

In southern Spain, ornamentation was intensified even further, reaching a frenzied tempo that can only be explained by foreign influences. The incredibly rich stucco decoration of the sacristy of the Cartuja in Granada is an example. This is a Rococo that has only its exaggerated vitality in common with the French or South German styles; in its details, it is quite unlike them. The forms are geometric, angular, divided by hard edges; because of the many contours running parallel to the profile, the total effect is linear and cool despite all the deep shadows cast by the rich carving. It has been suggested that this style resulted from Moorish influences in Spain, or influences from the Spanish colonies in North and South America. It can certainly be assumed that the motherland and the colonies affected each other; but the lines of influence run far more strongly from Spain to the new settlements in the Americas than in the opposite direction. The façade of the Sagrario Metropolitano in Mexico City, for example, is clearly derived from Spanish buildings. The architect, Lorenzo Rodríguez came to Mexico from Andalusia, bringing with him the rich vocabulary of forms of South Spanish façade decoration. Indeed, he then exaggerated this opulence—no doubt under the influence of the old, indigenous architecture of Mexico and Central America—creating a web of luxuriant details that seems inappropriate even for the all-too-richly ornamented Spanish architecture.

French influence was responsible for a residential palace at Queluz, near Lisbon, that in its intimacy and graceful forms is truly inspired by the Rococo spirit. The Portuguese architect Mateus de Oliveira, working with the Frenchman Jean-Baptiste Robillion, erected this building for the Infante Dom Pedro and his wife, Queen Maria I. Earlier, Oliveira had worked with other architects on the monastery-palace of Mafra. But in Queluz he managed to free himself from the pompous forms of that Portuguese Escorial, and created a pleasure palace comparable to the most beautiful in Europe in its graceful architecture and the tasteful choice of its furnishings.

MATEUS VICENTE DE OLIVEIRA (1706–86) and JEAN-BAPTISTE ROBIL-
LION (d. 1768). Queluz Palace, near Lisbon. Garden front. 1747–60

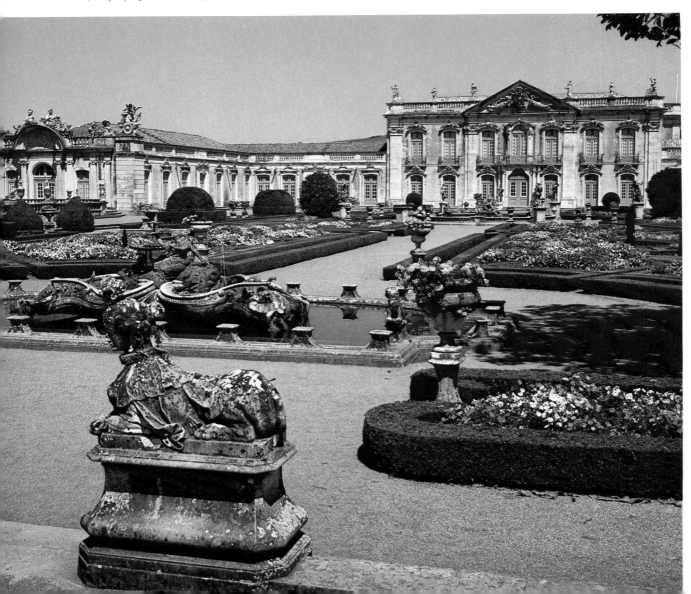

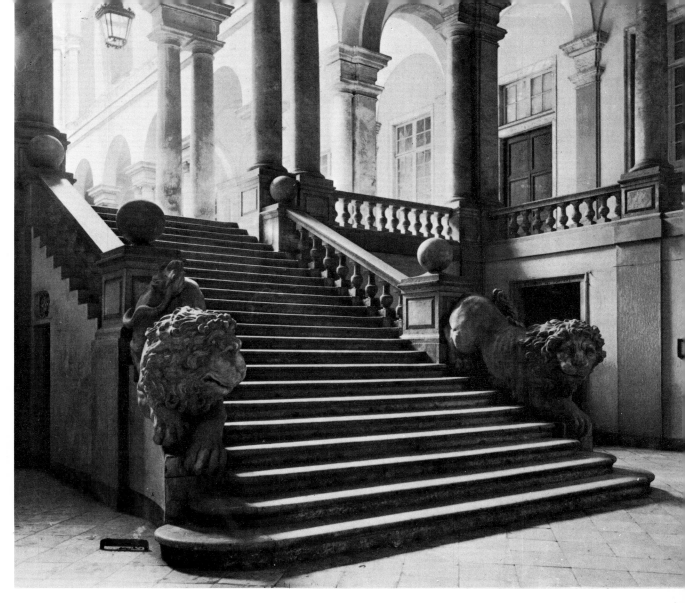

BARTOLOMEO BIANCO (before 1590–1657). Genoa University. Staircase. 1634–36

There is scarcely any period in European art history when the staircase has played so central a role as during the Baroque. For centuries, it was considered merely a passageway, hardly worth being treated as an artistic form. Genoa, hemmed in between the sea and the mountains, extends far up the slopes. Often, great differences in height have to be overcome within a single palace complex, and thus the staircase soon became one of the most interesting parts of the Genoese palazzi. It frequently descends, with a broad outward curve, to an open courtyard.

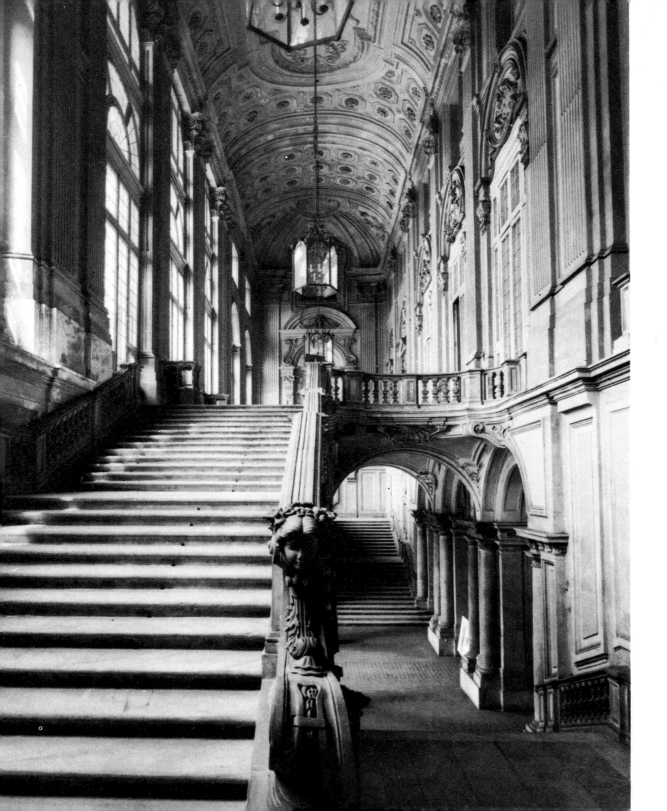

Throughout the Middle Ages, the spiral staircase was a favored means of connecting the different floors of buildings. In the late-medieval period, particularly in France and Germany, these spiral staircases were elaborated to form ingeniously designed stair turrets. After the Renaissance, new possibilities for design were revealed by the straight staircase. Here in Turin, for example, a stairway of two flights is made to appear double by the use of mirrors; it is further emphasized by being placed beneath a barrel vault, and the whole forms a unified hall. The structure which Juvarra cleverly added to the old citadel extends across the entire width of the front. The façade of the palace therefore becomes only a frame in which to display the stair hall, the first area the visitor sees as he enters the building.

In the gigantic palace complex of Caserta, near Naples, Luigi Vanvitelli has the Scala Regia, a stairway of three flights, lead upward into a wide, vaulted hall. A light-drenched vestibule receives the visitor at the top. In ascending the stairs, one experiences a finely modulated succession of light, semidarkness, and then once again light.

LUIGI VANVITELLI (1700–73). Palace, Caserta. View of the stair hall. 1752–74

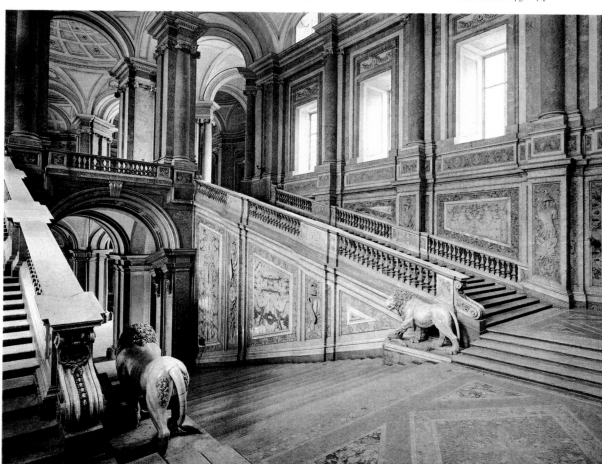

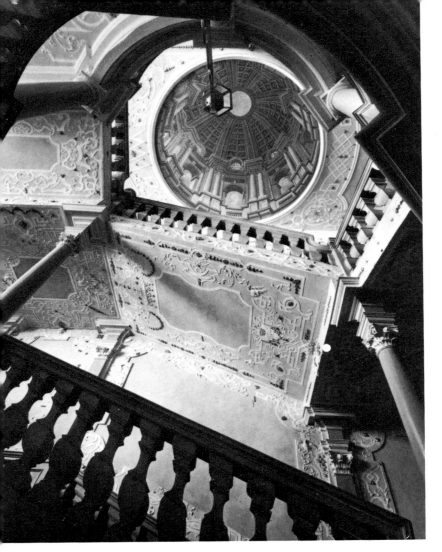

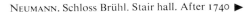
Residence of Marschalk von Ostheim, Bamberg. Stair hall. c. 1725–30. Architect unknown

In the houses of the bourgeoisie, as well as in royal palaces, the staircase became an essential component of the interior decoration, primarily intended to reflect the wealth of the owner—although, naturally, the bourgeois houses and their stairs were on a considerably smaller scale. Generally, the old form with a series of landings was retained—a form that had developed out of the spiral staircase. These staircases usually rose several stories, and the flights, with their landings, were grouped around an open well. This permitted charming views through the supporting pillars and along the steep undersides of the stairs as one ascended. With this type of construction, of course, the stair well remained isolated; certainly, it connected the stories, but did not form a spatial sequence with other, splendid rooms, as did, for example, the staircase of Schloss Brühl, near Bonn, designed by Balthasar Neumann. Here, the stairs, supported by graceful columns and caryatids, overflow into the airy vestibule. The guest was led up a triple flight, first into the *Salle des Gardes* and from there on into the dining and music rooms and the audience chambers of the Elector. The staircase forms a solemn *entrata*, a great opening chord for the symphonic sequence of grand rooms that continues with ever new aspects on the upper level. The hall rises two more stories above the upper landing of the staircase, and then the ceiling continues the effect of openness, allowing one to look past an airy gallery at a dome fresco illuminated by concealed upper windows. Through the marvelous color harmonies of its sculpture and ornamentation, the stucco further enhances the movement that seems to fill the whole space with vibrant life.

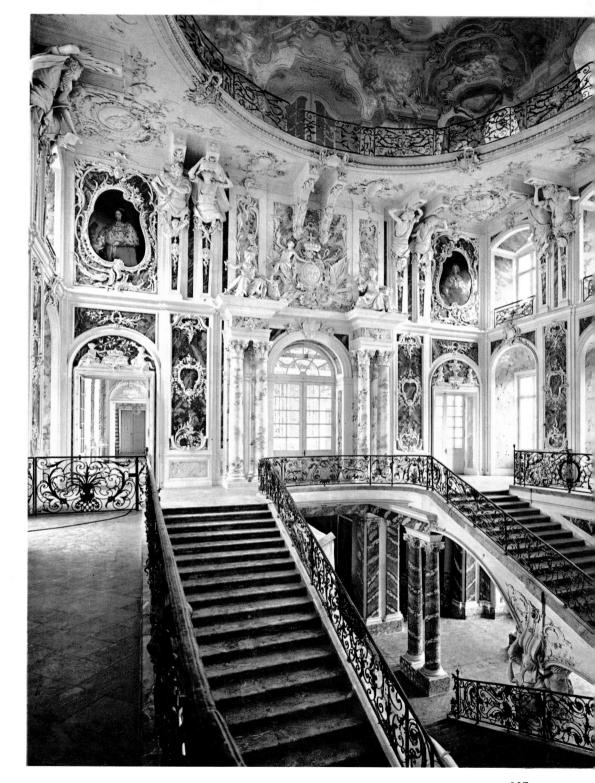

ALESSANDRO GALLI DA BIBIENA (?) (1687–1769). Design for a theater set.
Watercolor, 10¹/₂ × 16³/₄″. Staatliche Graphische Sammlung, Munich

The staircase has a natural, central place in the theater, where the action takes place on various levels and in artistically arranged movements and groupings. This design for a theater set, probably by Alessandro Galli da Bibiena, another member of the famous Bolognese family of artists (see page 209), shows a scene with garden architecture and an oval staircase, with a number of landings, that encircles a fountain. It is not certain how much of the set could actually be trodden by the actors and how much was only a painted backdrop, but the small proscenium suggests that at least the terraces at the first level were meant to be used. Innumerable stage designs with complicated staircase arrangements as their central motif were produced during this period. Filippo Juvarra, too, left a whole series of such imaginative architectural sketches for the theater. But the stage was not the only realm where architecture and nature were combined to create splendid visual effects. In garden architecture, especially in Italy, terraces were built at different levels to produce a variety of views. Count Karl von Hessen brought an architect from Rome to design the gigantic garden layout on the Karlsberg, near Kassel, in the grandest style. Giovanni Francesco Guerniero was the designer of an enormous garden that has no equal in Europe. At the top of a series of steps about eight hundred feet long and forty feet wide, he built a giant octagon with ashlar of volcanic basalt and crowned it with a thirty-foot high statue of the *Farnese Hercules*. Here, for all time, so to speak, is played out the dramatic struggle of the Greek hero

against the giants: Hercules has just hurled a giant to earth and cast an enormous stone on top of him; only the giant's head is visible as, in fury, it spits forth a high fountain against the victor. From here, the waterfall cascades over rocks and cliffs, then down the steps and deep into a valley, where it finally comes to rest in a great pool.

GIOVANNI FRANCESCO GUERNIERO (1665–1745). Wilhelmshöhe, Kassel. Waterfall with octagon. Statue of the *Farnese Hercules* by the Augsburg goldsmith Anthoni. Hammered copper, height 30′. After 1701

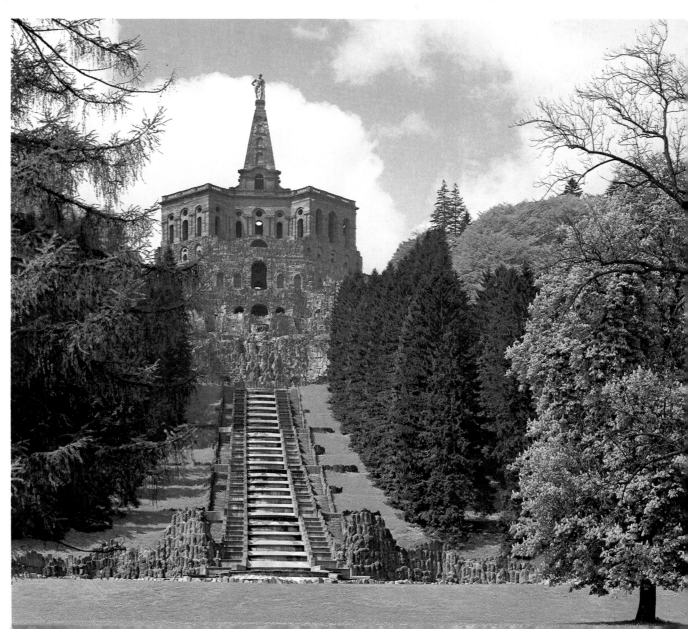

GAGLIARDI (?). S. Giorgio, Modica, Sicily. Façade. 1702–38

In religious architecture, too, steps played an important role during the Baroque, most frequently as an exterior flight. Here, too, of course, architects sought to create a "view," to use the façade as the climax of a monumental staircase layout, but here they also attempted to instill in the faithful the proper mood for entry into the church. Climbing slowly toward the church entrance, the worshiper should free himself inwardly from the mundane world, in order to attain peace before the altar in the sight of God. The motion of the exterior flight of steps thus contributes to the human drama through which man becomes purified for his meeting with the Almighty.

Where the climb to the church also presented the Stations of the Cross, it was not considered enough that one should merely cease to think of earthly things during the ascent; purification was to be achieved through painful acts of penance. In Bologna, an arcade with 666 openings leads the faithful in a wide curve past the various Stations to the sanctuary. In places such as this, the sinner had to climb the staircase penitentially, as far as possible on his knees, in order to receive final forgiveness before the shrine. Then, at the summit, absolved of his guilt, he could let his eye wander far over the land which, dominated by the church, lay at his feet. During the Baroque, religious buildings were repeatedly placed on heights: Melk in Austria, the Superga near Turin, and (below) the Madonna di S. Luca above Bologna are examples. At these sites, the architecture is skillfully incorporated into the landscape as its crowning accent.

CARLO FRANCESCO DOTTI (c. 1670–1759). Madonna di S. Luca, Bologna. After 1723. Stations of the Cross built 1674–1739

In palace building, too, flights of steps were employed again and again to enliven the façade—significantly enough, however, more often on the garden (that is, private) side than at the main entrance of the palace. A transitional zone was thus created between the living garden and the solid, static palace itself. The staircase, although entirely out-of-doors, was already a man-made structure, and was thus the bridge that connected the realm of nature with that in which man lived. On the garden side of the Villa Troja, built in 1679–96 by Jean-Baptiste Mathey, two elegantly planned flights of steps rise around a pool to the official rooms on the upper level. On the stone balustrade, a mythological battle of giants takes place with violent movement and countermovement. The theme of the sculptures—the conquest of untamed nature by the gods—was no doubt deliberately chosen by the owner or by one of his learned advisors for this intermediate zone between nature and the ordered world of men. The energy of the dramatically placed groups stands in stark contrast to the quiet façade of the central pavilion, in which, after the subjugation of the forces of evil, the princely life could take place with ease and festivity.

MATHEY. Villa Troja, near Prague. 1679–96. Staircase on the garden front with sculptures by Johann Georg and Paul Heermann (cf. page 151)

BERNARDO BUONTALENTI, attributed (1536–1608). Fountain at the corner of Borgo S. Jacopo and Via dello Sprone, Florence. End of sixteenth century

In describing the course of artistic development, ornamentation has been frequently mentioned. As an accessory to architecture and sculpture, it may at first seem to be merely incidental. However, one soon comes to realize its function in determining form. And when an entire epoch is named after its ornamental motif—like the Rococo after *rocaille*—the importance of ornamentation becomes obvious.

At the end of the sixteenth century, the so-called conch style originated, inspired by Renaissance motifs. Its name comes from the thickly flowing spirals that again and again combine to produce half-plant, half-animal hybrid forms that somewhat resemble ears. This fountain in Florence, attributed to Bernardo Buontalenti, displays this ornamental form in the rim of its basin, into which a mask with plantlike features spews out the water. The convolutions and indentations here combine with the water to form a strange, harmonious entity. Particularly around his windows and entrances, Buontalenti applied a thick layer of cartouches, shells, and garlands, along with leatherlike shawls and animal hides, which swarm over the actual architecture.

Two designs for a window (joined down the center). Copper engraving by Wilhelm Pfann in *Seulen-Buch, Oder Gründlicher Bericht von den Fünf Ordnungen der Architectur-Kunst...*, (Column-book, or A Fundamental Report on the Five Orders of Architectural Art...) edited by Georg-Caspar Erasmus, Nuremberg, 1667

Left: VAN VIANEN. Drinking ▶ cup. 1621. Silver, height 6$^{1}/_{8}$". Right: JANUS LUTMA (c. 1584–1669). Drinking cup. Silver, length 8$^{1}/_{8}$". Both Rijksmuseum, Amsterdam

As early as the end of the sixteenth century, and even more in the seventeenth, styles of ornamentation spread throughout Europe and elsewhere by engravings. Most of these engravings were based on the classical architectural theory of Vitruvius, showing his orders of columns with their various proportions; but they also frequently provided designs for the decoration of gates, doors, and windows. Often, such patterns for ornaments were not printed until the style was already being replaced by new forms. Thus, the gristly, grotesque shapes in the window design (facing page) by Georg Caspar Erasmus (active in Nuremberg in the second half of the seventeenth century) were already out of date when his collection of engravings appeared in 1667. Here are depicted ornaments that had reached their highest and most unusual development in the first half of the seventeenth century in the Netherlands.

Particularly in metalwork, the play with asymmetrical, flowing, swollen forms was pushed almost to the point of formlessness. On the border of a drinking cup by Adam van Vianen (see page 138), the figures of Bacchus, Ceres, Venus, and Cupid can still be recognized, despite their convolutions. The drinking cup by Janus Lutma, however, is amorphous, heavy, viscous, like a frozen river; only the head of a turtle is hinted at. Here, one can see how far artists had gone in distorting and obliterating the distinctions between human and animal forms, between swampy ground and the world of plants. A fantastic, uncanny, hybrid world arises to celebrate orgies of fantastic combinations. These forms have no symbolic content; they are simply the results of a play of mind, a pure joy in invention. Strangely enough, Art Nouveau took up this stylistic phase of the seventeenth century. Lutma's cup could, if one did not look too closely, be mistaken for an Art Nouveau product.

JOHANN BAPTIST MOD- ▶
LER (1700–74), attrib-
uted. New Episcopal
Palace, Passau. Detail
of the stuccoed ceiling
of the former third
antechamber. c. 1768

GIOVANNI (JOHANN
BAPTIST) ZUCCALLI
(d. 1678). Stucco dec-
oration in the mon-
astery church of St.
Lorenz (now the par-
ish church), Kemp-
ten. Third quarter of
seventeenth century

Italian artists never pushed their ornamentation as far toward the amorphous and asymmetrical as did the Dutch and, under Netherlandish influence, the North Germans. A certain order and solidity of structure are always present in Italian works. Thus, the stucco with which Giovanni (Johann Baptist) Zuccalli decorated St. Lorenz in Kempten remains clearly related to the architectural forms of the dome, emphasizing the vaulting, and filling only the intermediate areas with plantlike tendrils which, however, usually have some symmetry. Zuccalli came from a widely scattered artistic family from the Grisons that had done much work in Bavaria. This family was responsible for bringing North Italian architectural, as well as ornamental, forms across the Alps into southern Germany.

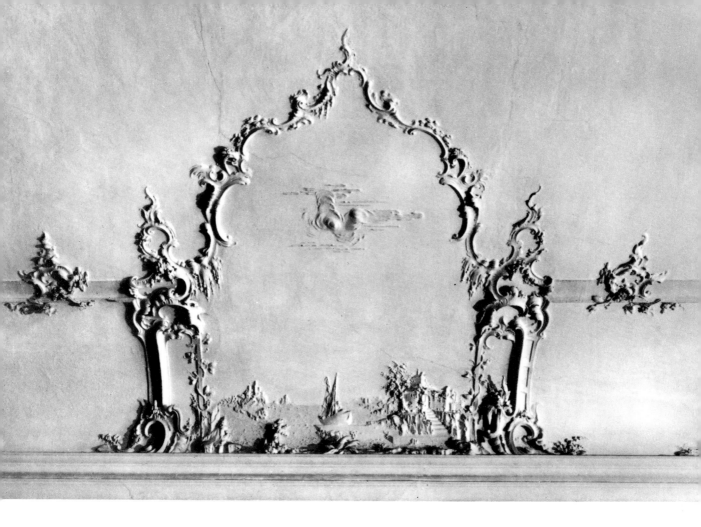

The stucco created about a hundred years later than Kempten to decorate the ceiling of the Passau Episcopal Palace looks very different indeed. There is nothing left to hint at the architectonic structure: the *rocaille* has arrived. It, too, like the ornamental forms of the early seventeenth century, was derived from the world of water creatures. But, here, the shell composition is altered, combined in great C- and S-curves with leaves such as the acanthus to create abstract forms that scarcely hint at models in the real world. This kind of ornamentation came to southern Germany from France via engravings. In Germany, imagination was given free rein and the *rocaille* was developed into forms that simulate a strange, dilapidated, and decaying world. Often, used as frames for realistic landscape, this decoration is combined with motifs or groups of figures in the painting, so that the observer feels himself set down in an intermediate realm between make-believe and reality.

BUSTELLI. Basin for consecrated water. 1763. Nymphenburg porcelain, height 9⅝". Bayerisches Nationalmuseum, Munich

JAKOB MICHAEL KÜCHEL (1703–69), JOHANN MICHAEL FEICHTMAYR ▶ (c. 1709–72) and JOHANN GEORG ÜBELHERR (1700–63). Altar of Mercy, pilgrimage church of Vierzehnheiligen. After 1764

In France, the *rocaille* was used chiefly in the interior decoration of rooms—that is, to ornament a background surface. In southern Germany, however, it was adopted in areas where it could appear as a self-sufficient form. Thus, in the minor arts, for example, vessels were made that seem to consist solely of *rocaille* ornamentation (see the baptismal pitcher on page 206). The actual function of such objects only plays a subordinate role. The porcelain basin for consecrated water, designed by Antonio Francesco Bustelli (see pages 198–99), is primarily a hanging wall ornament; the fact that the lower edge of the shell curves forward to form a small bowl for the holy water is almost irrelevant.

As the *rocaille* developed into autonomous forms, it appeared not only in small objects, but on a larger scale: in the pilgrimage church of Vierzehnheiligen in Franconia, it takes the form of a large altar, standing as an independent architectonic structure. The basic elements of all architecture, the load and the supports such as the columns and architrave, are obscured by a free play of flowing, meandering, inward- and outward-swinging forms which carry the baldachin above the altar as though in a parade. The lightness and grace of the *rocaille* style are expressed at their best here, where all the worldly weight of the actual buildings is forgotten and the baldachin seems to float almost miraculously. At the same time, the distinctions between different categories of art are dissolved: one can imagine exactly the same structure, on a much smaller scale, as a centerpiece for a table or, if made of quite different materials, as a coronation coach or as a canopy over a throne. However, these trends in the use of ornament were developed to this extent only in South Germany. At the same time as Vierzehnheiligen was being built, the first signs of Neoclassicism were appearing in France, and contemporaries in France and England who tended toward the new style condemned this altar as the peak of tastelessness.

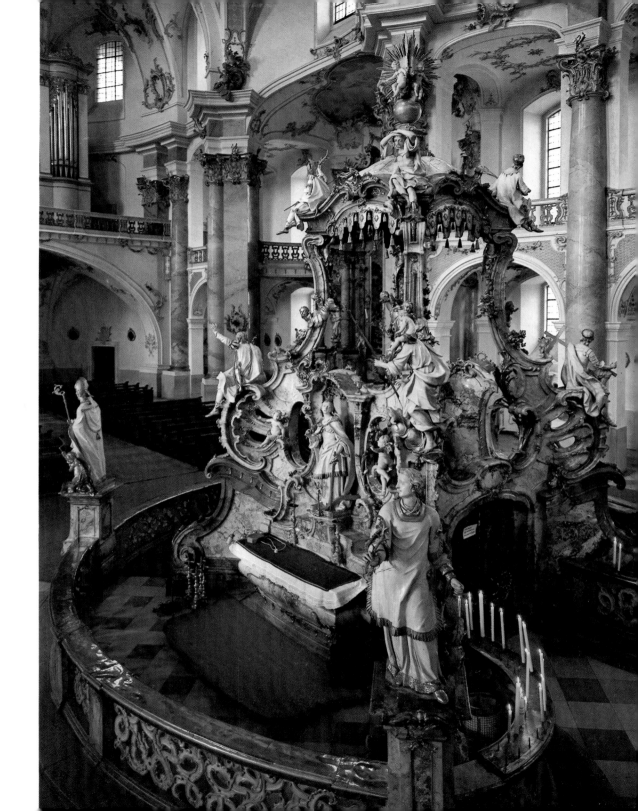

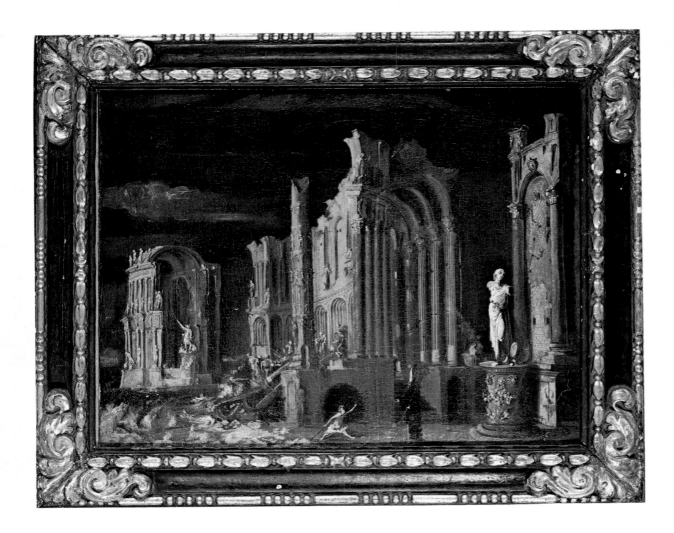

Ornament is not the only basis for establishing a connection between the eighteenth century and the Mannerism of the late sixteenth and early seventeenth centuries. In painting, too, one can discern a persistent tendency to question the reality of man's earthly surroundings—a theme that was first consistently sounded by the Mannerists. Some of the strangest and most mysterious of these pictures, in which man appears to be thrown into a sinister world whose transience constantly threatens him, are the work of "Monsú Desiderio." Only in the twentieth century, when the modern Surrealist movement reached its height, have they been rescued from oblivion. The personal life of the artist or artists is surrounded with mystery. Recently, the paintings of "Desiderio" have been shown to be the work of two different artists, Didier Barra and Francesco de Nomé. But the question of identity will not be debated here; we are concerned only with the uniqueness of the work. Every man-made thing that appears in "Desiderio's" paintings is in a state of decay—the statue in the foreground has no arms; the atmosphere is dark and stormy. The world is like a nightmare, gloomy and threatening; men blunder about almost as insignificant, and as lost, as insects.

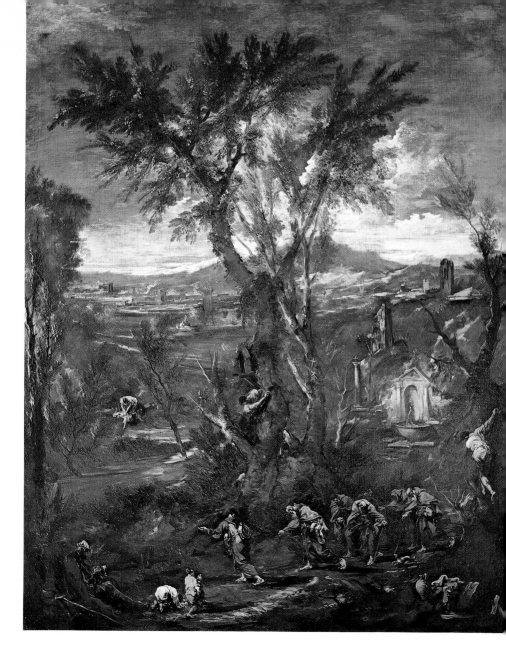

"MONSÚ DESIDERIO" (fl. early
seventeenth century). *Scene from
the Life of Saint Januarius*. First
quarter of seventeenth century.
Oil on canvas, 19$\frac{1}{8}$ × 24$\frac{1}{8}$".
Collection Richard Dreyfus,
Basel

ALESSANDRO MAGNASCO (1667
–1749). *Landscape with Pil-
grims and Monks*. c. 1720–30.
Oil on canvas, 92$\frac{1}{2}$ × 68$\frac{7}{8}$".
Brera Gallery, Milan

About a century after "Desiderio," Alessandro Magnasco painted the world as an ominous, ragged place,
shot through with flickering light; through these surroundings the wretched pilgrims drag themselves labo-
riously forward. Here, the crumbling works of men are less important than the decay of nature, the dying
boughs of the trees, and the pervasive sense of doom. In ghostly, impetuous brush strokes, the forms are put
down, in disarray, dilapidated, corroded by the transience of all that is of this world.

◄ GIOVANNI BATTISTA PIRANESI (1720 –78). *Imaginary Prisons,* plate 5. c. 1760. Etching, 22¼ × 16¼″

GIOVANNI FRANCESCO MARCHINI (active 1702–36). *Falling Architecture.* Fresco in the eastern room adjoining the Sala Terrena, Schloss Weissenstein, Pommersfelden. 1716–18

In the work of Giovanni Battista Piranesi, the whole world has become a prison in which man, threatened by uncanny machines, wanders from vault to vault. Much as in the work of "Monsú Desiderio," the ruins of classical buildings in and around Rome are engraved by Piranesi with topographical precision. In the *Imaginary Prisons,* he then expands the forms of Roman ruins and gigantic crumbling arches into unreal dimensions in which man is lost, as in a nightmare, and from which he can find no escape.

Half as a joke and curiosity, half as a warning of the impermanence of the world, Giovanni Francesco Marchini had already, in the first half of the eighteenth century, painted a collapsing ceiling in a side room of the Sala Terrena in Schloss Weissenstein, Pommersfelden. His fresco is, of course, not as sinister as the works of "Monsú Desiderio" or Piranesi. But since it is painted onto existing architecture and seems to represent the actual vault of the hall in the process of falling in, it seems even more chilling. Here, it is no world of fantasy but, rather, the real world that crumbles into disorder and decay—the very world in which the observer himself can be struck down by just such an accident.

SANDERSON MILLER (1717–80). Miller's Castle, Hagley Hall, Worcestershire. 1747–48

The fashion for ruins was not confined to the graphic arts; at an early date, artificial ruins were erected in England as an element of park design. The Gothic style, at least in certain characteristic features, had never been entirely dead in England; it continued to exist alongside Palladian buildings. In the first half of the eighteenth century, however, Gothic architecture was consciously and deliberately revived. Sanderson Miller was only an amateur artist, but gifted with a fine taste for architecture. He taught himself the fundamentals of the art and designed buildings for his friends in the most varied styles. After he had written an essay on the Gothic, he built a ruined medieval fortress in the park of Hagley Hall for Lord Lyttelton; in this work, Romanesque and Gothic elements were mingled. The intrusion of untamed nature into a decaying work of man, here artificially produced, was a preoccupation of Romanticism, and was constantly developed later, in the nineteenth century, in painting as well as in garden design.

HUBERT ROBERT (1733–1808). Grotto of Apollo in the park of Versailles. 1778–80. Sculptural ▶
group *Apollo Attended by the Nymphs of Thetis*, by François Girardon (see page 70). 1666

There is scarcely any other place where one can see the difference of attitude toward nature of the late seventeenth and late eighteenth centuries as clearly as in the Grotto of Apollo at Versailles. In the seventeenth century, the group of nymphs that wait on Apollo after his long day's journey were placed in a regular grotto, in a world ordered according to human dimensions (see page 70). About a hundred years later, the same sculptures by François Girardon and Thomas Regnaudin were placed in a new outdoor setting, in a grotto with ruins designed by Hubert Robert. The god now appears in a natural setting, surrounded by trees and bushes, instead of in a world based on man and built by him. He is, entirely in the Antique sense, a part of nature itself. It is obvious that man's feeling for nature had greatly altered; this same change of feeling allowed the irregular, "natural" English park design to develop from carefully laid-out Baroque and Rococo gardens.

Throughout the Rococo, classical forms—particularly in the exterior of official buildings—were never entirely forgotten in France. A façade like that of the cathedral of Santiago de Compostela or a building like the Zwinger in Dresden was unthinkable in France; such a design would have been considered disordered and barbaric by the French. Restrained as it may appear, however, a new spirit can be felt in the construction of the Petit Trianon at Versailles, especially if it is compared with the classical façade of the Louvre (see page 59). The forms are brittle and angular, the blocklike quality of the structure is sharply emphasized, and the façade is clear and hard. The noble proportions give the building a dignity and solemnity that are quite contrary to the spirit of the Rococo. The Petit Trianon originated on a rustic site where the King, with his mistress at his side, wanted to be able to forget the ceremonial etiquette of the court. In the enormous park of Versailles, Louis XV built a farm with a dairy and sheepfold for Madame de Pompadour. There, it was thought, they could live in the lap of nature and disregard the conventions of a pernicious society—as Jean-Jacques Rousseau was advocating. In 1762, a small palace was begun in the immediate vicinity. Madame de Pompadour died, however, before the interior decoration was completed, and it was the King's next favorite, Madame Du Barry, who dedicated the Petit Trianon in 1768.

Rousseau, with his turbulent nature and his thirst for freedom, had come into conflict with the prevailing social order at an early age. When he began to attack that social order in his writings, he was harshly persecuted both in religious and worldly circles—yet his ideas gained ground precisely in those upper levels of society against which they were directed. People were especially eager to accept his idea that man was naturally

good; that, if he remained close to nature, he could continue to be good; and that he was only made evil by the rules of society. Thus, the dissolution of the tightly organized French society did not actually begin with the Revolution; it had already begun when the court, at least in private, declined to follow courtly forms.

HOUDON. Portrait bust of Jean-Jacques Rousseau. c. 1778–80. Terra cotta. Musée des Arts Décoratifs, Paris

RICHARD MIQUE (1728–94) and HUBERT ROBERT. The Hameau
(rustic village near the Petit Trianon), Versailles. 1782–86

With Marie Antoinette, daughter of the Empress Maria Theresa, the Petit Trianon acquired a mistress who regarded every rule of etiquette as irksome. When she came to France at the age of eighteen, her husband, Louis XVI, gave her the little palace with the words, "This place was always the residence of the beloved of the King; so it must also be yours." Here, the spoiled young woman surrounded herself with an intimate circle of friends; among this group, all the rules of court life were dispensed with. One did not even rise when the Queen entered the room. Nearby, a small village was built, and peasant families were settled there. Among them, the Queen had her own house, outwardly disguised as a farm. Here, she could play as realistically as possible at leading a rural life, close to nature. Madame de Pompadour had wanted her farm chiefly so that Louis XV, who was very interested in botany, could have a life of his own aside from the duties of government. Marie Antoinette's little village, on the other hand, must be seen as a stage set for festivities, which it was then the fashion to put on as pastoral games or rustic celebrations.

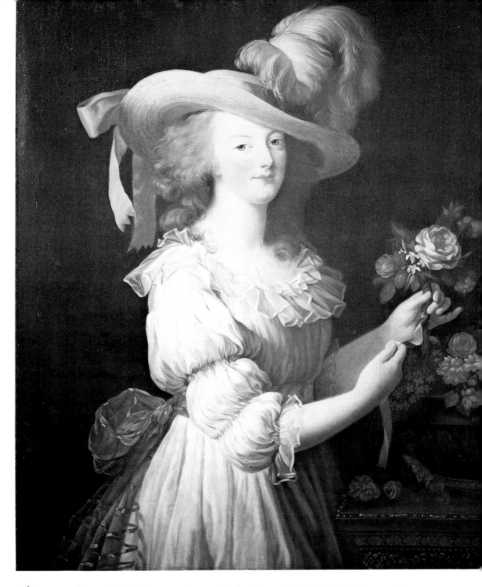

ÉLISABETH-LOUISE VIGÉE-LEBRUN (1755–1842). *Portrait of Marie Antoinette, Queen of France.* Before 1783. Oil on canvas, 35³/₈ × 28³/₈″. Collection of H. R. H. Prince Ludwig von Hessen und bei Rhein, Wolfsgarten

The fact that a strict consciousness of tradition reigned at the French court alongside the light, free atmosphere surrounding the Queen is shown by the fate of the portrait that Élisabeth-Louise Vigée-Lebrun painted of Marie Antoinette. It was exhibited in the official Salon of 1783, but had to be withdrawn because it depicted the Queen, in defiance of accepted etiquette, wearing a dress of white muslin cut in a "modern," that is, frivolous, style that caused a scandal at court.

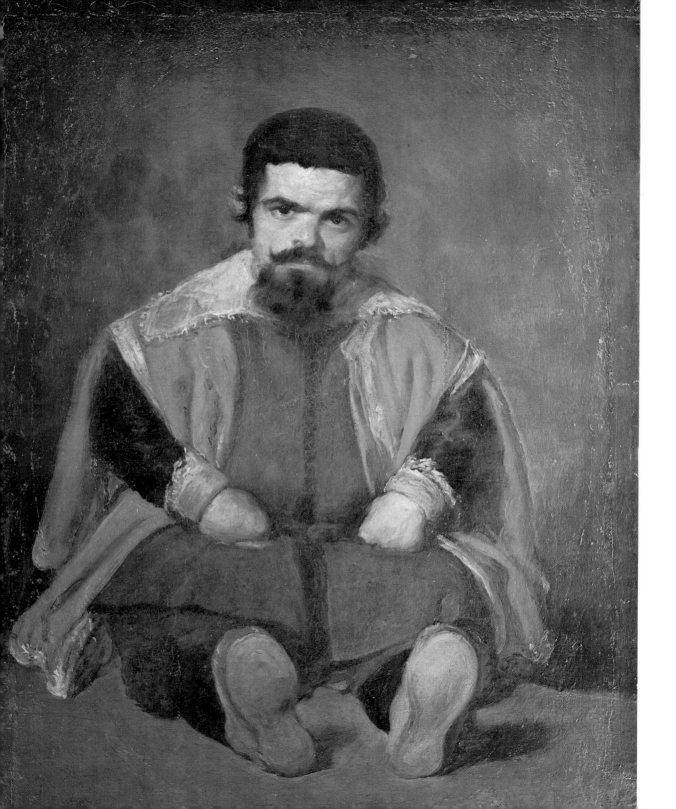

◄ VELÁZQUEZ. *Portrait of the Court Dwarf Don Sebastián de Morra.* c. 1643–44. Oil on canvas, 41³/₄ × 31⁷/₈″. The Prado, Madrid

PÍNTVRA D.D.DIEGO VELAZQVEZ.
Que Representa á un ENANO, y esta en el Palacio R. de Madrid, acabada p.º D. Fran. Goya Pintor á 1778

FRANCISCO JOSÉ DE GOYA Y LUCIENTES (1746–1828). *The Court Dwarf Don Sebastián de Morra,* after Velázquez. 1778. Etching, 8¹/₈ × 6″

The Revolution stands at the door. The old order, based on spiritual and temporal hierarchies that had remained basically untouched from the Middle Ages to the threshold of the nineteenth century, begins to totter. Not only in France, where the struggle was carried out openly and bloodily, but everywhere in Europe, the spirit of the people was dammed up—the spirit of individualism against the fetters of the old, traditional order of things. Velázquez had done more than paint the members of the Spanish Court as representatives of their position (see pages 44, 45); in his work, they were always men with their own individual lives. His portrait of the court dwarf Morra showed him also as a creation of nature, looking out at the observer with deep melancholy. But Morra accepted his fate and filled the office of court dwarf as a matter of course, as an appropriate position for him in the social hierarchy.

How differently Goya saw the same man: in Goya's portrait, fate has made Morra evil. The same face stares at the viewer, but this time with threatening hatred, almost ready to leap out to avenge himself upon a society that has compelled him to occupy so humiliating a position. Goya's work was like a seismograph, registering with great sensitivity the force of the earthquake that was to convulse the European world. His early pictures were still filled with the light spirit of the Rococo, although they already contained a certain irony. But then his horror at the cruelty and evil of the world burst forth, especially in his series of engravings.

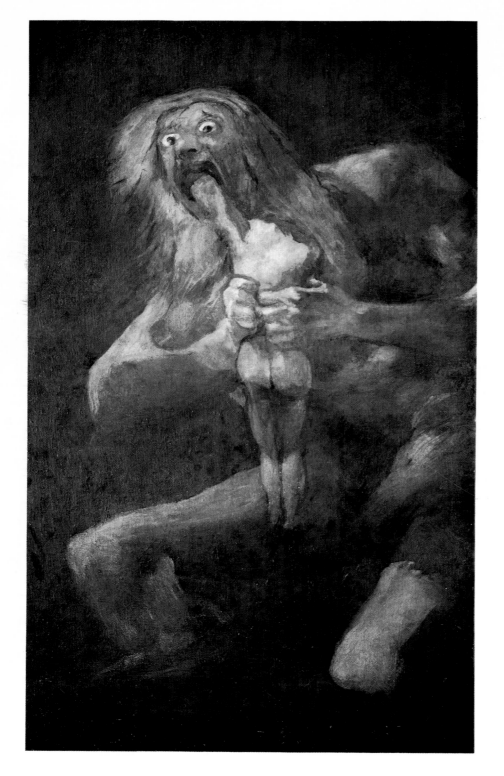

Goya's painting of Saturn greedily devouring one of his own children is not only a portrait of the age—the time of the bloody Napoleonic wars in Spain—but also the story of his own life, which proved that the revolution devours its own children. Here, we come face to face with all the demonism of a world dedicated to its own terrible destruction —a Last Judgment in which there is no mercy, only horror.

APPENDIX

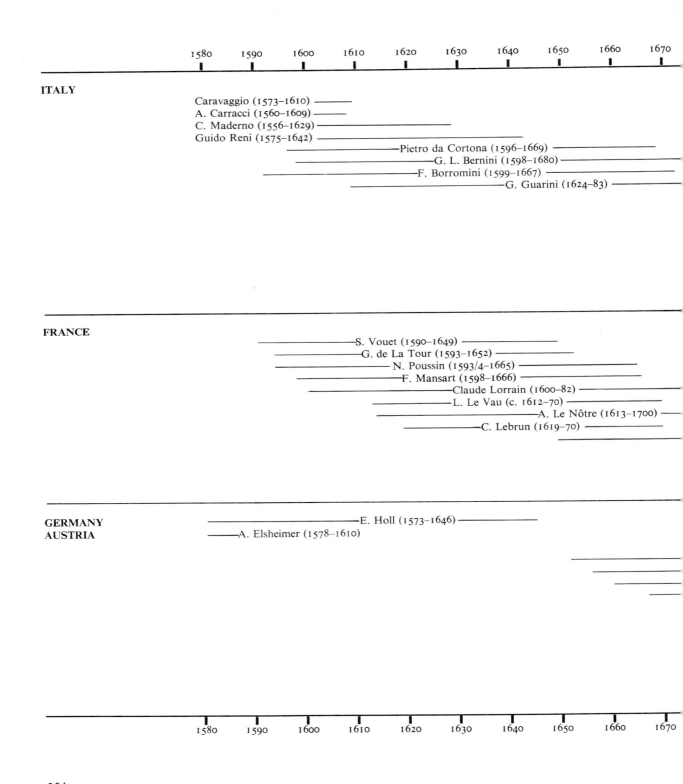

	1580	1590	1600	1610	1620	1630	1640	1650	1660	1670

ITALY

Caravaggio (1573–1610) ———
A. Carracci (1560–1609) ———
C. Maderno (1556–1629) ————————
Guido Reni (1575–1642) ————————————————————
————————————————Pietro da Cortona (1596–1669) ————————————
————————————G. L. Bernini (1598–1680) ————————
————————————F. Borromini (1599–1667) ————————
————————————————G. Guarini (1624–83) ————————

FRANCE

————————————————S. Vouet (1590–1649) ————————————
————————————————G. de La Tour (1593–1652) ————————
————————————————N. Poussin (1593/4–1665) ————————
————————————————F. Mansart (1598–1666) ————————
————————————————Claude Lorrain (1600–82) ————————
————————————————L. Le Vau (c. 1612–70) ————————
————————————————A. Le Nôtre (1613–1700) ——
————————————————C. Lebrun (1619–70) ————————

GERMANY
AUSTRIA

————————————————E. Holl (1573–1646) ————————
————A. Elsheimer (1578–1610)

	1580	1590	1600	1610	1620	1630	1640	1650	1660	1670

254

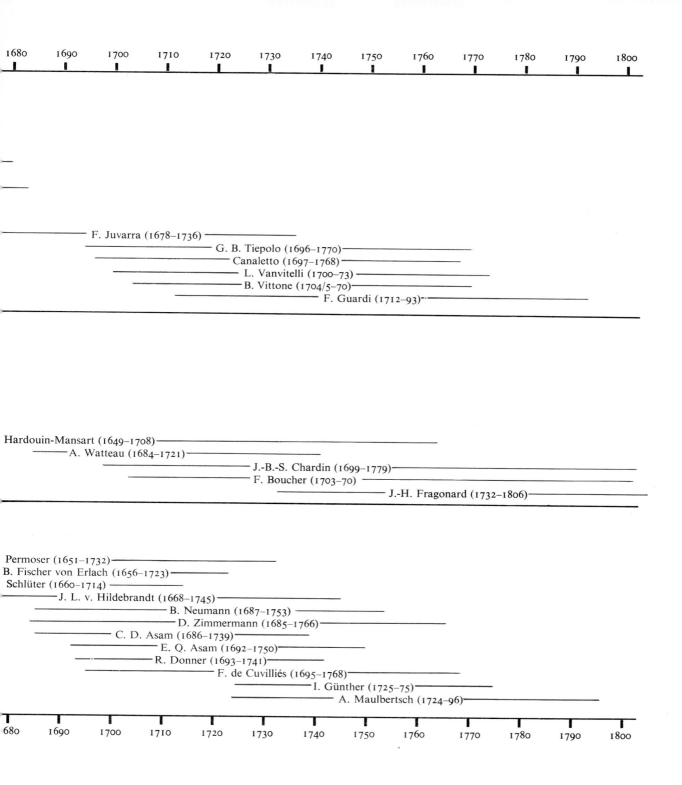

1680	1690	1700	1710	1720	1730	1740	1750	1760	1770	1780	1790	1800

F. Juvarra (1678–1736)
G. B. Tiepolo (1696–1770)
Canaletto (1697–1768)
L. Vanvitelli (1700–73)
B. Vittone (1704/5–70)
F. Guardi (1712–93)

Hardouin-Mansart (1649–1708)
A. Watteau (1684–1721)
J.-B.-S. Chardin (1699–1779)
F. Boucher (1703–70)
J.-H. Fragonard (1732–1806)

Permoser (1651–1732)
B. Fischer von Erlach (1656–1723)
Schlüter (1660–1714)
J. L. v. Hildebrandt (1668–1745)
B. Neumann (1687–1753)
D. Zimmermann (1685–1766)
C. D. Asam (1686–1739)
E. Q. Asam (1692–1750)
R. Donner (1693–1741)
F. de Cuvilliés (1695–1768)
I. Günther (1725–75)
A. Maulbertsch (1724–96)

680	1690	1700	1710	1720	1730	1740	1750	1760	1770	1780	1790	1800

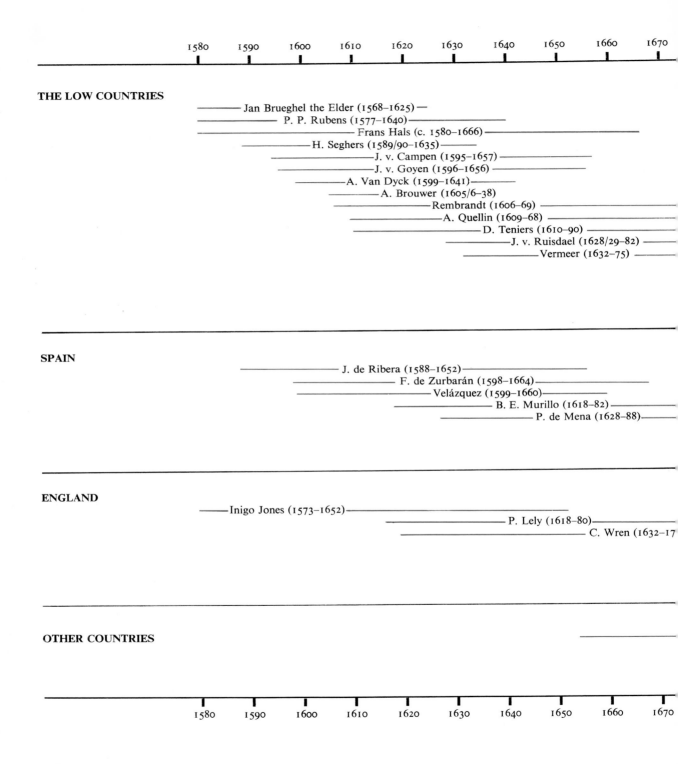

	1580	1590	1600	1610	1620	1630	1640	1650	1660	1670

THE LOW COUNTRIES

——— Jan Brueghel the Elder (1568–1625) ———
——————— P. P. Rubens (1577–1640) ———————
———————— Frans Hals (c. 1580–1666) ————————
——— H. Seghers (1589/90–1635) ———
——— J. v. Campen (1595–1657) ———
——— J. v. Goyen (1596–1656) ———
——— A. Van Dyck (1599–1641) ———
——— A. Brouwer (1605/6–38)
——— Rembrandt (1606–69) ———
——— A. Quellin (1609–68) ———
——— D. Teniers (1610–90) ———
——— J. v. Ruisdael (1628/29–82) ———
——— Vermeer (1632–75) ———

SPAIN

——— J. de Ribera (1588–1652) ———
——— F. de Zurbarán (1598–1664) ———
——— Velázquez (1599–1660) ———
——— B. E. Murillo (1618–82) ———
——— P. de Mena (1628–88) ———

ENGLAND

——— Inigo Jones (1573–1652) ———
——— P. Lely (1618–80) ———
——— C. Wren (1632–17

OTHER COUNTRIES

	1580	1590	1600	1610	1620	1630	1640	1650	1660	1670

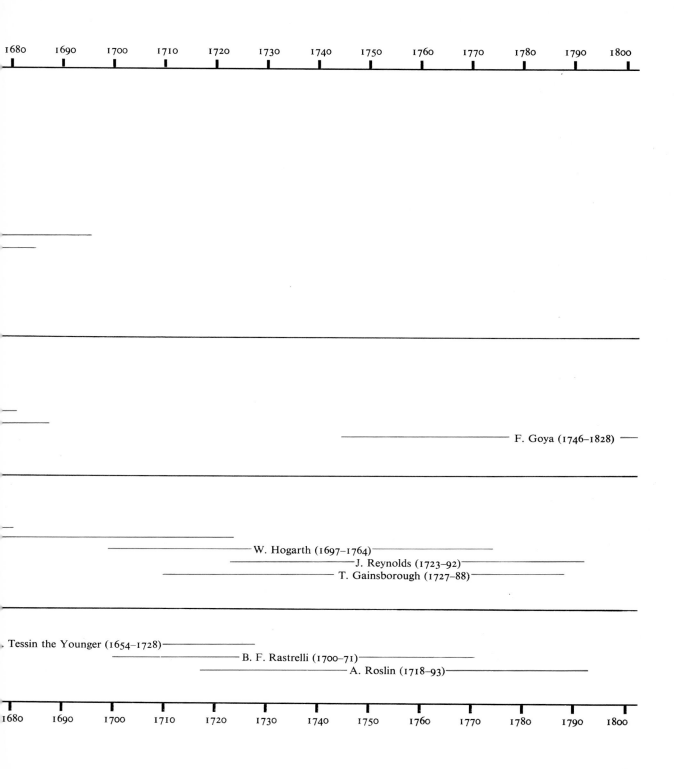

1680 1690 1700 1710 1720 1730 1740 1750 1760 1770 1780 1790 1800

F. Goya (1746–1828)

W. Hogarth (1697–1764)

J. Reynolds (1723–92)

T. Gainsborough (1727–88)

Tessin the Younger (1654–1728)

B. F. Rastrelli (1700–71)

A. Roslin (1718–93)

1680 1690 1700 1710 1720 1730 1740 1750 1760 1770 1780 1790 1800

Bibliography

CULTURAL HISTORY

BLEI, F., ed., *Geist und Sitten des Rokoko*, Munich, 1967

FLOERKE, H., *Studien zur niederländischen Kunst- und Kulturgeschichte*, Munich–Leipzig, 1905

HARTT, F., *Love in Baroque Art*, Locust Valley, N.Y., 1964

HASKELL, F., *Patrons and Painters*, London, 1963

HAUSENSTEIN, W., *Vom Geist des Barock*, Munich, 1920

HUIZINGA, J., *Dutch Civilization in the Seventeenth Century and Other Essays*, New York, 1968

PFANDL, L., *Spanische Kultur und Sitte des 16. und 17. Jahrhunderts*, Kempten, 1924

POBÉ, M., *Das klassische Frankreich: Die drei Jahrhunderte vor Ausbruch der Revolution*, Vienna–Munich, 1963

ART HISTORY

ADAMA VAN SCHELTEMA, F., *Die Kunst des Barock*, Stuttgart, 1958

ANGYAL, A., *Die slawische Barockwelt*, Leipzig, 1961

BAKER, C. H. C., and CONSTABLE, W. G., *Die Malerei des 16. und 17. Jahrhunderts in England*, Leipzig, 1930

BAUER, H., *Der Himmel im Rokoko: Das Fresko im deutschen Kirchenraum des 18. Jahrhunderts*, Regensburg, 1965

BAUER, H., *Rocaille: Zur Herkunft und zum Wesen eines Ornament-Motivs*, Berlin, 1962

BAZIN, G., *Baroque and Rococo Art*, New York, 1964

BERGSTRÖM, I., *Dutch Still-Life Painting in the Seventeenth Century*, London, 1956

BERNT, W., *Die niederländischen Maler des 17. Jahrhunderts*, Munich, 1960–62, 3 vols. and a supplementary vol.

BODE, W. VON, *Die Meister der holländischen und flämischen Malerschulen*, 3rd ed., Leipzig, 1921

BRANCA, V., ed., *Barocco Europeo e Barocco Veneziano*, Florence, 1963

BRINCKMANN, A. E., *Barockskulptur*, Berlin–Neubabelsberg, 1919, 2 pts.

BRINCKMANN, A. E., *Baukunst des 17. und 18. Jahrhunderts in den romanischen Ländern*, Wildpark–Potsdam, 1924

BRINCKMANN, A. E., *Theatrum Novum Pedimontii*, Düsseldorf, 1931

BURROUGH, T. H. B., *South German Baroque*, London, 1956

BUSHART, B., *Deutsche Malerei des 17. und 18. Jahrhunderts*, Königstein i. T., 1967, 2 pts.

BUSSE, K. H., *Die Illusions-Kunst des späten Barock: Die Verwirklichung des Überwirklichen*, Mainz, n.d.

DE LOGU, G., *Natura morta italiana*, Bergamo, 1962

DROST, W., *Barockmalerei in den germanischen Ländern*, Wildpark–Potsdam, 1926

ESCHER, K., *Barock und Klassizismus*, Leipzig, 1910

FANIEL, S., ed., *Le dix-huitième siècle français*, Paris, 1957

FEULNER, A., *Bayerisches Rokoko*, Munich, 1923

FEULNER, A., *Die deutsche Plastik des 17. Jahrhunderts*, Florence–Leipzig, 1926

FEULNER, A., *Skulptur und Malerei des 18. Jahrhunderts in Deutschland*, Wildpark–Potsdam, 1929

GALLEGO Y BURIN, A., and GOMEZ MARENO MARTINEZ, M., *El barrocco granadino*, Madrid, 1956

GANGI, G., *Il barocco della Sicilia orientale*, Rome, 1964

GERSON, H., and TER KUILE, E. H., *Art and Architecture in Belgium, 1600–1800*, Baltimore, 1960

GOERING, M., *Deutsche Malerei des 17. und 18. Jahrhunderts*, Berlin, 1940

GOERING, M., *Italienische Malerei des 17. und 18. Jahrhunderts*, Berlin, 1936

GRISERI, A., *Le metamorfosi del Barocco*, Turin, 1967

HAUTECOEUR, L., *Histoire de l'architecture classique*, Vol. II, Paris, 1948

HAUTTMANN, M., *Geschichte der kirchlichen Baukunst in Bayern, Schwaben und Franken, 1550–1780*, Munich, 1923

HEMPEL, E., *Baroque Art and Architecture in Central Europe*, Baltimore, 1965

HILDEBRANDT, E., *Malerei und Plastik des 18. Jahrhunderts in Frankreich*, Wildpark–Potsdam, 1924

HOFMANN, F. H., *Das Porzellan der europäischen Manufakturen im 18. Jahrhundert*, Berlin, 1932

JUSTI, C., *Diego Velázquez und sein Jahrhundert*, Zurich, 1933, 2 vols.

KEHRER, H., *Spanische Kunst von Greco bis Goya*, Munich, 1926

KELLER, H., *Das Treppenhaus im Deutschen Schloss- und Klosterbau des Barock*, Munich, 1929

KIMBALL, F., *The Creation of the Rococo*, New York, 1964

KUBLER, G., and SORIA, M. S., *Art and Architecture in Spain and Portugal and Their American Dominions, 1500–1800*, Baltimore, 1959

LAFUENTE FERRARI, E., *El realismo en la pintura del siglo XVII. Paises Bajos y España*, Barcelona, 1945

LAMB, C., *Die Wies*, Munich, 1964

LEMONNIER, H., *L'art français au temps de Louis XIV*, Paris, 1911

LEYMARIE, J., *Die holländische Malerei*, Geneva–Paris–New York, 1956

LORCK, C. VON, *Preussisches Rokoko*, Oldenburg–Hamburg, 1964

MINGUET, J. P., *Esthétique du Rococo*, Paris, 1966

MOUREY, G., *La peinture anglaise du XVIII^e siècle*, Paris, 1928

NEURDENBURG, E., *De zeventiende eeuwsche beeldhouwkunst in de noordelijke Nederlanden*, Amsterdam, 1948

PEVSNER, N., and GRAUTOFF, O., *Barockmalerei in den romanischen Ländern*, Wildpark–Potsdam, 1928

PIGLER, A., *Barockthemen: Eine Auswahl von Verzeichnissen zur Ikonographie des 17. und 18. Jahrhunderts*, Budapest–Berlin, 1956

PINDER, W., *Deutsche Barockplastik*, Königstein–Leipzig, 1933

PINDER, W., *Deutscher Barock: Die grossen Baumeister des 18. Jahrhunderts*, Königstein–Leipzig, 1938

PLIETZSCH, E., *Holländische und flämische Maler des XVII. Jahrhunderts*, Leipzig, 1960

RICCI, C., ed., *Baukunst und dekorative Skulptur der Barockzeit in Italien*, Stuttgart, 1922

RIEGL, A., *Die Entstehung der Barockkunst in Rom*, 2nd ed., Vienna, 1923

RINALDIS, A. DE, *Die süditalienische Malerei des 17. Jahrhunderts*, Leipzig, 1929

ROCHEBLAVE, S., *La peinture française au XVIII^e siècle*, Paris, 1937

ROSENBERG, J., SLIVE, S., and TER KUILE, E. H., *Dutch Art and Architecture, 1600–1800*, Baltimore, 1966

SAUERLANDT, M., *Die deutsche Plastik des 18. Jahrhunderts*, Florence–Munich, 1926

SCHNEIDER, R., *L'art français: XVII^e siècle (1610–1690)*, Paris, 1925

SCHNEIDER, R., *L'art français: XVIII^e siècle (1690–1789)*, Paris, 1926

SCHÖNBERGER, A., and SOEHNER, H., *Die Welt des Rokoko: Kunst und Kultur des 18. Jahrhunderts*, Munich, 1959

SEDLMAYR, H., *Verlust der Mitte*, Salzburg, 1948

SIMSON, O. G. VON, *Zur Genealogie der weltlichen Apotheose im Barock, besonders der Medicigalerie des P. P. Rubens*, Strassburg, 1936

SITWELL, S., *German Baroque Art*, London, 1927

STAMM, R., ed., *Die Kunstformen des Barockzeitalters*, Munich, 1956

STECHOW, W., *Dutch Landscape Painting of the Seventeenth Century*, rev. ed., New York, 1968

TINTELNOT, H., *Die barocke Freskomalerei in Deutschland, ihre Entwicklung und europäische Wirkung*, Munich, 1951

TINTELNOT, H., *Barocktheater und barocke Kunst*, Berlin, 1939

VERLET, P., *Le style Louis XV*, Paris, 1950

VOSS, H., *Die Malerei des Barock in Rom*, Berlin, 1925

WACKERNAGEL, M., *Baukunst des 17. und 18. Jahrhunderts in den germanischen Ländern*, Berlin–Neubabelsberg, 1915

WACKERNAGEL, M., *Renaissance, Barock und Rokoko*, Frankfurt a. M.–Berlin, 1963–64, 2 vols.

WEIGERT, R.-A., *L'époque Louis XIV*, Paris, 1962

WEINGARTNER, J., *Römische Barockkirchen*, Munich, 1930

WEISBACH, W., *Der Barock als Kunst der Gegenreformation*, Berlin, 1921

WEISBACH, W., *Französische Malerei des 17. Jahrhunderts im Rahmen von Kultur und Gesellschaft*, Berlin, 1932

WEISBACH, W., *Die Kunst des Barock in Italien, Frankreich, Deutschland und Spanien*, Berlin, 1924

WITTKOWER, R., *Art and Architecture in Italy, 1600–1750*, Baltimore, 1958

WÖLFFLIN, H., *Renaissance und Barock*, Ithaca, N.Y., 1966

ZIMMERMANN, E., *Meissner Porzellan*, Leipzig, 1926

MONOGRAPHS ON INDIVIDUAL ARTISTS

ADHÉMAR, H., *Watteau, sa vie, son oeuvre. Précédé de l'Univers de Watteau par René Huyghe*, Paris, 1950

BAUCH, K., *Rembrandt: Gemälde*, Berlin, 1966

BENESCH, O., *The Drawings of Rembrandt*, London, 1954–57, 6 vols.

COLLINS, L. C., *Hercules Seghers*, Chicago, 1953

DENVIR, B., *Chardin*, New York, 1950

EEMANS, M., *Breughel de Velour*, Paris–Brussels, 1964

ERPEL, F., *Die Selbstbildnisse Rembrandts*, Vienna–Munich, 1967

EVERS, H. G., *Peter Paul Rubens*, Munich, 1942

EVERS, H. G., *Rubens und sein Werk: Neue Forschungen*, Brussels, 1943

FREEDEN, M. H. VON, *Balthasar Neumann: Leben und Werk*, Munich–Berlin, 1963

FREEDEN, M. H., and LAMB, C., *Das Meisterwerk des Giovanni Battista Tiepolo: Die Fresken der Würzburger Residenz*, Munich, 1956

GLÜCK, G., *Rubens, van Dyck und ihr Kreis*, Vienna, 1933

GOLDSCHEIDER, L., *Rembrandt: Gemälde und Graphik*, Cologne, 1960

GOLDSCHEIDER, L., ed., *Vermeer: The Paintings*, rev. ed., New York, 1967

GRAUTOFF, O., *Nicolas Poussin*, Munich, 1914, 2 vols.

GRIMSCHITZ, B., *Johann Lucas von Hildebrandt*, Vienna–Munich, 1959

GRÖGER, H., *Johann Joachim Kaendler, der Meister des Porzellans*, Dresden, 1956

HANFSTAENGL, E., *Die Brüder Cosmas Damian und Egid Quirin Asam*, Munich, 1954

LAFUENTE, E., *Velázquez*, London, 1943

MORASSI, A., *G. B. Tiepolo: His Life and Work*, London, 1955

PASSANTI, M., *Nel mondo magico di Guarino Guarini*, Turin, 1963

RÖTHLISBERGER, M., *Claude Lorrain: The Paintings*, London, 1961

ROSENBERG, J., *Jacob van Ruisdael*, Berlin, 1928

ROSENBERG, J., *Rembrandt*, Cambridge, Mass., 1948

SCHNEIDER, A. VON, *Caravaggio und die Niederländer*, Marburg, 1933

SEDLMAYR, H., *Die Architektur Borrominis*, Munich, 1939

SEDLMAYR, H., *Johann Bernhard Fischer von Erlach*, Vienna–Munich, 1956

SORIA, M. S., *The Paintings of Zurbarán*, London, 1953

TELLUCCINI, A., *L'arte dell'architetto Filippo Juvarra in Piemonte*, Turin, 1926

TRAPIER, E. DU G., *Velázquez*, New York, 1948

TRIVAS, N. S., *The Paintings of Frans Hals*, London, 1949

VENTURI, L., *Caravaggio*, Munich, 1955

VRIES, A. B. DE, *Jan Vermeer van Delft*, Berlin–Darmstadt, 1953

WITTKOWER, R., *G. L. Bernini*, rev. ed., New York, 1966

Index

Photo credits: Aerofilms, Ltd. London, p. 87. Albertina (Graphic Coll.), Vienna, p. 153. Alinari, Florence, p. 13 (2×), 14 left, 15, 17, 48, 52, 53 (2×), 223, 233. Anderson, Florence, p. 14 right. Ashmolean Museum, Oxford, p. 84. E. Bauer, Bamberg, p. 168, 212, 213, 226. Bayerisches Nationalmuseum, Munich, p. 238. Bayerische Staatsbibliothek, Munich, p. 78–79. S. Becker, Kassel, p. 229. Bildstelle Rat der Stadt Dresden, p. 195. J. Blauel, Munich, p. 23, 95, 97, 100, 111, 137. E. Böhm, Mainz, p. 216, 217, 225, 230. R. Braunmüller, Munich, p. 194. British Museum, London, p. 108. H. Brix, Bayreuth, p. 209. Photo Bulloz, Paris, p. 22, 26, 27, 32, 33, 34, 35 upper, 38, 46, 59 upper, 60 upper, 62, 65, 98, 101, 123, 141, 175, 178, 179, 180, 182, 185, 245. Burkhard-Verlag E. Heyer, Essen, p. 227. Callwey-Verlag, Munich, p. 249. Chomon-Perino, Turin, p. 57 upper, 214, 215, 224. H.-J. v. Collas, Munich, p. 56 lower, 57 lower, 59 lower, 68, 70 lower, 77 lower, 88 lower, 234. Deutsche Fotothek, Dresden, p. 192. A. Fréquin, The Hague, p. 92. Gemäldegalerie, Dresden, p. 130. Gilchrist Photo Services, Ltd., Leeds, p. 102. Giraudon, Paris, p. 35 lower, 71, 99, 191, 248. S. Hallgren, Stockholm, p. 80 lower. A. Herndl, Salzburg, p. 143, 152, 196. Hochleitner, Passau, p. 237. G. Hofmann, Dürenstein, p. 161. Holle Verlag, Baden-Baden, p. 176. Internationales Bildarchiv, Munich, p. 221, 222. A. F. Kersting, London, p. 51, 82, 83 (2×), 85, 86, 244. R. Kleinhempel, Hamburg, p. 131. J.-A. Lavaud, Paris, p. 177 upper. Librairie d'Art Ancien et Moderne, Paris, p. 64. The Louvre, Paris, p. 61, 120. A. Luisa, Brescia, p. 241. Foto Marburg, Marburg, p. 146. Mauritshuis, The Hague, p. 96, 117, 118. J. de Mayers, Antwerp, p. 93. The Metropolitan Museum of Art, New York, p. 181. E. Meyer, Vienna, p. 107, 157, 159, 162, 163. Musée des Arts Décoratifs, Paris, p. 247. Musées Royaux des Beaux-Arts, Brussels, p. 104. National Gallery, London, p. 39, 134. National Gallery of Art (Rosenwald Collection), Washington D.C., p. 251. National Museum, Stockholm, p. 183. Niedersächsische Landesgalerie, Hanover, p. 16, 54–55. Österreichische Nationalbibliothek, Vienna, p. 160. Palau, Seville, p. 40. K. H. Paulmann, Berlin, p. 80 upper, 174, 242. Photopress, Grenoble, p. 28. Publications Filmées d'Art et d'Histoire, Paris, p. 69, 70 upper, 73, 246. Rapho, Paris, p. 63. J. Remmer, Munich, p. 44, 45, 47, 66, 81, 105, 106, 109, 110, 112, 113, 114–15, 127, 128, 136, 138 upper, 147, 150, 151, 155, 166, 173, 184, 186, 187, 197, 201 upper, 218, 232, 250, 252. Rijksmuseum, Amsterdam, p. 60 lower, 88 upper, 90, 91, 116, 119, 124, 126, 135, 138 lower, 139, 177 lower, 255. Rizzoli Editore, Milan, p. 21, 50, 56 upper, 140, 231. Roger-Viollet, Paris, p. 76. Foto Scala, Florence, p. 18, 19, 20, 24, 30, 37, 41, 43, 49. H. Schmidt-Glassner, Stuttgart, p. 154. G. Schöne, Wolfenbüttel, p. 142. M. Seidel, Mittenwald, p. 148, 149, 158, 164, 165, 167, 169, 170, 198, 199, 200, 201 lower, 202, 203, 204, 205, 206, 207, 210, 211, 220, 236, 239, 243. Service de Documentation Photographique, Versailles, p. 58, 67, 72, 74. J. Skeel, Ashford, p. 29, 36, 42, 133, 172, 188, 189. Staatliche Graphische Sammlung, Munich, p. 228. Staatliche Kunsthalle, Karlsruhe, p. 75. Staatliche Schlösser und Gärten, Potsdam–Sans-Souci, p. 193. W. Steinkopf, Berlin, p. 25, 31, 94, 103, 121, 122, 129, 132, 171, 190. H. Steinmetz, Gräfelfing, p. 208. Studio Gérondal, Lomme-Marais, p. 125. Treasury of the Royal Castle, Stockholm, p. 145. Verwaltung der Staatlichen Schlösser und Gärten, Berlin-Charlottenburg, p. 77 upper. H. Wiesner, Worpswede, p. 144.